AFRICA REMIX

 the
information store

 01603 773114
email: tis@ccn.ac.uk

D1494742

7 DAY LOAN ITEM

208 317

AKINBODE AKINBIYI

JANE ALEXANDER

FERNANDO ALVIM

GHADA AMER

EL ANATSUI

JOËL ANDRIANOMEARISOA

RUI ASSUBUJI

LARA BALADI

YTO BARRADA

LUÍS BASTO

MOHAMED EL BAZ

HICHAM BENOHOUD

WILLIE BESTER

BERRY BICKLE

BILI BIDJOCKA

ANDRIES BOTHA

WIM BOTHA

ZOULIKHA BOUABDELLAH

FRÉDÉRIC BRULY BOUABRÉ

PAULO CAPELA

CHÉRI CHERIN

LOULOU CHERINET

SOLY CISSÉ

OMAR D.

TRACEY DERRICK

CHEICK DIALLO

DILOMPRIZULIKE

MARLENE DUMAS

YMANE FAKHIR

MOUNIR FATMI

BALTHAZAR FAYE

SAMUEL FOSSO

MESCHAC GABA

JELLEL GASTELI

GERA

DAVID GOLDBLATT

ROMUALD HAZOUMÉ

JACKSON HLUNGWANI

ABD EL GHANY KENAWY

AMAL KENAWY

WILLIAM KENTRIDGE

BODYS ISEK KINGELEZ

ABDOULAYE KONATÉ

MOSHEKWA LANGA

ANANIAS LEKI DAGO

GODDY LEYE

GEORGES LILANGA DI NYAMA

FRANCK K. LUNDANGI

GONÇALO MABUNDA

MICHÈLE MAGEMA

ABU BAKARR MANSARAY

JULIE MEHRETU

MYRIAM MIHINDOU

SANTU MOFOKENG

ZWELETHU MTHETHWA

HASSAN MUSA

N'DILO MUTIMA

WANGECHI MUTU

INGRID MWANGI

SABAH NAIM

MOATAZ NASR

OTOBONG NKANGA

SHADY EL NOSHOKATY

AIMÉ NTAKIYICA

ANTONIO OLE

RICHARD ONYANGO

OWUSU-ANKOMAH

EILEEN PERRIER

RODNEY PLACE

PUME

TRACEY ROSE

CHÉRI SAMBA

SÉRGIO SANTIMANO

ZINEB SEDIRA

BENYOUNÈS SEMTATI

YINKA SHONIBARE

ALLAN de SOUZA

JOSEPH-FRANCIS SUMEGNÉ

PASCALE MARTHINE TAYOU

PATRICE FELIX TCHICAYA

GUY TILLIM

TITOS

BARTHÉLÉMY TOGUO

CYPRIEN TOKOUDAGBA

FATIMAH TUGGAR

ERNEST WEANGAI

Published on the occasion of the exhibition *Africa Remix: Contemporary Art of a Continent,* Hayward Gallery, London, 10 February – 17 April 2005

museum kunst palast, Düsseldorf
24 July – 7 November 2004

Centre Georges Pompidou, Paris
24 May – 15 August 2005

Mori Art Museum, Tokyo
May – August 2006

Developed in co-operation with the museum kunst palast, Düsseldorf, the Centre Georges Pompidou, Paris, and the Mori Art Museum, Tokyo, based on a concept by David Elliott and Jean-Hubert Martin

Chief curator
Simon Njami

Curatorial team
Marie-Laure Bernadac
David Elliott
Roger Malbert
Jean-Hubert Martin

Curatorial advisor
Els van der Plas

Project organiser
Mattijs Visser

Project co-ordinator
Claudia Banz

Catalogue project manager (German edition)
Angelika Thill

Hayward Gallery exhibition organised by
Roger Malbert, assisted by Henrike Ingenthron

This is an abridged version of the German, French and Japanese catalogues for *Africa Remix*

Art Publisher
Caroline Wetherilt
Publishing Co-ordinator
James Dalrymple
Sales Manager
Deborah Power

Catalogue design
Anna Wesek
Cover design
Alexander Boxill
Typesetting
Hildegard Knauer
Reproductions
Pallino Media Integration, Ostfildern-Ruit
Printed in Germany by
Dr. Cantz'sche Druckerei, Ostfildern-Ruit

Originally published in German by
museum kunst palast, Düsseldorf, Germany,
E: info@museum-kunst-palast.de,
www.museum-kunst-palast.de
in association with Hatje Cantz Verlag,
Senefelderstraße 12, 73760 Ostfildern-Ruit,
Germany, T: +49 (0) 711 4 40 50,
F: +49 (0) 711 4 40 5220, www.hatjecantz.de
under the title *Afrika Remix. Zeitgenössische Kunst eines Kontinents*

First published in English in abridged format in 2005 by Hayward Gallery Publishing, London SE1 8XX, UK, T: +44 (0) 20 7921 0826, F: +44 (0) 20 7401 2664, www.hayward.org.uk
in association with Hatje Cantz Verlag

Front cover: Samuel Fosso, *Le chef: celui qui a vendu l'Afrique aux colons*, from the series *Série Tati, autoportraits I–V*, 1997 (cat. 46)
© S. Fosso, courtesy J.M. Patras, Paris, for T&S Ltd

Back cover: Jane Alexander, *African adventure*, 1999–2002 (cat. 4)

africa remix

CONTEMPORARY ART OF A CONTINENT

SIMON NJAMI

WITH ESSAYS BY
LUCY DURÁN
DAVID ELLIOTT
JEAN-HUBERT MARTIN
JOHN PICTON
AND A DIALOGUE BETWEEN
MARIE-LAURE BERNADAC AND
ABDELWAHAB MEDDEB

MUSEUM KUNST PALAST
DÜSSELDORF

HAYWARD GALLERY
LONDON

CENTRE GEORGES POMPIDOU
PARIS

MORI ART MUSEUM
TOKYO

Hayward Gallery
South Bank Centre, London

IDENTITY & HISTORY

56 Jane Alexander
58 Fernando Alvim
60 Lara Baladi
62 Yto Barrada
64 Willie Bester
66 Andries Botha
67 Zoulikha Bouabdellah
68 Soly Cissé
70 Marlene Dumas
72 Ymane Fakhir
73 Meschac Gaba
74 Mounir Fatmi

76 Samuel Fosso
78 William Kentridge
80 Michèle Magema
81 Moataz Nasr
82 Abu-Bakarr Mansaray
83 Zineb Sedira
84 Hassan Musa
86 Ingrid Mwangi
88 Aimé Ntakiyica
90 Yinka Shonibare
92 Fatimah Tuggar

BODY & SOUL

98 Ghada Amer
100 Joël Andrianomearisoa
102 Hicham Benohoud
104 Bili Bidjocka
105 Frédéric Bruly Bouabré
108 Paulo Capela
110 Loulou Cherinet
112 Omar D.
114 Gera
116 Cheick Diallo
118 Jackson Hlungwani
120 Abd El Ghany Kenawy
and Amal Kenawy
121 Shady El Noshokaty
122 Abdoulaye Konaté

124 Goddy Leye
125 Georges Lilanga Di Nyama
128 Franck K. Lundangi
129 Myriam Mihindou
130 N'Dilo Mutima
132 Wangechi Mutu
134 Richard Onyango
136 Owusu-Ankomah
138 Eileen Perrier
140 Tracey Rose
142 Benyounès Semtati
143 Ernest Weangai
144 Joseph Francis Sumegné
146 Cyprien Tokoudagba

CITY & LAND

152 Akinbode Akinbiyi
154 El Anatsui
156 Mohamed El Baz
158 Rui Assubuji
160 Luís Basto
162 Berry Bickle
164 Wim Botha
166 Tracey Derrick
168 Dilomprizulike
169 Balthazar Faye
170 Jellel Gasteli
172 David Goldblatt
174 Romuald Hazoumé
176 Bodys Isek Kingelez
178 Moshekwa Langa
179 Titos
180 Ananias Leki Dago

182 Gonçalo Mabunda
184 Julie Mehretu
186 Santu Mofokeng
188 Zwelethu Mthethwa
190 Sabah Naim
191 Patrice Felix Tchicaya
192 Otobong Nkanga
194 Antonio Ole
196 Rodney Place
198 Pume
200 Chéri Samba
202 Chéri Cherin
204 Sérgio Santimano
206 Allan deSouza
208 Pascale Marthine Tayou
210 Guy Tillim
212 Barthélémy Toguo

CONTENTS

8 Map of Africa

9 Preface
 ROGER MALBERT

11 Introduction
 ROGER MALBERT

13 Chaos and Metamorphosis
 SIMON NJAMI

24 Africa, Exhibitions and Fears of the Dark
 DAVID ELLIOTT

29 The Reception of African Art
 JEAN-HUBERT MARTIN

40 Africa Begins in the North
 DIALOGUE BETWEEN MARIE-LAURE BERNADAC AND
 ABDELWAHAB MEDDEB

47 Made in Africa
 JOHN PICTON

50 Ah-Freak-Iya: Challenging Perceptions of Africa's Contemporary Sounds
 LUCY DURÁN

 Plates
 Introductions by Simon Njami

53 IDENTITY & HISTORY
95 BODY & SOUL
149 CITY & LAND

215 Bibliography

217 List of Works

224 Notes on the Authors

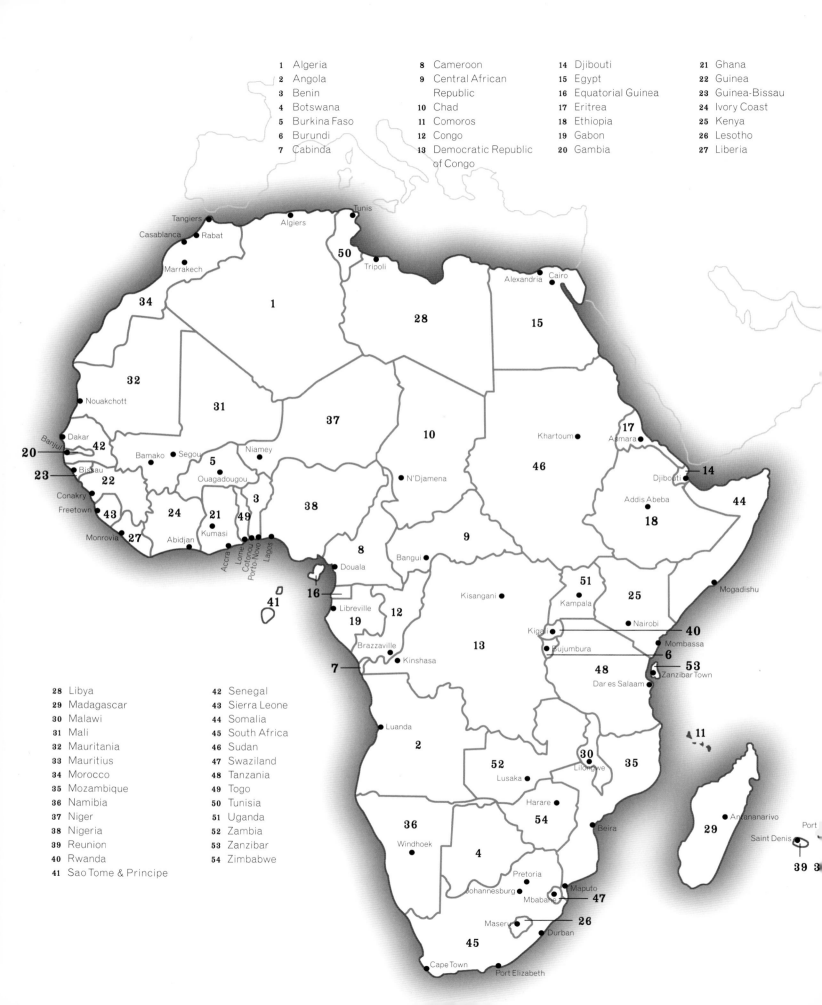

1 Algeria
2 Angola
3 Benin
4 Botswana
5 Burkina Faso
6 Burundi
7 Cabinda

8 Cameroon
9 Central African Republic
10 Chad
11 Comoros
12 Congo
13 Democratic Republic of Congo

14 Djibouti
15 Egypt
16 Equatorial Guinea
17 Eritrea
18 Ethiopia
19 Gabon
20 Gambia

21 Ghana
22 Guinea
23 Guinea-Bissau
24 Ivory Coast
25 Kenya
26 Lesotho
27 Liberia

28 Libya
29 Madagascar
30 Malawi
31 Mali
32 Mauritania
33 Mauritius
34 Morocco
35 Mozambique
36 Namibia
37 Niger
38 Nigeria
39 Reunion
40 Rwanda
41 Sao Tome & Principe

42 Senegal
43 Sierra Leone
44 Somalia
45 South Africa
46 Sudan
47 Swaziland
48 Tanzania
49 Togo
50 Tunisia
51 Uganda
52 Zambia
53 Zanzibar
54 Zimbabwe

PREFACE

Africa Remix is the largest exhibition of contemporary African art ever seen in Europe, an international collaboration between four galleries: museum kunst palast in Düsseldorf, who took the lead in organising the exhibition, and staged its first showing in July 2004; the Hayward Gallery, London; Centre Pompidou, Paris; and the Mori Art Museum in Tokyo. Simon Njami acted as chief curator, supported by a curatorial team consisting of Jean-Hubert Martin, Director of the museum kunst palast, Marie-Laure Bernadac, curator for Centre Pompidou, David Elliott, Director of the Mori Art Museum, Tokyo, and myself, for the Hayward Gallery.

The idea of a major exhibition of African artists was first discussed by David Elliott and Simon Njami in 2000 in Senegal, when they were judging the Dakar Biennial. Simon Njami, a founding editor of the Paris-based journal *Revue Noire*, has travelled extensively in Africa for more than 15 years, writing and curating exhibitions. He has been a particularly strong advocate of African photography. When David Elliott approached the Hayward to propose a collaboration on the project, with Simon Njami acting as the researcher and chief curator, we immediately affirmed our wholehearted enthusiasm and support. Jean-Hubert Martin had at the same time been developing plans for a large-scale exhibition surveying the whole spectrum of recent art across the African continent. Jean-Hubert Martin's celebrated and controversial exhibition at Centre Pompidou in 1989, *Magiciens de la terre*, brought a number of African artists to European attention for the first time. That exhibition centered on the art of visionary artists, while *Revue Noire*, by contrast, was less concerned with the *'magiciens'*, supreme in their spiritual homes but remote from the concerns of modernity, than with an urban sophisticated art produced by Africans who are connected to the discourse of the contemporary international culture. The dialectic between these two opposing views of

African creativity has helped to propel the discussion on principles of selection for this exhibition.

Because of space limitations, the London showing has been reduced, and we apologise to the artists who have been omitted for this inescapable reason; however, all the artists are illustrated in the catalogue – which is itself an abridgement of the German, French and Japanese editions.

Our thanks are due firstly to Simon Njami for leading the curatorial team in selecting the exhibition. His knowledge and vision have informed our thinking about the project at every level. The museum kunst palast took on the task of organising the exhibition with impressive vigour and efficiency. We thank Jean-Hubert Martin, Project Organiser Mattijs Visser, Project Co-ordinator Claudia Banz and her team, and everyone at the museum kunst palast for ensuring the exhibition's success in Düsseldorf and throughout the tour. Our colleagues in Paris and Tokyo have also been a pleasure to work with, and we have valued the participation in curatorial discussions of Els van der Plas, Director of the Prince Claus Fund in the Netherlands, which has supported some of the new commissions. Susan Ferleger Brades, the Hayward's Director until the summer of 2004, welcomed the proposal for this exhibition at the outset and her endorsement and encouragement through the period of its gestation was immensely valuable.

In London, the exhibition is the focus for a South Bank Centre-wide season of cultural events featuring artists, musicians, performers and writers. The *Africa Remix* Project Co-ordinator Denise Bradley has represented the Centre in our collaboration on *Africa 05*, a London-wide celebration of African creativity, co-organised by the South Bank Centre, the British Museum and Arts Council England, with more than 40 partner organisations throughout the capital. Augustus Casely-Hayford has been inspiring as the Director of *Africa 05*, and we are pleased to have played a part in bringing his ambitious plans to fruition.

Among our partners on *Africa 05*, several have collaborated with us especially closely. The Hackney Museum is hosting a satellite exhibition of photography by five artists selected from *Africa Remix* by Simon Njami. We thank the Museum's Director, Erica Davies, for her enthusiastic support for this project. We are also delighted to be working in partnership with London Underground's Transport for London, whose Curator Tamsin Dillon has commissioned artist Samuel Fosso to present his work at Gloucester Road station.

The exhibition has many facets, among them a programme of recent African music selected by the London group SAI SAI Productions, consisting of broadcaster Lucy Durán, Theodoros Konkouris and Dudu Sarr. The film programme, conceived as an integral part of the exhibition, has been co-curated by Simon Njami with Keith Shiri. The audio-visual technician is Jem Legh. The exhibition design for *Africa Remix* is by David Dernie, the graphics by Violetta Boxill and the lighting by John Johnson. We extend our thanks to all of them as well as the following, who have made the exhibition possible: Olivier Poivre d'Arvor, AFAA, Association Française d'Action Artistique, Paris; Agence Intergouvernementale de la Francophonie, Paris; Bénédicte Alliot; Gemma de Angelis Testa; Jeanne Auscher; Mark Sealy, Autograph; Negar Azimi; Esperanza Bassadone; François Belorgey; Binta Zarah Studios, Indianapolis; Hans Bogatzke Collection of Contemporary African Art; Andrea Rose, The British Council; CAAC, The Jean Pigozzi Collection, Genf; Camouflage, Brussels; Hervé Chandès, Fondation Cartier, Paris; Bruno Racine, Alfred Pacquement, Martine Silie, Centre Georges Pompidou, Paris; Centro Cultural Franco-Moçambicano, Maputo; Jean-Michel Champeault; Elsbeth Court; Thomas Dane Limited; Doual'art, Duala; Christine Eyene; FRI-ART, Centre d'Art Contemporain, Freiburg (Switzerland); Kirsten MacDonald Bennett, Stephen Friedman Gallery, London; Gabriel and Lucas; Gagosian Gallery, New York; Robert Loder, Gasworks; The Goodman Gallery, Craighall (South Africa); Jonathan Greenberg; Salah Hassan; Pieter van der Houwen; Institut of Visual Arts, Bandjoun, Cameroon; Johannesburg Art Gallery, Johannesburg; Ronald Jung; Rita Kersting, Kunstverein für die Rheinlande und Westfalen, Düsseldorf; Salifou Labo; André Magnin; Jacques Mercier; Tracy and Gary Mezzatesta; Musée d'Art Contemporain, Lyon; Musée du Quai Branly, Paris; Musée International des Arts Modestes, Sète; Jules N.; Mark Nash; Collection of Eileen Harris-Norton and Peter Norton; Nana Ofori-attaayim; Galerie Maï Ollivier, Paris; Chili Hawes and Elisabeth Lalouschek, October Gallery, London; Ovitz Family Collection; Camilla Jackson, The Photographers' Gallery; Galerie Polaris, Paris; Prince Claus Fonds; Cyrille Putman; Revue Noire, Paris; Jeanne and Nicolas Rohatyn; Nathalie Rosticher; Galerie Lia Rumma, Mailand/Neapel; David Jones and Claire Witaker, Serious; Jack Shainman Gallery, New York; Michael Stevenson Contemporary; Stichting De Pont, Tilburg; The Townhouse Gallery, Cairo; Galerie Trafic, Ivry; Vlaamse Gemeenschap, Brussels; Barbara Vanderlinden; Vlisco, Helmond; and William Wells. Our thanks go as well to Hildegard Knauer and Angelika Thill for their help and hard work on the catalogue.

We are grateful to all of our colleagues at the Hayward Gallery who have been involved in the realisation of this exhibition and the catalogue. Above all, we thank the artists for contributing generously to this international touring exhibition, and the lenders who have allowed us to borrow works for the prolonged period of the tour.

Roger Malbert
Senior Curator, Hayward Gallery

INTRODUCTION

ROGER MALBERT

The African continent consists of more than 50 countries with a total population of over 800 million. To attempt in a single exhibition to provide a comprehensive or coherent survey of the art of so vast a region is clearly impossible. *Africa Remix* should be thought of, rather, as an anthology or compilation, serving to introduce a selection of significant artists to a wider public largely unfamiliar with them. The fact that so many of these artists have not previously been seen in Britain, despite this country's long historical links with the continent, is evidence of a neglect that extends into other spheres, from political economy to the circulation of ideas, which is why exhibitions like this continue to be necessary. Despite the supposed openness of postmodern culture, the privileged centres of influence remain overwhelmingly in command, their long-established commercial and critical infrastructures providing artists who happen to live within their compass with distinctly preferential treatment. Artists from elsewhere, especially from economically disadvantaged societies, must, unless they are lucky enough to be 'discovered' by generous benefactors, devise skilful strategies in order to survive.

Simon Njami remarks that what Africans have in common firstly is their relationship with the old colonial powers of Europe; it is this, rather than any notion of a unified African aesthetic, that provides the rationale for an exhibition organised for the benefit of constituencies outside the continent. There may be other questions, relating to taste and what defines it in Europe and what kind of African art the Western world responds to, as distinct from the tastes of African followers and collectors of art. The aim of *Africa Remix* is to confound those differences by deliberate eclecticism, embracing both the art that is made to be seen in galleries and art that is created for other introspective, religious or communal purposes (a false distinction in any case). The emphasis, however, tends to be on the work of urban and sophisticated artists who – like so many Africans in other spheres – are truly international, multi-lingual and versatile in their approach to contemporary society. As individuals – and that is above all what artists are – they may not wish to be identified simplistically as 'Africans'. Their identities are as unique as their situations and modes of practice. Some work collaboratively – like the photographers of Maputo, Mozambique – and others in relative seclusion. The question of an African contemporaneity is one that Simon Njami has frequently addressed, both theoretically and practically – by meeting and talking with artists in many places and treating the work of each on its own terms, rather than starting with a theoretical construct and selecting work to verify it.

One distinction of *Africa Remix* is that it is the first large-scale exhibition to embrace the whole continent, north and south, from Cairo to Cape Town. Another is that it dissolves the boundaries between francophone and anglophone Africa. Of the many complex and contradictory legacies of colonialism, one of the most striking is that the French and English languages dominate and divide much of the continent, however many hundreds of other languages are spoken. This exhibition, an international collaboration, ignores that separation. Each of the European powers (and this applies to Portugal and Belgium as well) has a particular relationship with its former colonies. The French cultural links are in general more formally and officially sustained than the British. At the same time the tenor of the postcolonial debate in the English-speaking world inevitably differs from that of the French. It is perhaps engaged more directly with transatlantic – especially African American – perspectives. The Africas of the diasporic imagination – political, cultural, musical, poetic – enter into this discourse as well as the voices of experience. We are privileged to be able to include here essays by both francophone and anglophone writers who have been deeply involved with African life and culture for many years.

CHAOS AND
METAMORPHOSIS

SIMON NJAMI

1.
Convened by the German Chancellor Otto von Bismarck in 1884, the Berlin Conference agreed a final carve-up between European powers of those parts of Africa which remained uncolonised.

2.
Meeting of 29 African and Asian countries, held in the Indonesian city of Bandung in 1955, with the aim of promoting economic and cultural co-operation and of opposing colonialism. (South Africa was not invited to the conference.)

3.
The German anthropologist Leo Frobenius (1873–1938) was one of the first anthropologists to make Africa his special field of study. See Leo Frobenius, *Prehistoric Rock Pictures in Europe and Africa,* (1937), Ayer Co Pub, 1972; Leo Frobenius and Douglas C. Fox, *African Genesis,* (1938), New York, Arno P, 1976.

4.
Michel Leiris (1901–90), French anthropologist, poet and novelist; his journal was published as *L'Afrique Fantôme,* Paris, Gallimard Broché, 1934.

5.
Presidents: Léopold Sédar Senghor, Senegal (1960); Kwame Nkrumah, Ghana (1960); Antonio Agostinho Neto, Angola (1975); Gamal Abdel-Nasser, United Arab Republic (1954); Thomas Sankara, Burkina Faso (1983); Modibo Keita, Mali (1960); Anwar Sadat, United Arab Republic (1970); Nelson Mandela, South Africa (1994). Steve Biko was a South African black consciousness leader, born 1947; murdered in custody in 1977.

6.
Self-evident truth, obvious remark, truism (after Jacques de La Palice, 1470–1525).

7.
Sahel is a 'one-million-square mile area reaching from Senegal in the west to the Horn of Africa in the east, which contains Burkina Faso, Chad, Mali, Mauritania, Niger and Senegal.' (E.L. Bute and H.J.P. Harmer, *The Black Handbook. The People, History and Politics of Africa and the African Diaspora,* London and Washington, Cassell, 1997, p. 98.)

OF SCANDAL AND CHAOS

It is impossible to comprehend fully what Africa is. Like placing a bet that cannot be won. So we grope around with more or less shaky definitions and accepted ideas. Then come the certitudes. The dates engraved in our history books. The arrival of the first Europeans, the slave trade, the Berlin Conference,[1] colonisation, the Bandung Conference,[2] Leo Frobenius,[3] Michel Leiris[4] and the others. The ghost-Africa enclosed in anthropological museums and museums of civilisation. The political figures like Senghor, Nkrumah, Neto, Nasser, Sankara, Modibo Keita, Sadat, Nelson 'Madiba' Mandela and Steve Biko.[5] The writers, the Nobel prize-winners, the artists, the singers, the snows of Kilimanjaro in danger of losing their eternity, the wars, corruption, AIDS, malaria, poverty and hunger. If this kind of clinical enumeration were enough, we would all have one 'objective' idea of what Africa is. But none of our pre-conceived notions, certitudes or intuitions would suffice to account for the schizophrenic reality of this continent. For yes, though we forget it all too easily, Africa is a continent. A contradictory entity eternally branded by the seal of history. This no doubt produces a different way of envisioning the world, like in Asia or Latin America, a way of being elsewhere, of thinking oneself elsewhere.

To use a *lapalissade,*[6] and say that Africa is made up of the group of countries that form it, will certainly not satisfy the 'enlightened specialists'. Yet some obvious facts are worth recalling. Most people think of Africa as being limited to a group of countries south of the Sahara, with the region that starts in the north as almost a whole other world. This kind of revisionism, eager to set the 'Ethiopian' fraction against the 'Mediterranean' fraction of a continent across which the desert opens up like an interminable parenthesis, is pathological, for it seeks to negate the multiple influences fuelled by exchanges between the large Sahelian cities[7] and their North African neighbours since the Middle Ages. It contradicts the importance of Islam throughout sub-Saharan Africa, already present well before the European 'discoverers' set foot there. In short, it seeks to negate the common history that united the destinies of nations colonised by the same powers and their ensuing struggles for liberation. As though the Europe being built before our eyes did not present equally glaring contradictions. Wider circles exist too, including

the one encompassing other continents which, along with Africa, have formed a procession of what Frantz Fanon called 'the wretched of the earth'.[8] But that's another story.

The pan-African dream of political, economic and cultural unity fizzled out long ago. And the pale Organisation of African Unity (OAU), renamed the African Union, will not be capable of replacing that utopia. But even in this materialistic and pragmatic society of ours, where personal comfort and ephemera have replaced humanistic projects, the occasional sign does appear. In 1994, on my way back from a trip abroad, a taxi driver who discovered my Cameroonian origins spent the entire journey talking about African pride and the symbol Cameroon had become in everyone's minds. My country had qualified for the quarter-finals of the football World Cup, and only missed the semi-finals by a whisker. A few years later, during another World Cup, the whole of Africa joined together to support Senegal in a highly symbolic match against France. Inconsequential anecdotes, some will say. Yet the unquestionable symbolism of these instinctive reactions translates the consciousness of a people transcending the borders inherited from colonial partition. On both these occasions, Africa found itself reunified in the space of a mirage not just two times 90 minutes long, but with repercussions that are still uppermost in many minds. So what if this consciousness is only reactivated when it comes to finding a common adversary? After all, football is not yet war. That those adhering to this new-style Pan-Africanism know nothing of the fights that their elders waged in the early days of independence to avoid the Balkanisation of the continent is of no importance. They are still the heirs of an aborted dream.

Beyond the history and the geography, something else unites these nations. They all live in the chaos engendered by history, and each adapts to it in their own way. This apparent chaos, seen by some as purely the symptom of a chronically ill continent, must not be lived as a fatality, a confirmation of the pessimism about Africa's inability to project itself into modern times. To do so would be to forget that time is relative and that one man's viewpoint does not necessarily coincide with another's. Modern Africa is traversing a compressed time out of which it has to create a future. But this notion of the future is risky, because life is lived in the present. There is everything to be done, built and lived, and at the same time a memory and an identity to be restored. At the heart of time, wrote Maurice Merleau-Ponty, there is a gaze, a forcibly subjective gaze that can neither correspond to nor satisfy the gaze of the other. You only have to cross any African capital to understand that abstract projection into a distant future is not one of Africa's preoccupations. Modern Africa is in its early forties. In many of its countries most of the inhabitants are older than their nation. Not even the United States, which was founded relatively recently, has an inhabitant older than its constitution. Which goes to show the extent of the collective and individual chaos that Africa has to live with.

Africa is both very old and very young. It is from the geological clash between these two states that a new Africa will arise. Africa is a scandal. Even its

8.
Frantz Fanon, *The Wretched of the Earth*, (1961), Contance Farrington (trans.), London, Penguin Books Ltd, 2001.

everyday speech is hybrid, and it's no surprise to hear a French expression crop up in a conversation held in Bambara or Arabic. As for the idioms inherited from the colonial powers, they merely fool you: the English spoken in Lagos, Accra or Johannesburg, like the Portuguese spoken in Maputo or Luanda, has acquired accents, intonations and meanings it did not originally contain. The French spoken in west, central and north Africa has been completely 'colonised' by the natives. The population shifts and culture shocks sparked by the boom of the 'European' town have become elements of physical and intellectual rifts in African consciousness. Today's Africa is inevitably the illustration of this cultural syncretism underlying all contemporaneity. You only need to stroll through the streets of Cairo or Addis-Ababa, Johannesburg or Douala, Bamako or Lagos, Maputo or Marrakech to be struck by the obvious: Africa is a continent in constant mutation. A mountain in the making.

This is where the scandal lies. Forged at the heart of the Judeo-Christian religion, scandal is a chaste and hypocritical veil which we cast over anything we do not want to see or hear. Christ himself made no bones about it, telling his disciples not to flee scandal but even sometimes to seek it out. In those troubled times, the mere mention of His name incurred the direst penalties. Assimilating scandal to shamelessness, as bourgeois society did, was another form of avoidance. But while Africa may be scandalous, it is never shameless. Or only inasmuch as it forces us to witness its metamorphosis, like those reality TV shows Western viewers so enjoy that have got off to such a promising start in Africa. We can look away, but we cannot ignore it. And this we cannot bear. For what is on show is the plain and simple dramatisation of our own shortcomings and failures, cowardice and lost grandeur. It is this kind of vital yet suicidal vigour that can make a young man I once met burst out laughing and say that AIDS stands for Abominable Invention to Discourage Sex.

At a colloquium that I was invited to a while ago whose title *Can one be alive in Africa?* announced the organisers' basic premise, I expressed surprise at such a naive, or perverse, question. To my knowledge, Africa does not have the world's highest suicide rate. To my knowledge, in a continent where daily reinvention is a necessity, men and women laugh, dance, love and give birth without knowing if all their children will outlive them. This is scandalous indeed. Africa refuses to hide itself. It wouldn't be able to even if it wanted to. In Cairo or Kinshasa music spills out of bars onto pavements and no-one is surprised to see people dancing in the streets. Laughter and voices ring through the neighbourhoods and children run down streets paying no heed to cars. Horns blare constantly. Life is lived outdoors, with no uncalled-for shame, and nothing that goes on behind the walls – non-existent in poorer neighbourhoods – is a secret to anyone. It is this inevitable 'scandal', in its physical, social or economic aspects, that constitutes the very essence of Africa. Modesty, for it does exist, is found elsewhere – in all that is not said, in all that is kept for your nearest, your dearest and the gods.

OF SILENCE AND WORDS

On a continent where voice is a privileged means of expression, creativity does not speak. Or rather, long refused to. This silence might have been an act of defence and timidity, a sign of the stupor which the world kept on producing with its speeches and machines. A refusal to lay itself bare, to give in to rules devised for and by others. A refusal to partake in self-comment: 'one does not recount oneself, one lives.' As a result, others decided to try and decipher this history dating back to the dawn of time, traced in the rock paintings of Brandberg, Namibia, and other sites. A few thousand years down the line, Egyptologist Jean-François Champollion was confident he could decipher the message in the Rosetta stone. Then came the masks. But Africa remained silent. Resolutely, fiercely silent.

The objects refused to reveal their secrets. After all, what is a mask that refuses to dance, apart from a pretty sculpture? All interpretations contain an inherent misunderstanding. A silent mask cannot contradict an interpreter, it just lets him comment. This millennial misunderstanding came to a climax with the attempt to decipher the world of artistic creation through a single perspective: the history of (Western) art. Due to its silence, African creativity was sent into an obscure, ill-defined limbo. From the start of colonisation – ever since the African Middle Ages in fact – pure, authentic, identifiable indigenous creativity ceased to exist. Africa was already in the throes of transformations that would only be gauged much later. The method claiming that the only true African creativity was the one corresponding to our fantasies, however, held fast, backed by researchers on Africa who started producing increasing amounts of scholarly literature on the subject from the nineteenth century onwards. Yet the creators of the objects stayed silent, almost indifferent to all that could be said about them. Invisible. It was the Surrealists who wanted to prevent colonial exhibitions, not the 'natives'. Neither Senghor, nor Césaire,[9] nor any of the other people who rebelled in the name of an original Africa, could affirm the meaning of a sacred object's 'charge'. Faced with the creators' constant silence, the productions were catalogued and labelled according to this or that person's interpretations, and stored away in European ethnological museums.

A few centuries on, African artists (for we can now call them this) are no more loquacious than their elders. They have learned the need to speak, of course, or rather they have unlearned remaining silent. But the discourses their voices convey are mere decoys, *trompe-l'oeil* theories. Some artists have even turned into perfect forgers, delivering the conventional discourse to anyone who wants to hear it, endlessly replaying the Hegelian dialectic of master and slave. Deep down they remember that some things should be left unsaid and that objects have a meaning and an origin no analysis can erase. For the last 15 years a bitter-sweet comedy has thus been played out involving – a side-effect of globalisation – an increasingly large number of players. Indeed, we should here stress one of the many paradoxes of this globalisation which, in its bid to make us all the same – single consumers of a single market – spawned the most striking return to nationalism of the late-twentieth

9.
Léopold Sédar Senghor, see note 5. Aimé Césaire was a writer and politician in Martinique, and co-founder in 1934 of *L'Etudiant Noir*, a magazine supporting *négritude*.

century. People think they have a better understanding of each other, when in fact they have forgotten the very essence of what understanding means.

Many African artists, however, stay silent. Even though they are today offered what was once forbidden. They travel the world and present the fruits of their quest to a public that changes daily. They are famous. Recognised? Maybe so. But this matters little to them. Only yesterday an artist who had studied in the Fine Art college of a major European capital and spoke the language of what would end up as his adopted country was viewed suspiciously by those seeking the authentic African. Terms like 'scholarly art', 'international art' and whatever else have evolved. Now and then I have found myself debating these themes with a number of artists. Their response has never varied. They care little about the labels pinned on them. All that matters is for their work to be seen. African artists can be indifferent to the way the surrounding world sees them because, deep down, they pursue a different goal, think different thoughts and speak a different language. Their refusal to raise their voices amidst the throng is not a throwback to the timidity passed on from other eras, it marks their deliberate will to master their own space – that precious and unique space that is the hearth of all creation worthy of the name. This now all too long-forgotten silence is, in my view, the best way to approach African creativity. Everything starts and finishes with this silence.

Endless silences of mosques and sacred forests; oneness of spirit and its environment; the silence of prayer, when men suddenly stop in the middle of a crowded pavement and throw themselves to the ground facing Mecca. For you don't just have to be within the walls of a mosque for His word to be audible. Africa is without doubt the kingdom of immateriality. Admittedly, ever since the Middle Ages the empires have built palaces made of earth, as though to stress the transitory nature of all things; the mass industrialisation that transformed the face of nineteenth-century Europe did not travel this far. Even in cities like Johannesburg, Lagos or Cairo the order is provisional and there is a constant feeling of being in a pre-industrial world. One where men have not yet been replaced by machines and, given the extent to which bartering still represents a founding element of society, the virtuality of the stock markets has no established rights. The importance of giving your word, of trading words, of this silent word only revealed to those who can hear it.

The partition of Africa, like that of Berlin after the Second World War, was an aberration. Peoples who had been cousins or brothers, whose lands had known no borders other than the line of sight, found themselves separated from one day to the next. Drawn and quartered. Yet words still travel beyond these absurd frontiers. They transcend the cold materiality of politics. On my way back from Ghana one day, I found the border to Lomé closed. The Togolese customs officers I spoke to across the barbed wire of no-man's land told me their border was still open, that the problem came from Ghana's side. I had to be in Cotonou early the next morning. Just then, a stranger approached and told me to follow him. We

walked through a maze of buildings for a few minutes that seemed like hours and reached the side of a road. He pointed to the pavement on the other side. That's Togo! To confine African nations within borders is futile. The history of Europe in the past few centuries is an African history, whether one likes it or not. Just as African history is resolutely European. The conscious or unconscious refusal to accept this has often turned African artists unwittingly into suspects. We have seen how much simpler and easier it is to be able to situate human beings, store them away in intelligible pigeonholes. But what happens when one of them no longer lays himself open to easy interpretation? He becomes a hybrid, alienated, incapable being, unfit to represent those who, unlike him, stayed 'back home'. He is suspected, if only unconsciously, of treason. His creativity no longer holds the emblematic value of his land. He is sometimes ranked alongside the workers who travel elsewhere to look for what cannot be found at home. The Diaspora artist, for this is what this mutant will now be called, has no refuge but silence. Take the Mauritanian filmmaker Abderramane Sissako, for example, who told me how he decided to make films. When he was ten years old, his family moved from Mauritania to Senegal. A new country, where he did not understand the language. He could not join in with the other children's games because they instantly saw him as the foreigner. So he decided to watch, and keep silent.

Europe, or more broadly speaking, the West, is not the promised land people would like to believe. I have met numerous African artists who say they never want to leave their native land. Others have left – it's true. But I believe it would be a mistake to put their move just down to material contingencies. There are many reasons for leaving beyond the obvious political and economic ones: no longer being able to share, in the case of contemporary artists, for example, your inner language with the people around you. Realising that you will have to go elsewhere to find a silence that corresponds to you. This is no doubt what being contemporary is all about. Artists share the same quality of silence, expressed according to different accents and sensibilities, and through these silences their background and vision of the world appear. It can sometimes be easier to get along with a perfect stranger than the people we grew up with. Migration then becomes a kind of necessary evil that makes moments from the past echo inside you. It gives you a better comprehension of the things that sometimes baffle you. It's not untrue to say that self-discovery is easier in a foreign setting. The collective silence becomes replaced by a more personal, egotistical silence which, for artists, can sometimes be salvational.

The art critic Pierre Restany claimed that the artist should never be cut off from life. If there is one thing Africans cannot cut themselves off from, it's life. Whatever they do, whichever ivory towers they try to surround themselves with, there will always be an aunt, brother or cousin to remind them that life is lived on earth and that its demands, however prosaic, are the top priority. Hence their occasional need to place some distance between themselves and this excessively familial

10.
Ernst Bloch,
*The Spirit of Utopia:
Meridian Crossing
Aesthetics,* (1919),
Anthony A. Nassar
(trans.), Standford,
California, University
Press, 2000, p. 3.

11.
Afrocentrism is an
intellectual and ideo-
logical movement
comprised mostly of
African-Americans
who believe that the
world has too long
been dominated by a
Eurocentric view-
point. The movement
supports an African-
centred worldview
with positively
expressed African
values.

silence with which they are sometimes one. This distance is not necessarily physical, and this is why they are able to avoid over-hasty conclusions. Being in Hamburg, Amsterdam, New York or Paris no doubt fulfils the same need as building a studio away from the family home. It is doubtless the indispensable condition for a project to mature. You have to be in the appropriate state to receive, filter and digest the multiple signs in our saturated lives before releasing them in other forms. Streets, walls, a conversation you didn't think you'd remember, a book, a stadium, tele-vision and radio shows… we are all of us children of lands that leave their marks on us forever. All movement has an origin. The place where we love, laugh and cry is the raw material from which the first raw movements spring. It plays a full and inevi-table part in the gestation and birth of art. It pre-determines and shapes the work, as it were. And its influence can be seen in insignificant yet determining details.

The real challenge is to manage to capture this energy sheltering behind the unsayable. If you had to find something all African artists have in common, you would probably notice that they all draw from the materials they grew up with, each in their own way. Our five senses are the gateways to the soul. Art – in Africa as elsewhere – can only be its most sensitive, human and imperfectly completed trans-lation. Its quest, I believe, is translated in the search for the self. The silent com-munion of shisha-smokers on the pavements of Cairo has no purpose other than that, silence and communion. The silence forged in the bosom of childhood deve-lops later in artists and becomes a metaphor. It is the attempt to solve what Ernst Bloch called 'the problem of the We in itself'.[10] The We of community, the We of art, the We of the collectivity we live and dream in. What are these different 'We's' made of and, for an artist, how to translate them into a work that testifies to one's singu-lar belonging to the world? This is the question. But let there be no misconception: stating one's belonging does not amount to proclaiming one's Africanness. African-ness is self-evident. A fact. A fundamental that can be kept silent. What shows through is the sense of this Africanness. What makes a work open, legible to all, is that it contains a slice, no matter how tiny, of ourselves.

OF CONTEMPORANEITY

Questions on contemporary African art have developed hard and fast since the early 1990s. The origins of local quests for modernist practices can be traced back to mid-to-late-nineteenth-century inceptions of resistance to colonial rule by élite black intellectuals in the cities of West Africa. And the history of these debates goes back to the African independences, when the new states tried to define their own aesthetics. But this art, which could be called 'modern art', was restricted by politi-cal and aesthetic questions. The primary aim of the schools founded at the time, like the Dakar school, was self-assertion. Being an African artist had to mean some-thing. Intellectuals like the historian Cheik Anta Diop, one of the celebrators of Afrocentrism,[11] went so far as to advocate a social and functional art. Since then, African creativity has tried to break free from the exogenous and often Western gaze

in which it was imprisoned. But not until the late 1980s did a structured debate on the nature of this creativity begin to emerge.

In 1989, the *Magiciens de la terre* exhibition at the Centre Pompidou in Paris sparked things off by proposing a definition of contemporary creation that fuelled many years of debate. Since then, numerous other exhibitions have been held in the United States, Europe and Japan, displaying other visions. A split appeared between English-speaking, French-speaking and Arabic-speaking visions – though the latter have been kept out of the major debates – that revealed ideological divides among young exhibition curators, a number of whom, notably, were African. Nevertheless, and despite the odd isolated attempt, it seemed a hopeless gamble to want to approach this creation in a purely aesthetic manner, without all the historical, political and ideological trappings. Doubtless for many reasons, the most obvious in my opinion being that you cannot think a continent without taking into account its complexity. Africa is not a country!

For even though the last decade has witnessed an interesting evolution in the approach to African art, the same theoretical stumbling blocks still stand firm. That some artists from the continent have managed to make a small space for themselves on the international circuit cannot suffice. Until today, the possible unity of a contemporary African creativity had still not been tackled head on. The exhibitions dotted over the last decade have mainly striven to define historical and thematic frameworks focusing on context more than aesthetics or sources of inspiration, political problems rather than creative processes. The time had come to tackle the contemporary fact as such, i.e. look first at the work, then envisage the intellectual context that produced it. This is where a continent-wide vision of creativity can be justified. We have seen the contradictory currents that ripple across contemporary Africa: from the end of apartheid in South Africa to the land disputes in Zimbabwe; from learning peace in Angola and Mozambique to the explosions coursing through Central Africa; from the upsurge in religious fundamentalism in the North to the apprenticeship of what, for want of a better word, we will call democracy. Several questions underlie the spirit of the *Africa Remix* exhibition: what is Africa? What does contemporaneity represent within this geographical entity? How is it defined?

It is these aesthetic and intellectual shifts of identity that the artists in *Africa Remix* express. This is why we needed to avoid reproducing Western classifications that have split creativity into distinct disciplines. To show the contemporaneity of Africa without including music, film or literature would be like looking at a global phenomenon through tunnel vision. *Africa Remix* is multi-disciplinary because creativity is multi-disciplinary; because Africa has always considered creativity in its entirety, by integrating – in an often cosmogonic totality – all creative forms and disciplines. Art, as Jean-Hubert Martin wrote, has remained magic. And while the West killed God in order to enter the modern age, Africans have too many gods – it would be pointless to kill them all now. Some of the artists will no doubt deny it, but it seems to me that in each presented work the spirit, in the broadest

sense of the word, is fully visible. Perhaps this is what André Malraux called 'dialoguing with masks', i.e. transforming what was into something else. For the majority of artists in *Africa Remix,* the Africa that was – the myth some people still feel nostalgic for – ceased to exist long ago. They have exchanged the dreamland for the real land, though nonetheless still virtual. A land they recompose each in their own way, with their own sensibility.

The secret of a work of art that achieves its aim is that it speaks to us. Whichever language the artist has chosen to use, whatever very personal accents it contains, the work will touch the part of ourselves that defines humanity. This is no doubt why it has not always been easy to tackle contemporaneity in Africa. It is not about forms, it's about accents. The debates on post-colonialism that some commentators on African creativity have held over the past few years strike me as answering questions that are no longer an issue. While historical understanding now throws light on our perception of the culture of the continent taken as a whole, it is no longer of any use to us when it comes to understanding the process the artists have consciously or unconsciously brought into play. Indeed, African creativity of the latter half of the twentieth century has gone through so many different phases that it is important to avoid confusion when approaching the contemporary phenomenon.

There are roughly three stages in the metamorphosis, or 'finding a voice' of African artists. The first was the sometimes extreme celebration of their roots, which corresponded to the period directly following the independences. Artists wanted to show and assert their Africanness, and make use of the virtual library of symbolism to show they were finally free of all colonial influence. The second stage, which fell between the late 1970s and the late 1980s, was a period of denial. Artists had felt so trapped within the narrow limits of their origins that they needed to get away from the images that others created of them. This is when you would hear people say, 'I am not an African. I am an artist.' This declaration was a cry. It expressed the will finally to be perceived as people in their own right, participating in the artistic creativity of the planet just like anyone else, not as exotic beings turning up to confront a world that is not their own. The third stage, the one that *Africa Remix* proposes to illustrate, bears witness to a certain maturity and appeasement, where artists have no need to prove anything through their work. The stakes have changed. They are no longer essentially ethnic, though no-one can disown their roots, they are aesthetic and political. The quest remains, but its nature has changed.

Their quest today is existential. It is a quest where space and territory – as a shaper of individuality – intervene naturally. But the notions of space and territory no longer correspond to tangible borders. They no longer apply to an enclosed political or geographical space. This is why we have divided *Africa Remix* into three parts – identity and history, body and soul, city and land. Again, this should not be seen as a classification, but rather as an attempt to understand which forces are at

work in contemporary African art, which recurring elements leave traces in each of the works on show. For we have had ample time to learn that contemporaneity, African or not, cannot be restricted to a single, global definition. It inevitably passes through individual filters. It reveals itself as recognition of the other. The artists brought together in *Africa Remix* are here because they all have something in common. From one end of Africa to another, artists share ambitions and doubts that don't necessarily find an echo in their own societies. One could say that this contemporaneity is sometimes orphaned, in that the questions it raises and the ways it chooses to answer them do not always match the collective sensibility of the artists' own countries. The notion of interdict, for example, now meaningless in the West, is still highly prevalent in societies that have by and large stayed very close to ancestral traditions and organisations.

But here too we must avoid confusion. Different forms of contemporaneity co-exist without necessarily echoing each other. A distinction could be made between collective contemporaneity, on the one hand, and elective contemporaneity on the other. I confess to long having only concerned myself with the latter. Collective contemporaneity is a daily phenomenon that crosses all levels of African societies. It is not bothered with the urban or the rural and responds to an atavistic need to create. Its themes and aesthetic require a special initiation. It is societal. It is often rooted in the deep sources of a culture which it transforms in ways sometimes perceived by purists as acts of treason. It is innovative in that it shakes up established rules without taking environment into account. It can draw its sources from religion, daily life or tradition. It can look as though its sole aim is to exist. This contemporaneity is not concerned by the international market principle that drives artists to seek out museums and galleries, even though it is frequently found exhibited alongside the other form of creativity, the one I have called elective contemporaneity.

Elective contemporaneity is not fuelled solely by environment. A generational phenomenon, no doubt, it keeps its feet on a specific ground and its senses plugged into world movements. It is often politicised and individualistic, for its artists have noted the failure of politics and ideologies and take a nostalgic, rather than romantic, look at the world. They do not have a lost paradise. There is no longer a place on this planet that does not remind them of their unique, special condition, while making them feel they belong to a greater whole – a whole of which they are elements but which can never be fully comprehended. For contemporaneity is and always has been history on the move. A history that we witness, or engender perhaps, but whose finality we cannot ponder. A history that makes us rethink ourselves, not in reference to one fixed, outmoded identity, but as protean beings with multiple, changeable identities.

The necessary synthesis of the past and projection into the future are problematic undertakings. We will carry on, feeling our way. We will always try to understand the incomprehensible, grasp the intangible. But don't get me wrong,

12.
Ernst Bloch, ibid,
p. 10.

Africa Remix is above all a contemporary art exhibition. To broach contemporaneity in Africa, however, inevitably leads to a re-reading of history. It also involves creating a theoretical framework that will make the different aspects of the exhibition accessible to a broad public. This is why, instead of tackling for the umpteenth time the question of the existence of a homogeneous collective African creativity, the curators decided to focus on the artists and their productions. To highlight the individuals rather than drown them in a debate that does not necessarily concern them. It is through the works, and the works alone, that the answers will transpire, or at least the routes towards renewed reflection.

Let us nonetheless keep in mind this capacity to bounce back, to recycle life and turn old things or ancient ideas into avant-garde works. Let us remember these words of Ernst Bloch: 'We are poor, we have unlearned how to play. We have forgotten it, our hands have unlearned how to dabble.'[12] African artists still 'dabble', not in the conventional sense of the word, but in the noble sense of *bricolage* that Bloch intended, which involves a relationship with matter and 'know-how'. Perhaps through this *bricolage* we will finally manage at least to feel – if not understand – what we still call, for lack of a better term, contemporary African art.

Translated from the French
by Gail de Courcy-Ireland

AFRICA, EXHIBITIONS
AND FEARS
OF THE DARK

DAVID ELLIOTT

Africa has long been a curator's graveyard. Big, 'dangerous', impossible to pin down, this vast continent has dwarfed any attempt to contain it and many exhibitions of contemporary African art have ended up reinforcing those stereotypes of backwardness, exoticism or dislocation that their curators have struggled to combat. The question has even been raised whether, with the burden of its colonial past, Africa could ever be regarded as 'modern' in its own right. In the face of this the temptation has been to step outside history, to deny context and geography. Yet, in spite of the post-modern conviction that geography and history may be dead, in the people and the art they remain, implacably present. Undeniably they both have a future.

What is Africa? I have never seen this maddeningly simple, almost unanswerable question addressed in an exhibition of contemporary art. But there is an opportunity here; the open-endedness of art, its engagement with life, its need for a past, a place and a future, its impulse to represent different levels of feeling and reality and its dedication to quality make an exhibition the best place to reflect on such matters. Here there are possibilities for new constellations of thinking, reflection and enjoyment and, because art is not life itself, little is at risk. But, most of all, such an exhibition is long overdue because, more than any other continent, Africa has been both defined and confined by the tragic weight of its past.

Forever a victim, forever an underdog, forever backward – in culture benighted or belated – poor Africa! And poverty, disease, famine, war – with an admixture of 'moral darkness' – were all part of the justification for colonisation. But Africa was not alone in this experience. De-humanising and culture-denying stereotypes were pretexts for empire the world over – think of the crude racial categories applied to the 'natives' in India or East Asia by the imperialists or to the first peoples of the Americas by the settlers. But in Africa the negative archetypes have dragged on, long surviving independence. In spite of the growth of an African intelligentsia, a continuing debate about what constitutes the post-colonial in a post-modern world,[1] the whole continent, along with its internal communications systems, is still encased within a vestigially colonial framework.[2]

But our knowledge of Africa, as well as of its increasingly dynamic contemporary art and culture, all contradict this. In the past decade South Africa has

1.
See for example R. Grinker and C. Steiner, *Perspectives on Africa. A Reader in Culture, History and Representation*, Oxford, Blackwell, 1997; O. Oguibe and O. Enwezor, *Reading the Contemporary. African art from Theory to the Marketplace*, London, inIVA, 1999; S. Njami, *El Tiempo de África*, exhibition catalogue, Gran Canaria, Centro Atlantico de Arte Moderno, 2000; N'G Fall and J. L. Pivin, *Anthologie de l'art africain du xxe siècle*, Paris, *Revue Noire*, 2001; O. Enwezor, *The Short Century. Independence and Liberation Movements in Africa 1945–1994*, exhibition catalogue, Munich, Prestel, 2001; G. Tawradros and S. Campbell, *Fault Lines. Contemporary African Art and Shifting Landscapes*, London, inIVA, 2003; S. Fitzgerald and T. Mosaka, *A Fiction of Authenticity. Contemporary Africa Abroad*, exhibition catalogue, St Louis, Contemporary Art Museum, 2003. A full list of recent writings can be found in the Bibliography on pp. 215–16.

2.
The present transport system is just one example of 'vestigial colonialism' and mirrors trade and economic support. For example, it takes longer to fly from Cape Town to Dakar than it does to Paris or London because there are no direct flights. And it is much quicker (and safer) to reach Yaoundé (Cameroon) from Dakar via Paris.

3.
Nelson Mandela's term for the present democratic non-racial Republic of South Africa.

4.
The exhibition was shown during 2001 and 2002 in Munich, Berlin, Chicago and New York. For details of the book see note 1.

5.
Sir H. M. Stanley, *Through the Dark Continent,* London, 1878. See also *In Darkest Africa,* 2 vols, 1890. Stanley was largely responsible for mapping out what was then called The Congo Free State which was allocated to the Belgian Crown at the Berlin Conference of 1884–85.

6.
General William Booth, *In Darkest England and The Way Out,* London, 1890.

7.
Ibid, pp. 9–16.

8.
'They are possessed with a perfect mania for meat. We were obliged to bury our dead in the river, lest the bodies should be exhumed and eaten, even when they had died from smallpox…, ibid.

succeeded in establishing itself as a 'Rainbow Nation' that works.[3] Okwui Enwezor's exhibition and publication *The Short Century. Independence and Liberation Movements in Africa 1945–1994*[4] challenged the prevailing art world climate of special pleading and political correctness by answering the question 'is there a modernity in Africa that has not been pre-ordained by the colonialism?' with an emphatic 'yes'. Wherever we look we cannot escape African culture in one form or another: genetic and palaeontological research now tell us that we are all 'Africans' in origin and the hieratic art of ancient Egypt has become accepted as the prototype of Greek and Roman classicism. Lost pre-colonial civilisations that traded across the Sahara and with the rest of the world have been discovered, excavated, researched and published. Yet the negative, uncultured image remains, enervating and disempowering. The harsh legacies of empire are deeply rooted in the Western mind. Why do these hang on?

The answer lies at the centre. The Congo Basin in particular, situated at the 'almost impenetrable' heart of the continent, provided a perfect screen upon which the West could project its fears. One of the earliest to do this was the British adventurer and explorer Henry Morton Stanley, whose book *Through the Dark Continent* (1878) described his journey along the line of the Congo River to the Atlantic coast.[5] His lurid descriptions of the 'savagery' of the nature and people he encountered were fell upon by an avid readership. One of these was the evangelical campaigner General William Booth, founder and head of the Salvation Army, who, in 1890, impressed by Stanley's report, published his social manifesto *In Darkest England And the Way Out.*[6]

Africa now had become a symbol of the dark forces at work within England itself and Booth liberally quoted from Stanley's journal to drive his point home. In his first chapter, 'Why "Darkest England" The African Parallel',[7] there was the impenetrable rain forest: 'where the light is so ghastly, and the woods are endless, and are so still and solemn and grey; to this oppressive loneliness amid so much life, which is so chilling to the poor distressed heart; and the horror grew darker with their [Stanley's native bearers'] fancies… And when the night comes with its thick palpable darkness, and they lie huddled in their damp little huts, and they hear the tempest overhead, and the howling of the wild winds, the grinding and the groaning of the storm-tost [sic] trees, and the dread sounds of the falling giants, and the shock of the trembling earth which sends their hearts with fitful leaps to their throats, and a roaring and a rushing as of a mad overwhelming sea – oh, then the horror is intensified!' And the two kinds of Pygmy cannibals who inhabited the forest were no less terrifying.[8]

All this got the good General thinking: 'It is a terrible picture, and one that has engraved itself on the heart of civilisation. But while brooding over the awful presentation of life as it exists in the vast African forest, it seemed to me only too vivid a picture of many parts of our own land. As there is a darkest Africa is there not also a darkest England? Civilisation, which can breed its own barbarians, does it not also breed its own pygmies? May we not find a parallel at our own doors and discover

at a stone's throw of our cathedrals and palaces similar horrors to those which Stanley has found existing in the Great Equatorial Forest?'

Booth's, and many others', greatest fears had been realised: 'Africa' and its darkness were actually an expression of our own world; it had become a dumping ground for the negativity of Europe itself.

Stanley's books had a vast influence on the development of 'moral imperialism' as well as on the projection of the colonisers' worst fears onto Africa. The impenetrable rainforest and the savage cannibal subsequently became the stock-in-trade of many an imperial adventure yarn but also provided the basis for Joseph Conrad's celebrated novella *Heart of Darkness* (1902), in which the 'horror' noted by Stanley becomes the mantra of an enigmatic trader (Kurtz) who many miles up the Congo, bereft of all trappings of Western civilisation, gazed into an abysmal conflict within himself that he could no longer bear. A prototypical existentialist anti-hero, Kurtz's valediction 'The horror, the horror', uttered in a moral-free-zone where there was nothing to hold on to, is the *doppelgänger* to what Conrad bitterly described as the Western 'dustbin of progress'. These words were a premonition of the carnage of the whole twentieth century.[9] After the First World War T.S. Eliot appropriated Conrad's 'horrors' as an epigraph for his poem *The Waste Land* (1922), and these words – or at least these sentiments – have reappeared on the pages of Graham Greene, George Orwell, William Golding, Theodor Adorno, Erich Fromm, Jean-Paul Sartre, Samuel Beckett, Albert Camus and many others.[10] In 1978 the corpse of Kurtz was exhumed in the Cambodian jungle in Francis Ford Coppola's war film *Apocalypse Now* and the image of horror continues to stagger on. In the case of Africa it seems to need only one more war, massacre, famine or epidemic to trigger the response 'apocalypse always'. No, not at home, but a surrogate, vicarious apocalypse reassuringly projected, as it always has been, onto the screen of the dark continent – a terminal basket case without hope or future.

Such negative prejudices have of course not gone unchallenged. In the 1960s Martin Luther King gave his life for equal Civil Rights for African Americans and *négritude,* Pan-Africanism and Black power have all had the common aim of transforming the segregated mirror image into a positive attribute.[11] Just like its opposite, black essentialism is ultimately self-defeating if one believes in a common future, yet it has, under duress, been important and necessary in building up a sense of cohesion, ownership, self-confidence and hope that has gradually permitted the inclusion of 'others' in a spirit of good will rather than of potential harm or theft. However, 'white' or 'black', the obsession with skin colour has had a reductive effect. How can Africa be defined by 'darkness' when, if we look around the continent, there are so many people of Asian, Arab, Malay, Berber, Philippine, European and other origins who live there, as well as infinite permutations between them all?

The abolition of apartheid and the 1994 democratic elections in South Africa have encouraged widespread fundamental changes in how we talk, think and act about contemporary African culture. The Marxist stereotypes of weapon and

9.
Joseph Conrad, *Heart of Darkness,* London, Penguin, 1989, p. 111.

10.
Eliot subsequently dropped these words at the suggestion of Ezra Pound, but he used a different quotation from the same passage in *Heart of Darkness,* 'Mistah Kurtz – he dead', three years later in *The Hollow Men* (1925).

11.
For information on *négritude* see Jean-Hubert Martin p. 32, note 6. Pan-Africanism refers to various movements that share the goal of African unification and the elimination of colonialism and white supremacy from the continent. Black power is a term that was popularised in the 1960s in America, and which refers to advocates of black racial pride and social equality through the creation of black political and cultural institutions. See E.L. Bute and H.J.P. Harmer, *The Black Handbook: The People, History and Politics of Africa and the African Diaspora,* London and Washington, Cassell, 1997.

12.
For Marxist termino-
logies within the
Struggle see
D. Elliott, 'Babel In
South Africa', in *Art
from South Africa*,
London/Oxford, 1990.

13.
H. Musa, Letter to
Jean-Hubert Martin,
5 May 1999, in
*Partage d'Exotismes,
5 Biennale d'Art con-
temporain de Lyon*,
exhibition catalogue,
vol. 1, Lyon, 2000,
pp. 15–16, 25–26.
Translated from the
French by D. Elliott.

struggle or theories of separation on grounds of colour no longer work.[12] Nelson Mandela's rejigging of the ANC doctrine of non-racialism into The Rainbow Nation to include all peoples and interests, has had an impact on the way that we can look at the whole continent. Africa is, must be – like any self-respecting continent should now be – a Rainbow Continent. Immediately Africa becomes no longer a 'special case' but part of a much wider discussion about culture in general. So far African music and drama have been successful in making an international impact, and even in contemporary art the situation has started to open up – it is now good form to include at least one or two African artists within large international shows. But inevitably the suspicion of neo-colonialism lingers on because the power of selection remains in the West. Because of this the category of 'African art' has remained problematic.

It almost seems as if some curators and artists have felt that they have needed to sidestep neo-colonialism by denying or leapfrogging their Africanity in order to retain integrity. The politics of this are complicated as the artist Hassan Musa made clear in his decision not to participate in *Partage d'Exotismes*, the 5th Biennale in Lyon in 2000. He explained: 'African art is an enormous ethical misunderstanding, which I try to take advantage of without aggravating it; but this leaves me with only a narrow margin for manoeuvre. Personally, as an artist born in Africa, but with no urge to bear the burden of the African artist, I know that the only opportunities open to me to present my work in public outside Africa are of the "ethnic" type, where people assign to me the role of "the other African" in places designed for the kind of seasonal ritual where a certain kind of Africa is "in favour". It is a situation which is not lacking in ambivalence, and which gives me the impression of being a hostage to this strange machine which integrates African-born artists into the world of art, while at the same time shunting them off into a category apart…'[13]

This is not only a matter of the artist reacting against a particular exhibition, more fundamentally, he objects to the 'expectations of European aesthetics that encourage Europeans to invent their own version of African art… It is an African art that Africans never see because it is often produced in Europe for those Europeans who collect it, exhibit it and make it an object of aesthetic reflection.' Musa's main objection was, however, on ethical grounds: '…The main expectation of European aesthetics is ethical… [which] allows people to define themselves in relation to each other, to define the boundaries between good and evil, and to set out norms of life, art, etc.' And he surmises that this ethical obsession is now focused on Africa because previously the Europeans 'behaved, and still behave, in a way that has been devoid of ethics.' In short, Africa has again become a screen onto which Europeans – or the equivalent colonising powers of today – project not, as before, their fear of darkness but their profound guilt.

So, again the African is forced to play a passive role and the fear of darkness has been given new life. It is a situation in which African history and culture have been compacted with virtually no space allowed between the colonial and the

contemporary that the artist can shape and occupy. Without an articulated factual and theoretical history it is difficult, if not impossible, to interpret the present. In the stifling environment of the – still Western dominated – art world, a number of exhibitions and books – of which this is a part – have recently been struggling to create some air and space.

The new histories are just beginning to be compiled and because history, too, is an attribute of power, it will be a considerable time before they are permitted to enter the mainstream. We already know, for example, that the development of modern and contemporary art in Nigeria, Mozambique or South Africa since the 1940s has taken very different paths and has been shaped far more by local political and market forces than by 'indigenous' or traditional cultures. But these individual stories have not yet been digested, disseminated or integrated into a general history of modern African culture that includes the colonial with the post-colonial or the Maghreb with the sub-Saharan regions.[14] Along with the colonial mindset, divisions of language, history, religion and culture still predominate. The exhibition *Africa Remix,* while not claiming to give a comprehensive view of Africa, disregards such divisions and structures by taking an unapologetically open and thematic approach. The themes in the exhibition have emerged out of the works chosen by Simon Njami, the senior curator, and reflect the realities of life, art and memory inside the continent, as well as in the recent diaspora. As one would expect they do not always offer an easy ride.

Openness has been the keyword both in tracing histories and establishing useful categories and critical frameworks with which to build *Africa Remix.* And in doing this a pattern has been established which, while not out of step with artistic discourse in other parts of the world, acknowledges the specific qualities and concerns of contemporary African art. As part of this the power of the big exhibition as both a conduit for research and a platform for showing together previously unrecognised bodies of work should not be underestimated.[15] Of course such an exhibition may be only one small step in a much larger process leading towards absorption, and perhaps acceptance, in dominant culture but, whatever the critical response, the art world will never be quite the same again. The people who will visit the museums and galleries in the different countries in which *Africa Remix* will be exhibited will have been exposed to the tip of an iceberg of an incredible creative energy that can be neither ignored nor forgotten.

My own intention is that *Africa Remix* should present a view of contemporary African art that expresses, but is no longer limited by, the darkness of its past; only then can it move on to celebrate the infinite possibilities of its future. The impression that these myriad works evoke should be challenging, stimulating, at times upsetting, but, above all, the works themselves should be memorable and beautiful just as in any other 'good' exhibition of art.

14.
The exhibition and accompanying catalogue *Seven Stories About Modern Art in Africa,* London, Whitechapel Art Gallery, 1995, attempted to partially fill this gap by focusing on the particular situations in seven different African countries. The format however stressed the local situations and art politics of the separate countries at the expense of a more general presentation of the state of contemporary African art.

15.
The methodology used in making this exhibition follows that used for *After the Wall: art and culture in post-communist Europe 1989–1999* that I initiated for Moderna Museet in Stockholm in 1999. Over 170 artists from 23 countries were shown as a result of the research visits made by the three curators.

THE RECEPTION OF
AFRICAN ART

JEAN-HUBERT MARTIN

Being the same and different seems to be the paradoxical condition in which contemporary art evolves. When there is innovation, it often has to come from within, from an approved, established artist with the support of a status-enhancing discourse. The art world likes to see itself as completely open to everything new, but is in fact governed by habits, conventions and methods that constitute an unspoken set of rules that every postulant has to be able to master. It did not take a young generation of African artists long to assimilate these parameters and put them into operation. Today we are dealing with a group of artists who have no inhibitions about availing themselves of the methods and techniques current in contemporary Western art to handle topical questions relating to a post-colonial African reality. Several of them take part in the international exhibitions that are now held throughout the world. They travel widely, some dividing their time between Africa and other continents, which is why *Africa Remix* makes no distinction between those artists residing in Africa and those scattered across other countries. Where the latter are concerned, all those who have been invited to contribute to *Africa Remix* refer to their African roots in one way or another. They often speak of them in a raw, direct manner; hardly any trace of references to so-called 'traditional' or 'primitive' art practices can be found. In this sense African art has made a huge leap since 1989, when I curated the exhibition *Magiciens de la terre* at the Centre Pompidou.

The purpose of *Africa Remix* is not historical. It does not attempt to reconstruct the chronology of developments that have taken place over several decades. Rather it sets out to show the state of African creativity in its most recent manifestations, though at the same time not excluding an older generation of artists that has had the advantage of having gained some recognition in contemporary art circuits. *Africa Remix* combines the work of self-taught artists and those who are actively involved in the international art scene, across the whole continent: sub-Saharan Africa as well as North Africa. However, it must be said that there are many places that curator Simon Njami did not have time to visit during the selection process for *Africa Remix*, each constituting a gap that our successors will have to bridge.

The knowledge that we had in the late 1980s was very fragmentary. It may be useful to recall what we did know at that time in order to gain a better

understanding of the developments that have taken place since. What follows is an outline summary of Africa as I knew it when I was preparing for the exhibition *Magiciens de la terre*.

THE COLONIAL HERITAGE: SCHOOLS AND TRENDS

The 1940s and 1950s witnessed the emergence of schools of painting in Africa that experienced real success internationally, some as a result of European involvement. For instance, the Lubumbashi school in the Congo, founded in 1953 by Belgian artist Pierre Romain-Desfossés, turned out animal paintings in dull hues and agricultural scenes treated as decorative tracery, which quickly evolved into a stereotyped output for foreign customers. Similary, the Potopoto school, started by French artist Pierre Lods in Brazzaville, French Congo, in 1951, provided traditional iconography (markets, masks, etc.) with schematic graphic techniques and bright, contrasting colours. While occasionally paintings revealed some pictorial qualities, all of them were made leaden by imagery that was servilely adapted to the demands of a European clientele. Other schools with European connections were more progressive, at least for the age. In 1962, Ulli Beier helped to establish workshops in Oshogbo, Nigeria, which, with no prescribed programme, set out to release the creative capabilities of its members in the different fields of music, theatre and painting. Chief Juraimoh Buraimoh, with his coloured bead pictures, and Prince Twins Seven-Seven,[1] who began as a printmaker and later produced narrative paintings depicting Yoruba legends, were among the school's finest artists.

In Western museums in the 1960s there was a latent theoretical interest in any form of art that would take over from traditional art and connect with modernity. There was an ongoing desire to show African art other than masks or votive sculptures, but there was a lack of information, and a cross-continental investigation was not seen as a priority. So curators and museum officials made do with existing information, often imparted by Westerners on the movements they were supporting.

The Oshogbo artists were shown at a few exhibitions, as were two movements favoured by whites in East Africa – Shona and Makonde. Shona sculpture is the finest example of a 'return to sender' aesthetic produced by the links between modernity and 'primitivism'. In the mid-1950s, Frank McEwen, a British art administrator and then director of the National Gallery of Rhodesia (now Zimbabwe), met Thomas Mukarobgwa, who taught him about the Shona tribe, their religion, dance and music. Inspired by what he heard, McEwen gave Mukarobgwa and other young artists painting and drawing materials, encouraged the artists to draw from their Shona backgrounds and introduced them to sculptures by Picasso, Henry Moore and Gaudier Brzeska. This led to one of the most productive workshops anywhere in Africa that is still regularly exhibited today. In 1971/72, the sculptures with elementary forms made of polished serpentine were shown at the Musée Rodin in Paris and the Institute of Contemporary Arts (ICA) in London.

1.
Born in 1944 as Prince Taiwo Olaniyi Wyewale-Toyeje Oyekale Osuntoki. The name Twins Seven-Seven alludes to the fact that he is the only survivor of all his siblings – seven sets of twins.

2.
See *Makonde,* exhibition catalogue, Museum of Modern Art Oxford, 1988; *Art Makondé, Tradition et Modernité,* exhibition catalogue, Musée des Arts Africains et d'Océanie, Paris, 1989.

3.
Max Mohl, *Masterpieces of the Makonde,* exhibition catalogue, Museum in der Au, Heidelberg, 1974; Max Mohl, *Masterpieces of the Makonde, Vol. II: ebony sculptures from East Africa, a comprehensive photo-documentation,* exhibition catalogue, Museum in der Au, Heidelberg, 1990; Max Mohl, *Masterpieces of the Makonde, Vol. III: ebony sculptures from East Africa, a comprehensive photo-documentation,* exhibition catalogue, Heidelberg, Verlag Max Mohl, 1997.

4.
See Abdelhafid Chlyeh, *Les Gnaoua du Maroc, Itinéraires Initiatiques, Transe et Possession,* Grenoble: Editions La Pensée Sauvage, 1998. Mohamed Tabal Abdelkader Mana (ed.), *Les Gnaoua et Mohamed Tabal,* Casablanca, Edition LAK International, 1998.

In 1969/70, the Grosvenor Gallery in London put on an exhibition of Makonde sculpture.[2] These wooden figures are typified by the extreme elongation of the filiform limbs that allows a very complex interweaving of the figures in extravagant poses. Mohamed Peera, an Indian dealer in curios for sale to Europeans in Dar es Salaam, favoured such inventiveness and imagination in the works that he purchased. After he left, the African art exported to Europe mostly declined into stereotypical and repetitive works, with the exception of a few artists who clung to their original ideas, such as John Fundi. When these works appeared in Europe they caught the attention of Max Ernst and Salvador Dali. I came across John Fundi's work in 1989 while selecting the works for the *Magiciens de la terre* exhibition. One of the selection principles for this exhibition was never to rule out any African movement *a priori,* even if at first glance it seemed only formulaic, but to investigate these movements to see whether they might not have given rise to an outstanding, truly original figure. That is how we came upon Fundi, a Makonde artist whose work we found in various catalogues.[3] The size of his sculptures alone implied a real commitment in his work that went beyond easy sales. One of the descendants of Makonde sculpture today is Georges Lilanga di Nyama (cat. 63–71, pp. 125–27), who again conveys that strange anthropomorphism in a weird universe of paintings and polychrome sculptures. Traditional Makonde sculptures comprised face masks with impressive scarifications and ventral masks with jutting-out breasts used for ritual feasts. Taking over this tradition, Lilanga's later sculptures show tangles of skeletal bodies arising from unleashed dream-like imaginings, which he has now taken into a world of fantasy not far removed from cartoon strips.

The Shona and Makonde schools eventually suffered a loss of popularity in the art world. Once artists had begun to produce works in large quantities there was a tendency for collectors and critics to reject everything. These artists were observed but ultimately dismissed for paradoxical reasons: they were reproached either for repeating themselves or for developing and thereby losing their 'authenticity'.

The Moroccan scene, and the trance music of the Gnawa of Essaouira in northern Morocco in particular, has long fascinated artists and musicians.[4] A pictorial movement associated with the Gnawa developed, supported by a local gallery owner, Frédéric Damgaard. These works, with their loud colours, conjure up an almost Expressionist world of phantasmagorias and chimeras, especially in the work of Mohamed Tabal, one of the movement's finest representatives. The origin of the movement is hard to place; the artists' position is based on dreams or injunctions given by a divine being. The self-stimulation of the group and the demand for sales by the gallery served to ferment it.

South Africa has long been known for woodcuts and linocuts made in the townships' studios after northern European models. The publication of Sue Williamson's book *Resistance Art in South Africa* in 1989 and the *Art from South Africa* exhibition at the Oxford Museum of Modern Art in 1990 were real revela-

tions. From then on growing attention was paid in Europe to this effervescent, committed milieu. Among the first modern artists to have emerged from South Africa is Ernest Mancoba, one of the only African artists to have played an active part in an avant-garde European movement (COBRA). Provoked into emigrating to Europe as a result of the political regime, Mancoba lived a long life and later experienced real recognition in his own country at the *Sibambene* (Hand in Hand) exhibition at Johannesburg Art Gallery in 1994. This was a year before the first Johannesburg Biennial which, in spite of its very ambitious scale, did not quite succeed in showing off the most fertile movements in South Africa or in the rest of the continent.

Alongside these movements there were a large number of art schools, some initiated during the colonial period and continuing to operate after independence. The countries with the most numerous and active schools were Nigeria, Senegal, Ivory Coast, South Africa, Ghana, Sudan and Uganda. Three art schools had real visible influence in the 1970s and 1980s and numerous Nigerian universities have art departments.

In Nigeria, art education goes back to the 1920s and 1930s with the appointment in 1927 of British art teacher Kenneth C. Murray[5] at King's College, Lagos, under the instigation of artist Aina Onabolu. The most active schools in Nigeria are in Zaria, and above all in Nsukka. Originally from Ghana, El Anatsui (cat. 12–13, pp. 154–55) has been teaching at University of Nigeria, Nsukka, since 1975. There he brought his talent to fruition, succeeding with remarkable mastery in transposing a typically African environment into assemblages with variable forms.

The Ecole de Dakar in Senegal came into being in the early 1960s under the auspices of President Léopold Sédar Senghor, who was responsible for popularising the concept of *négritude*.[6] The school was at its height in 1966 at the time of the first *World Festival of Pan-African Arts* in Dakar. The Festival was organised by Iba Ndiaye, an artist who had taken up his position on the side of modernity and the School of Paris. The efforts made by painters of the Dakar school to achieve artistic cross-fertilisation, trying to combine modernity and primitivism, poetry and tradition, in line with Senghor's theories, ultimately were not successful. All in all the hybridisation turned out to be laboured and remained dependent on European modernism. We had to wait until the 1990s to see the blossoming in Senegal of the talent of artists like Moustapha Dimé – who died at a young age – and El Hadji Sy, who has distinguished himself primarily in dialectics and performance with the Laboratoire Agit-Art.[7]

The Abidjan school of art in the Ivory Coast owes its reputation to the presence of Bertrand Lattier who embarked on an original path with his impressive sculptures made of sisal rope. After his premature death in 1973, there followed a return to more conventional practices. In accordance with the good old pattern of modernism, a group of young artists then rebelled against excessively academic teaching methods. They formed the Vohou-vohou group, which advocated more material-centred abstraction; its finest representatives, such as Kra N'guessan, reject

5.
Kenneth C. Murray's fine art curriculum was later introduced into other major regional colleges.

6.
Négritude was an aesthetic formulated by black intellectuals in 1930s Paris as a response to French racism. 'The movement reasserted black cultural values and attempted to encourage black people to take pride in their heritage and to study African life and culture.' (E.L. Bute and J.J.P. Harmer, *The Black Handbook. The People, History and Politics of Africa and the African Diaspora*, London and Washington, Cassell, 1997, p. 152.)

7.
The Laboratoire Agit-Art refers to a loose collective of visual and performance artists, which was founded in Dakar, Senegal, in the late 1970s in opposition to what was perceived to be the 'official' art of the Ecole de Dakar. See Clémentine Deliss (ed.), *Seven Stories about Modern Art in Africa*, Whitechapel Art Gallery, London, and Konsthall, Malmö, Paris and New York, Flammarion, 1995.

8.
See Júlio Navarro (ed.), *Malangatana Valente Ngwenya*, Tanzania, Mkuki na Nyota Publishers, 2003.

9.
See Jean-Hubert Martin, 'La peau plutôt que la toile', in *Farid Belkahia*, exhibition catalogue, Musée d'art moderne et d'art contemporain, Nice, and Musée national des arts d'Afrique et d'Océanie, Paris/Nice, 1999, pp. 13–15. Cf. Raoul Ruiz's film, *Paya et Talla: L'atelier de Farid Belkahia*, 1988.

10.
See Anne-Marie Bouttiaux, *Senegal behind glass: images of religious and daily life*, exhibition catalogue, Musée royal de l'Afrique Centrale, Tervuren, Munich/New York, Prestel, 1994.

the constraints of flat painting and favour the freedom of assemblage, recalling the work of such European artists as Alberto Burri or Manuel Millares.

PERSONALITIES AND TRADITIONAL PRACTICES

These various forms of Cubist-Primitivist abstraction and the endeavours that followed them were hailed as both a renaissance of African art and a rapprochement with Western art. Unfortunately they failed to be of serious interest to those in America and Europe who dictated the trends in the art world. They were encouraged and commented upon by a pro-African intellectual lobby, but attracted very little attention from the art market and the major museums. Thus an international movement of abstract painting was established for a few years, without it being realised that the medium was the message and critics were congratulating themselves primarily on the fact that African painting existed. In spite of the efforts of those promoting it, it remained largely a by-product of Western modernity.

The struggles for independence were sometimes accompanied by intense cultural movements. For instance, the artist Malangatana[8] identified himself with the progressive anti-colonial fight in Mozambique. His vividly coloured paintings piling up crowds of bodies and faces embody the emergence of an African cultural identity. One of the painters to have really thought about local specificity, not solely in terms of iconography (two-dimensional representation of the three-dimensional volumes of the mask) but in terms of support (copper and skin) and technique, is the Moroccan Farid Belkahia.[9] For him it was not a question of representing traditional Moroccan art but of availing himself of systems of signs such as the Tifinagh alphabet in use in the Sahara, and reflecting a range of colours borrowed from high-quality craft work, using dyes applied to tanned hides. The resulting non-orthogonal paintings re-orientate a conscious modernity in the context of a stylistic and spiritual history – trance and Moroccan craftsmanship. From 1962 to 1974 Farid Belkahia had the opportunity to develop these ideas at the Ecole des Beaux Arts in Casablanca, of which he was the first director. However, at that time, European critics were interested only in naïve Moroccan painting.

Outside those initiatives mentioned above, where Westerners played a determining role, most artistic activities in Africa developed in specific local contexts. The European art world paid them (often disdainful) attention only well after they had emerged. Sometimes anthropologists were the first people to take an interest. Departing from the usual modernist model, which involved drawing from popular and archaic traditions, these artists do not seem to have paid those traditions much heed, probably because they were looking too hard at metropolitan examples.

The Dakar paintings on glass, or *souwères*[10] as they were known, initially, in the early twentieth century, concentrated their iconography on Koranic history, later incorporating portraits, often funerary ones. The simplification of the forms and the heightening of local colour applied in flat tones with no shadows endow the

33

best of these little pictures with an almost Matisse-like authority, especially those by Gora M' Bengue.

Cement sculpture is practised on the west coast of Africa from the Ivory Coast to Nigeria. Cement (because it is more solid and durable) replaced dried earth as a material for sculptures representing divinities, guardians and other figures in the M'bari sanctuaries, and then later for Christian figures or statues of local chiefs and military men. This kind of work is found particularly in cemeteries where tombs are often topped by a life-size effigy of the deceased. As far as I know, there has been no comprehensive study of this very widespread artistic phenomenon. Photographs of the cement works of Koffi Mouroufie were shown at the Pompidou Centre in 1977 before Jacques Soulillou organised *Sculptures en ciment du Nigéria,* a proper exhibition of the works of the two Nigerian sculptors Sunday Jack Akpan and Aniedi Okon Akpan in Paris in 1986.

Popular sign painting, which is found throughout West Africa, developed in Zaire/the Democratic Republic of Congo after 1945, retracing the dramatic political history of the country and of the Mami Wata. There is still a strong movement of sign and poster painters in Kinshasa, whose works reveal recurrent themes of the colonial humiliations, independence and the assassination of Patrice Lumumba in 1961.[11] Some of the most gifted of these painters, such as Chéri Cherin (cat. 34, pp. 202–03), Syms and Sim-Simaro have made names for themselves locally. This is the background from which Chéri Samba (cat. 112–14, pp. 200–01) came, though he has now broken free from it to follow his own path and is now internationally renowned.

In 1986 the wall paintings of the N'dbele women were made famous by Margaret Courtney Clarke's book *Ndebele: Art of an African Tribe* (with a preface by the photographer David Goldblatt). Developed from decorations drawn by hand in cow-dung with patterns similar to those used in their ceremonial beadwork, and thanks to easier access to industrial colours, their paintings, covering the walls of their houses, originated as a form of cultural self-expression in a people deported by the racist policy of apartheid.

In addition to these artists who belonged to groups sharing collective innovative practices, there are also, on the one hand, artists producing traditional works, relying on transmission of forms like masks and wooden statues made for ritual festivities or shrines and, on the other, a few isolated cases of artists such as Frédéric Bruly Bouabré (cat. 28–32, pp. 105–07) in the Ivory Coast, or Bodys Isek Kingelez (cat. 58, pp. 176–77) in Kinshasa, whose works initially made little impact on those who encountered them. They are, to my mind, among the few artists who should properly be described as self-taught. The drawings of Bruly Bouabré are often not without some awkwardness, even if from time to time he makes a real formal breakthrough, like the very humorous 'cap' in his work *L'Invention de la Casquette,* 1993 (cat. 28, p. 105). His work is interesting as much for his encyclopaedic ambitions,[12] his need to record his surrounding in drawings on card, as for the droll

11.
These themes have been studied extensively by Bogumil Jewsiewicki, who curated an exhibition called *A Congo Chronicle: Patrice Lumumba in Urban Art* at The Museum for African Art, New York, in 2000. See Bogumil Jewsiewicki, *Mami wata: la peinture urbaine au Congo,* Paris, Gallimard, 2003.

12.
Searching for a way to preserve and transmit the knowledge of his people, the Bété, which has no written culture of its own, Bruly Bouabré constructed an alphabet of 448 monosyllabic pictograms representing phonetic syllables. Given the collective title *Knowledge of the World,* they combine to form an encyclopaedia of universal knowledge.

JEAN-HUBERT MARTIN

13.
The term 'Art Brut' was first used by the French painter and sculptor Jean Dubuffet to describe paintings, drawings, sculpture and archi-tecture created by self-taught artists.

comments he conscientiously adds to them. Bodys Kingelez's biography shows that he was always preoccupied with art. One of his relatives taught him how to sculpt masks, and he later restored some traditional masks for the Kinshasa Museum. His decision to embark on the construction of architectural maquettes was indicative of artistic obsession, especially as he had no outlet for them when he began. The few gallery owners he approached when he started out dismissed him, on the grounds that 'art equals painting'.

MAGICIENS DE LA TERRE

Several parameters need to be made explicit to understand the choices made for the exhibition *Magiciens de la terre* that I curated for the Centre Pompidou in 1989. Generally speaking, to describe any artist who has not attended a school of art as self-taught would be wrong for the West, where thousands have trained 'on the job', and for Africa would be tantamount to simple-minded colonialism, implying that the only valid culture was modernist. I have often been asked why I did not include Art Brut[13] in the exhibition. Apart from the fact that I did not see how a few works taken out of their environment could be shown, I wanted at all costs to avoid any amalgam between the activities of individuals who were socially isolated or suffering from psychological problems, as found in Art Brut, and the community-based practices of tribal art or of the groups described above. In fact, all the artists outside the acade-mic system mentioned were either taught by an elder or belonged to a movement where there was reciprocal stimulation, or were advised by a player in the art world. So there can be no question of them being self-taught in the sense meant by Art Brut.

In Western art, after the period of dominance of conceptualism and mini-malism in the 1970s, the 1980s saw the emergence of a strong resurgence of paint-ing. This movement seemed to wipe out the benefits of two decades of avant-garde artists who had taken Dada as their reference point; decades in which artists had been busy endorsing the idea that art could result from any material. The dogma that determined that painting was the superior medium for art had been seriously under-mined. Now the same galleries that had defended these innovative practices could be seen presenting painting as the latest avant-garde medium, which was tantamount to performing a little conjuring trick to assert that nothing ever changes. The advantage of the non-pictorial practices, and of installation in particular, was that art could at last escape from the dogma of painting – which colonialism had imposed on Africa – and accommodate very diverse techniques: ritual objects, shrines or altars. That is why I tended at the time to exclude from my selection of works for *Magiciens de la terre* painting that had emerged from art schools. In addition I felt that the exhibition would otherwise have attracted only indifference or right-minded comments instead of stimulating the kind of discussion that did take place. Today, when the danger of an exclusive return to painting as the dominant art form seems to have been averted, the opposite is happening, with many curators justifiably rebelling at its eradication from leading events. On the art market it is still pre-eminent, however, even if

photography, a more accessible means of recording our way of life, is beginning to catch up with it.

The alternative at the time was either to show African art that resembled Western art and endorse the inglorious idea that slowly but surely the West is going to bring every culture into step with it, or on the contrary to engage in a defence and illustration of cultures in the process of rapid transformation, far from becoming extinct. The fact that African art is often called 'traditional' when it is undergoing constant development is just as inappropriate as the English term 'ethnic art'. Modernism itself has emerged from a long tradition of rupture, and it cannot lay claim to any extra quotient of universality in relation to any other culture, the fact that it was inspired by primitivism doesn't change anything. *Magiciens de la terre* did not fit into any category because it was exploring a no-man's land. None of the major lobbies could be found there. Recognised African artists who were already established were not represented in it; collectors of traditional African art found brand new masks or hybrid works that did not conform to the canon of so-called 'primitive' art. By being curious, by taking the trouble to travel and meet the artists rather than waiting for the galleries to pressure me, I wanted to open up the spectrum and question once more the self-referential art on which the professionals congratulated themselves.

'ESTABLISHED' POSITIONS

In the 1980s conceptual art had not reached Africa, and schools there were still teaching abstract painting. Since then this gap has been filled. From the 1990s on, a certain number of new approaches have become evident. El Anatsui (cat. 12–13, pp. 154–55) and Antonio Ole (cat. 100, pp. 194–95) forcefully transpose the brutality of their environment into their installations, while Abdoulaye Konaté (cat. 59, pp. 122–23), who studied in Cuba, gives an account of a traditional reality by including hunters' amulets or a Bambara funerary bed in his works. Painters have emerged in a great variety of genres. From Germany, Owusu-Ankomah (cat. 103–04, pp. 136–37) borrows symbols from the *adinkra*, a funerary cloth used by the Akan people of Ghana, containing signs arranged in a specific manner to convey messages to the departing soul. He incorporates these into a visual narrative grid and juxtaposes them with symbols from various other cultures to create a hybrid visual language. Among the *adinkra* symbols which Owusu-Ankomah employs, one of the most prominent is the *Sankofa,* which looks like a curvilinear heart. It is now widely used to represent groups returning to their roots, as its literal translation is 'go back and fetch it'. In Kenya, Richard Onyango (cat. 101–02, pp. 134–35) follows the life of a mixed-race couple – the artist and his voluminous English model and patroness, Souzy Drosie – in narrative paintings in vibrant colours.

Dak'Art, the Biennial of Contemporary Art in Dakar, Senegal, has been running since 1992, and is an opportunity for all admirers and buyers of contemporary African art to meet. However, the exhibition is often seen as more of a

14.
See *Le roi Salomon et les maîtres du regard, Art et médecine en Ethiopie,* exhibition catalogue, Musée national des arts d'Afrique et d'Océanie, Paris, 1992.

15.
See *Podai, Malerei aus Westafrika,* exhibition catalogue, museum kunst palast, Düsseldorf, 2003.

networking opportunity. The first Johannesburg Biennial opened in 1995, corresponding to political change in South Africa and the end of apartheid. An artistic milieu that had hitherto been repressed and semi-clandestine enthusiastically renewed its links with the rest of the world. This very large-scale exhibition unfortunately failed to provide a platform for South African art and a panorama of innovative creativity in Africa. However, the second biennial was better organised, with resolutely worldwide ambitions. At these African biennials, but also right across the international scene, a certain number of young artists who have emerged from European or African art schools and are in direct contact with the most innovative trends in contemporary art, stand out. Their links with African culture vary in closeness.

Yinka Shonibare (cat. 119, pp. 90–91), who stresses the fact that under no circumstances did he want to become a 'traditional modernist painter', has been able, with his Victorian 'wax' cloth costumes, to consider the complexity of the relationships between Europe and its colonies over the centuries. The danger lying in wait for many artists today, when there is some interest in African art, is that they may fall into the simplistic framework of reversing white-black values. This exercise may prove revealing when it is sophisticated and based on a plurality of signs. It is tedious when it results from an inversion mechanism.

Romuald Hazoumé (cat. 52, pp. 174–75) makes reference to the Fon signs, but subverts the stereotype of the African mask by recomposing it ironically from rubbish or *objets trouvés*. After a series of installations stained with nihilistic graffiti, Pascale Marthine Tayou (cat. 124, pp. 208–09) gives an account of a shabby reality, rebalanced by the vitality of social exchanges. Barthélémy Toguo (cat. 128, pp. 212–13) deals with the problems of immigration; he persists in using wood for his sculpture, but it is not clear whether his attachment to this material has anything to do with his original culture. Bili Bidjocka (cat. 24, p. 104) makes installations of an elegant, thoughtful purity, while Meschac Gaba (cat. 47, p. 73) seeks rather to situate his work in relation to his viewers and placing them in its context. Marginal activities halfway between the votive shrine and the expression of urges and desires repressed by the surrounding social circle have been identified by players in the art world who have thrust the Benin artist Georges Adéagbo and, to a lesser extent, Paulo Capela (cat. 33, p. 108–09) to the front of the stage. A new generation of artists coming from North Africa is attempting, with video in particular, to bring back to light the traumas buried in the recent history of the Maghreb: for example, Zineb Sedira, *Mother, Father and I,* 2003 (cat. 116, p. 83) and Zoulikha Bouabdellah, *Dansons,* 2003 (cat. 27, p. 67). These artists live in Africa or Europe, sometimes dividing their time between the two.

Every so often, disregarded by the contemporary art circuits, amazing works turn up, such as the talismanic paintings of the traditional Ethiopian doctor Gera (cat. 49–50, pp. 114–15),[14] or the Podai body paintings[15] for the Loma initiatory rituals of a village in Guinea. The fact that they have been identified by

Europeans who encouraged their production by supplying the materials which they were totally lacking taints them in the eyes of purists who will not hesitate to pontificate at length about hybridisation and creolisation, an irreparable loss of authenticity.

AN UNBOUNDED VISTA

16.
Founded in Paris in 1991, *La Revue Noire,* a magazine of contemporary African art, is published by Jean Loup Pivin, and edited by Simon Njami.

17.
See André Magnin (ed.), *Contemporary Art of Africa,* New York, Harry N. Abrams Inc, 1996.

Since its first issue in 1991 *La Revue Noire*[16] has vehemently defended the point of view of an Africa resolutely turning its face towards modernity. It has campaigned for an urban, go-ahead Africa, looking towards international relations, and against a sometimes outrageously far-fetched European concept of magic, sorcery and witchcraft. Trance, sacrifices and spells continue to fascinate Christians. *Les maîtres fous* (1958), a film by Jean Rouch, only served to reinforce that tendency. It is only understandable that many Africans want to put paid to these stereotypes. Reality is stubborn for all that, and outside the major cities there are all sorts of visual expressions that have very little to do with the traditional sculpting of masks and statues; nor are they devised for an élitist clientele that is catered for by galleries. Someone like Cyprien Tokoudagba (cat. 129–30, pp. 146–47) pursues his career as a painter and sculptor of vodun shrines at Abomey, Benin. He places his figures authoritatively, the compositions are balanced and the range of colours iridescent. While he sells canvases, to one collector in particular, and is invited to exhibit abroad from time to time, it cannot be said that he has a presence on the art market. His main work is still religious wall painting in his home town.

Should we not also take an interest in artists who make no effort to make themselves known on the market and develop no strategy for doing so? Two concepts of the profession of 'curator' meet head on when it comes to considering this problem. Is it a question of looking for and describing visual practices in specific cultural contexts that differ from ours, like André Magnin does,[17] or should we be satisfied with participating in a system of promoting artists by espousing their strategy to ensure them a good place in the audience ratings? Those favouring the latter concept, which could be described as fundamentalist, justify themselves either by trying to play up the winning artists, or by defending their ideas with those who see beyond commercial success. What they both deny, in any case, by what is not said or by the refusal to ask themselves the relevant questions, is the capacity of a 'rural' African painter to work out an artistic thought.

Two arguments militate against this reductive view. Anthropology has amply demonstrated the complexity of the systems of thought peculiar to each culture and worked out on the basis of the problems posed by its environment (Levi-Strauss); and the theory of art that postulates the existence of visual thought (Arthur Danto) that works out its own set of problems, parallel to philosophy – of which art could not possibly be a mere illustration.

Do not discursive ideas and exegesis substitute for the physical and visual characteristics of the work of art? When, at the end of the 1960s, artists in the West

explicitly laid claim to the capacity to think through their practice and even make that thought their work, art seemed to be evolving towards a better control of its means and a more effective coherence. The generalised teaching of conceptual art in art schools ended up, inevitably, in an academicism that replaced the creation of intelligible forms with a complexity of poorly assimilated ideas and intentional contortions where a political reference, however stretched, could take the place of absolute dogma. The examples of music and the theatre are there to show that dialogue is possible. Re-orientations in the visual arts will perhaps allow greater openness in the future.

The dogmas of Modernism and the grand, adventurous path they have followed have regularly needed the recall to disorder represented by Dada, primitivism, popular art and Art Brut. No doubt Post-modernism, permeated with Christian values of a quest for authenticity and feelings of guilt towards money, will not avoid the same fate. Today there is a chance to widen the spectrum of contemporary art which in the West still maintains narrow, restrictive limits. To do this we must first revitalise formal and semiological analysis and then hide a little less behind discursive formulas and theories that get in the way of project itself.

Translated from the French
by Judith Hayward

This is an abridged version of the essay published in the German edition of *Africa Remix*

AFRICA BEGINS
IN THE NORTH

DIALOGUE BETWEEN
MARIE-LAURE BERNADAC AND
ABDELWAHAB MEDDEB

MARIE-LAURE BERNADAC (MLB): *Africa Remix includes – for the first time I think – the North African countries, Egypt, Tunisia, Algeria and Morocco, within the term African art or contemporary Africa. What is your position on this geographical linkage of North and sub-Saharan Africa?*

ABDELWAHAB MEDDEB (AM): From the outset Africa was a geographical designation. The word came into being in the Mediterranean. In the Roman period the name 'Africa' referred to the region comprising present-day Tunisia and part of eastern Algeria. The name survived with Islam until the fifteenth century. It passed from Latin into Arabic in the form *Ifriqiya*. A beautiful allegory of Africa, represented by a Numidian girl, forms the subject of a Roman mosaic discovered 20 years ago.

MLB: *So Africa began with the North?*

AM: The name comes from the North. And later this name came to refer to the whole continent. It also has the dignity of a concept containing the issue of the relationship between history and anthropology. Some North African countries participated in the history of the great states and empires (of Egypt, Carthage, Greece, Rome, Byzantium and the Omayyads, Abbasids, Fatimids and Ottomans). But we also know, from the sculptures of twelfth-century Nigeria and the descriptions of Mali by the Arab geographer El-Idrisi of Sicily (twelfth century), that some regions of sub-Saharan Africa had experience of states. I think it was right to bring the two together in the same exhibition, despite their undeniable differences. North Africa's history is linked to that of states, and southern Africa to that of the vernacular societies. But this categorisation must be qualified. Because the latter was not untouched by the tradition of the state, which produced archives and documentation that now fuel the historians' investigations. And North Africa is not without its vernacular signs and actions that draw the attention of ethnologists.

MLB: *So there are structural differences…*

AM: The components are the same; the difference lies in the way they are organised into a hierarchy and used: the space of the state and that of the tribe or ethnic group are articulated differently in the fields of history and anthropology. From the time of Ancient Egypt, followed by Carthage, North Africa was a part of Mediterranean antiquity. At the same time it never lost its vernacular dimension, it is a space that draws the attention of the ethnologists as well as the historians and archaeologists. And this duality of history and ethnology persisted after Islamisation. Von Grunebaum, the American Orientalist of Austrian origin, stresses this duality, seeing it as a characteristic of Islam apparent in countries such as Egypt and Morocco. Islam gave expression to a unified culture in which the clerics and the literate classes shared the same categories of thought in the same language. For centuries Arabic was the vehicle of an erudite culture whose works were in circulation from Delhi to Cordoba. Alongside this

unified culture, each country had its own popular culture, maintaining a link with what had been there before Islam. It is the tension between unity and diversity which underlies the civilising principle. The stratum of popular culture survived until the twentieth century; it is particularly apparent in the cult of saints. The followers of popular Sufism are maintaining a form of paganism; they have taken over the resistant elements of the animist cults and incorporated these vestiges into their monotheistic belief. This phenomenon of adopting the traces of earlier beliefs is not the preserve of Islam; it can also be seen in Christianity. Similar operations were performed on the northern shores of the Mediterranean, in Greece, Sicily and Spain; to get an idea of this we need only think of what happens in Andalucia, and particularly in Seville during the gatherings of Holy Week, the Feria and the pilgrimage to El Rocio. The same phenomenon can be observed beyond the Mediterranean – in Mexico for example. In the 1932 film *Que Viva Mexico!* Eisenstein uses the simple eloquence of his images and contrasting montage to show how the traces of Indian culture continue to work within Catholicism. It is just that Africa offers two highly contrasting illustrations of the workings of the vernacular within universal cultures. The concept of Africa is crystallised in this manifest tension between history and anthropology.

MLB: *Is it symptomatic that these two histories are being brought together today, that the historical perspective is changing? That North Africa no longer looks solely towards the Mediterranean basin, but is turning towards a different past?*

AM: Personally, what fascinates me most in North African culture is the trace of shamanism that makes the connection with the sub-Saharan countries. As a child of the Maghreb, I had a very strong sense of a condensation of historical change in the process of Westernisation: the community into which I was born moved from the Middle Ages into the post-modern era in two decades. Returning to the Maghreb after my move to Europe, and marked by the culture of my generation having read Nietzsche, Heidegger, Freud, Artaud, Bataille, Lacan, Derrida, Foucault, Dumézil, Lévi-Strauss and Jakobson, I realised that in my country modernisation was taking place at the price of anthropological death. In Tunisia in the late 1950s we witnessed the emergence of a modernist secular nation state marked by the reductive spirit of the French Third Republic. This state assimilated the existence of the vernacular to a clear sign of historical backwardness, of which it had to rid itself. With my Europeanised awareness, I knew how valuable it was for the world to retain what Segalen calls the diverse. I could see the importance of maintaining a plurality of times in a world destined for modernisation. It was Pasolini who spoke of *anthropological death.* I remember some of his writings in which he talks about the disappearance from Europe of festivities, of the carnival spirit, like the festivals shown in Flemish painting. In order to restore the link with the element of expenditure, of excess, of festivity, he decided to adapt the earthy freedom of popular culture to the screen, drawing on the *Thousand and One Nights,* the *Decameron,* and the *Canterbury Tales.* I'm also thinking of Antonin Artaud's writings on Mexico (1932), in which he draws a distinction between instruction and culture; he shows that the educated people of Mexico were uncultured, and that those who preserved a symbolic energy and creative imagination were illiterate people belonging to the vernacular stratum. He predicted that an important Mexican culture might emerge once a connection was forged between the Westernised intellectuals and the peyotl sorcerers. It seemed to me that the categories and judgements contained in these writings were directly applicable to the North African situation. In my most recent book *Face à l'Islam* (Face to Face with Islam, Textuel, 2004), I caught myself re-using terms I had used in one of my very first published pieces, which came out in 1977 in *Les Temps Modernes.* In it I said that North African culture is fenced in by ersatz modern

European art and a loss brought about by anthropological death, which saps the vernacular energy. This diagnosis is perfectly illustrated by the case of painting. Many artists in Tunisia, Egypt, Algeria and Morocco found it difficult to avoid ersatz after the popular signs were taken over by Paul Klee. Local painters were unable to escape the domination of European art, even when drawing on national vernacular sources. Theirs is a submissive art, a by-product of Western painting, supported by ministers of culture. In countries like Morocco, where the vernacular energy had been sapped to a lesser extent, I could see that more art was circulating in the street than among the artists subjugated by European ersatz. I saw more visual worth in the innovative objects manufactured in the craft workshops open to the streets and squares in Marrakech, such as buckets made from truck tyres or the drainpipes made from the ductile metal of tin cans. Images and signs slip away, they elude the artist, so then they migrate, moving from the artist's studio to the craft workshop, where the artisan adapts his forms to recycled materials. The artists had to be made to realise that art was moving to a different place. North African artists had to be unbound by being told that all they need do was open their eyes, that they could use all these artefacts as the basis of their inventions, that everything belonged to them, whether it be deposited in a museum or circulating freely in the bazaars. I remember visiting the Bardo museum in Tunis. The Roman mosaics found on Tunisian soil – on African soil – can also be part of the painter's genealogy. There are mosaics at the Akouda monuments near Sousse whose technique leads us to the Quattrocento. They contain very fine heads that resemble those of Piero della Francesca, in that they acquire their beauty by verging on monstrosity but never settling into it. Thick lips whose lovely deformity comes close to a hare lip, domed foreheads, slanting eyes, flat noses – they play with Mongolian attributes while keeping a distance from them. I thought that everything on the North African soil could contribute to developing painters and free them from their fate as fakes, including the inventiveness of the artisan who reappropriates industrial rubbish and the archaeological remains of the Roman tradition, which can acclimatise them to the Renaissance…

MLB: *This position also often depends on the political and ideological context. It's no coincidence that it was the poets – Artaud, Pasolini and you yourself – who looked at the cultures of the past in a different way and brought them back to life. The situation is different again today. You have given a rapid account of the Bourguiba years and the desire for modernisation. Could you give a brief summary of the main stages of political and cultural development from the 1960s to the present day, to the emergence of the contemporary globalised world?*

AM: I should like first to refer to an analogical situation, in which we find Octavio Paz thinking about the relationship between Mexico and the United States: this North-South relationship with a common border sheds light on the relationship between North Africa and Europe. Octavio Paz called on his compatriots to leave behind the Third-Worldist vision that the South projects onto the North. He called on the artists and poets of the South to stop thinking of themselves as excluded from the shared space offered to them by the democratic cosmopolitanism that governs the northern lands; he believed there was room for them on the international stage of the mind. A similar kind of phenomenon has occurred in the link between the two sides of the Mediterranean. North Africans moving to Europe have been able to test their skills and produce an effect among those who have not left their native land. This development has changed the landscape of artistic creation. The fact that you have organised *Africa Remix* is proof of this. People have moved around, have opened their eyes and have perhaps jumped over the stage of modernism, of the classics of modernism, to emerge fully active

in the post-pictorial phase. It remains true that with the new generation the official art I mentioned before, caught between ersatz and loss, completely loses any kind of credit.

> **MLB:** *Perhaps it was obligatory, necessary to pass through that stage.*

AM: Who is to blame for its futility? I don't think that the schools of fine art have contributed to the flowering of creativity. Today artists say what they feel through installations, video and photography. All the same I regret the eclipse of painting. Who knows what painting the Maghreb might have obtained had it given birth to painters who knew how to draw on Sufism? Sufism contains a great many fascinating observations on the question of the visible and the invisible, which can be converted into pictorial, aesthetic, visual problems. This could have opened up new directions providing fertile responses to the European innovations of the early twentieth century.

> **MLB:** *Didn't you once say that for you Matisse was the most Sufi of painters?*

AM: I wasn't thinking of him in this context. I was thinking more of Malevich in his relationship to the theory of icons. Or Kandinsky in the way he linked abstract art and orthodox spirituality. Or closer to us and in the cinema, Tarkovsky and the way his meditation on the Christian Fathers affected his work. I would also say that Matisse had assimilated the beatific state attained by the Sufis. To be persuaded of this we need only think of his *Café Marocain,* in which figures lying on mats float as though in a state of levitation, hanging, defying the constraints of the body and the law of gravity, breaking down the division between inside and outside, no longer subject to their singularity.

> **MLB:** *What role is there for photography in the North African countries?*

AM: Like everywhere else, it could be enormous. A great deal of documentation has been accumulated on the Maghreb. The possibilities for its exploitation in art are infinite. There is an interplay between the documentary image and its relation to the present situation. Work on the printed image, through collage and montage, reveals the transformation of places and people. I should also like to remind North Africans of Emir Abdelkader's extraordinary writing on photography. It dates from the 1860s, when he was in exile in Damascus. Discussing the Sufi concept of *tajalli* (epiphany), the Emir says that it is better expressed by photography ('this art of our times') than by the traditional metaphor of the mirror. He takes his new metaphor in two directions: first, in the operation of taking a photograph he sees an analogy with mystical vision. In both cases there is a need for light and the process of revelation arises out of a manipulation that necessitates a passage through darkness. The Emir then proposes a fiction that sheds light on the phenomenon of the visibility of the invisible God, whom he compares to a king living in a forbidden city, whose protocol demands that he should not visibly appear to his subjects. But because he wishes to make himself known, he decides to distribute his photographic portrait; in this way his subjects are able to identify and recognise him without ever having seen him in the flesh. This text (which I have referred to here only very schematically) expands the scope of the imagination and invites us to make a richer use of photography in art.

> **MLB:** *Do you see any differences between Morocco, Algeria and Tunisia resulting from the policies they have followed? Can distinctions be made between them?*

AM: As a Tunisian, I was fascinated by the richness of popular culture in Morocco. The persistence of shamanism is much more apparent there, the ancient elements are better preserved. The survival of the ancient in Morroco has consoled me from the losses caused by the anthropological death that has taken so many vernacular treasures in my own country. When I went to Morocco for the first time in the late 1960s, I was fascinated and panic-stricken to equal degrees: 'savage thought' was alive

and well there and I experienced it as disturbing, 'uncanny'. In Morocco I encountered the Dionysian: festivities, the theatricality of excess, of expenditure, of the accursed share; I saw the things that Nietzsche, Mauss and Bataille speak of unfolding before my eyes. I attended moussems, mystical carnivals, pilgrimages, the celebrations of saints. I felt as though I were exploring mines designed to provide the raw materials for Artaud's theatre of cruelty. In Morocco I had the same shock that Delacroix experienced in 1832, when he wrote in his Journal: 'I thought I had gone to the East, I discover Antiquity, the least beggar is a Cato or a Caesar…'

MLB: *How do you explain the fact that Morocco has preserved its traditions more than the other countries? Is it the monarchical system?*

AM: The traditional state, which so fascinated Lyautey, has undeniably played a part. Lyautey, first Resident of the Protectorate, wanted to save this ancient element while adapting it to modern administration. In a way post-colonial Morocco has reflected Lyautey's wishes; it has lost less at the vernacular level, although it was unable to avoid the dangers of Western ersatz. Besides, Tunisia is more Mediterranean and Morocco more African; this aspect underlies the greater natural beauty of its forms.

MLB: *We have talked about Morocco and Tunisia, what about Algeria?*

AM: Algeria is more deeply marked by the trauma of colonialism and the loss was more destructive there. This is the trauma caused by what I have called genealogical interruption, which leads to a less considered and more radical fantasy of regaining identity. There is a deeper narcissistic wound.

MLB: *On which the artists are working today…*

AM: The main thing is not to get the wrong subject, not to concentrate on the appearances of identity. Whether in painting, music or architecture, there are exceptional resources on which to draw in regaining selfhood. But it is crucial to recover the spirit of these remains, rather than the apparent forms they display. The thing is not to reproduce the old but to translate it. To my knowledge Le Corbusier has best translated the spirit of the Moroccan madrasas, not some *arabisance* imitator.

MLB: *Let me return to our two entities, North and sub-Saharan Africa, to put it simply. Do racial problems play a part in the relationship between the two?*

AM: I think that North Africa is racist. It too has provided historical illustrations of the ordeal of black people, which forms the second segment of Africa as a concept. The ordeal of black people implies slavery, which had a two-fold existence on the continent's Mediterranean shores. It was exploited for itself and in an intermediary way, in the sending of black people to other shores.

MLB: *I come now to the other link between the two entities, that of the religion of Islam. Is this link not sufficient to create a community?*

AM: This community, revived by fundamentalist preaching, is a fantasy. What is called for in the name of the *umma,* is uniformity which, in the name of orthopraxy, leads to the anthropological death of all the vernacular Islams which deviate from and are unfaithful to scriptural prescription. Ultimately the secular modernist reformers, rationalist Muslim reformers and fundamentalists all collaborate in this anthropological death. The rigorism of the latter denies validity to the very principle of making visual art. Such is the solidarity that brings together a complete range of variations, from the lawyer who is master of positive law to the terrorist who uses violence to impose the rule of divine law. But southern Africa is naturally resistant. An aesthetic energy animates every fibre of its people's bodies. It is this that has struck me on my forays there. Bodies there have a radiant physicality; it is through the aesthetic bearing of the body that individual sovereignty is acquired. The beauty of the bodies in this part of the continent is irrefutable. The physical qualities of the body inform both dance and sculp-

ture, two arts that have given so much to the revolutions in Western representation in the twentieth century.

MLB: *African sculpture is often criticised for associating itself with modern Western art, although it has made an extremely positive contribution to the history of art.*

AM: The arts are a contribution in themselves, independent of the influence they may have exerted. If we were to rewrite Hegel's *Aesthetics*, stripping it of its ethnocentrism and blind spots, Africa would naturally become the place of sculptural form and choreography.

MLB: *As the artists saw…*

AM: To this we can add music. To me the effectiveness of sculpture arises from the relationship between music and the body. I am also thinking of sculptures that express the extreme, that remind us that we are dealing with living beings seized by the death that lies within them. The late self-portraits of Artaud would find their equivalents in the reserves of the 'dark continent'.

MLB: *That is clear in the drawings of Totems, moreover… Lastly, according to what you say, the Maghreb's orientation towards its Africanness and the new exchanges in the globalised world are quite positive…*

AM: The visual artists of North Africa must be nomadic; they must travel in the sub-Saharan countries in order to become acclimatised to the natural physical qualities of the people and forget their Mediterranean haughtiness (to borrow Marcel Griaule's phrase). But penetrating the continent in this way does not oblige them to turn away from the history emanating from their own lands; they need to take seriously the fact that they belong to a place enriched by sub-Saharan Africa, while recognising their participation in Mediterranean Antiquity. Moreover such local considerations should not prevent them from crossing the Northern shore in order to refine their place in a world which belongs to those who dare.

MLB: *Do you regard globalisation as having a positive effect on art and culture?*

AM: It is thanks to globalisation that for the first time we have a generation of artists who are working internationally.

MLB: *Let me come back to Islam. On the destruction of the Bamiyan statues in Afghanistan in February 2001, we might ask ourselves whether, without attaining the same symbolic value, the living culture in North Africa could act as a rampart or effective force to counter fundamentalism. How can culture combat fundamentalism?*

AM: Fundamentalism is a revelation for us all, it is a symptom affecting West and the East alike. Fundamentalism is a form of barbarism. It generalises anthropological death to a degree that precipitates the end of culture. How did the religion of Islam create a civilisation? Throughout its history cultural realities have overflowed and absorbed the letter of prescription. This explains why the Buddhas of Bamiyan stayed in place for 1,400 years. Their destruction reflects a maniacal application of the letter of the iconoclastic law. Today the fundamentalists want to impose the reign of the letter, whose application can only lead to the desertification of the world. Fundamentalism is a form of nihilism, and no one is safe from such a threat. The European experience of the twentieth century reminds us of this. Clearly the creation of art restores cultural reality, and it is this that disturbs the fundamentalist project.

MLB: *So it is an important fight to pursue…*

AM: An essential fight…

MLB: *Let me come back to the current situation for the artists of the Maghreb to the extent that they are all French…*

AM: Why is it working now? Because of what is happening in the world today, a shared space is being created; we are in the heart of the post-colonial phase, which was foreseen by some clairvoyants. I'm thinking of the presaging aspect of the *Magiciens de la terre* exhibition. As time goes by we are increasingly

aware of its pertinence. We need to create a space for things to circulate, in which all who have the desire and capacity to tell their story are welcome. This is the modern nomadism, dissemination and displacement, and the end of a one-dimensional, self-referential world. The best way to fight against fundamentalism is to give credibility to the multi-dimensional world of the free-for-all, shaped by concurrent axiologies. Movement is created by what I call the aesthetics of passing through and betweenness. These French North Africans are the children of the new nomadism and post-colonial relocation.

 MLB: *Is that cross-fertilisation what is now called* métissage?

 AM: I don't like that word. Everything that migrant people do is echoed in the culture. It is a bit like the phenomenon of translation. In translating the ancient Sufi texts (ninth century), I have noticed that their passage into modern French revives a meaning that was latent in the original text and now becomes manifest. Translation adapts a meaning to a different time and a different way of imagining and in so doing reveals potentialities in the text that escape the horizons of the language and culture in which it was written. In a text from the theocentric period, modern translation can reveal the premises of disenchantment which were hidden in its folds.

 MLB: *I should like to return to the question of the relationship to the past, to tradition. People often speak of the uniformity which is the end-point of globalisation. The relationship with the past is often an argument advanced by fundamentalist ideology. How can we escape this paradox?*

 AM: To what culture of the past are the fundamentalists looking? We need only think of the current state of the past in Saudi Arabia, which has been involved in spreading fundamentalism. The past in that country is a cemetery, which receives the corpses of anthropological death. Look at what Mecca has become: a gigantic Disneyland. The

destruction of the old and increasing uniformity are a threat in any process of modernisation. Flaubert commented on this. Goethe also foresaw such a danger. That is why he expressed a concern to preserve the past while advocating poetic renewal and expansion beyond the national canon by extending his referential horizons in the name of *Weltliteratur*. It is better to set out on the adventure of form and fulfil the duty to invent, while retaining a concern for the past, than to act like the fundamentalists, who unconsciously submit to the most alienating effects of their period in the belief that they are contemporary with their prophetic utopia. It is through this alternative that traces of the past are etched, like memories that make their mark and continue to dwell within you.

Translated from the French
by Trista Selous

MADE
IN AFRICA

JOHN PICTON

1.
Atta Kwami, 'Ghanaian Art in a Time of Change', in Christiane Falgayrettes-Leveau and Christiane Owusu-Sarpong (eds.), *Ghana Yesterday and Today,* exhibition catalogue, Musée Drapper, Paris, 2003, p. 319.

2.
James Meek, 'World's first artwork found in Africa', in *The Guardian,* London, 11 January 2002.

3.
Tom Phillips (ed.), *Africa, the art of a continent,* exhibition catalogue, Royal Academy of Arts, London, 1995, pp. 11 and 187.

4.
Peter Garlake, *Early Art and Architecture of Africa,* Oxford, Oxford University Press, 2002; John Mack, *Emil Torday and the Art of the Congo,* London, British Museum, 1990; Tom Phillips (ed.), ibid.

5.
Anthology of African and Indian Ocean Photography, special edition of *Revue Noire,* Paris, 1999 (French and Portuguese editions, 1998).

6.
Elsbeth Court, 'Notes', in *Seven Stories about Modern Art in Africa,* Clémentine Delisse *et al,* exhibition catalogue, Whitechapel Art Gallery, London, 1995, pp. 291–308.

The past is still evident in all kinds of contemporary visual practice, driving a society forward and defining its sense of what it is. It is developed, invented, or re-presented through exhibitions, revues, festivals and so forth. Locating the history of this art in new contexts guarantees its future. [1]

'The world's first artwork found in Africa': a headline in *The Guardian* in January 2002 announced the discovery of red ochre crayons, some marked with engraved patterns, in a South African cave in deposits dated to 77,000 years ago. [2] Did the 'art' reside in those marks merely, or in the possibilities for using crayons in making marks on things, thereby transforming them? It matters little: people still make marks on things, and on themselves. There are many forms of art-making, and women and men in Africa have been doing all of them for a very long time.

The earliest clear evidences of pictorial activity are the fragments of painted rock found in Namibia in deposits a mere 26,000 years of age; [3] but all this is just the work of *Homo sapiens.* The record of making goes back more than two million years if we include the stone tools of *Homo habilis* in Ethiopia. Making art began in Africa as the indispensable prerequisite for our thinking and talking; and yet, whatever we make of this very grand antiquity, most of the art in Africa that we actually study dates from the period since about 1850. There are exceptions: Ethiopia, Edo, Bushoong, ancient Ife and other archaeological material; [4] but most of the masks and figure sculptures that we find in ethnographic museums, and which initially established an 'international' interest in African art, were collected in the context of colonial rule and can be dated to the period after its inception.

The mid-nineteenth century is a very approximate turning point marked by the transition from Atlantic (and trans-Saharan and Indian Ocean) slave trading to a relatively brief period of colonial rule, a transition accompanied by resistance to that very same colonial rule. The late-eighteenth-century establishment of the colony of Sierra Leone had initiated the emergence of a west African intellectual elite, soon to be trained at the best universities of Europe; and colonial rule, and resistance thereto, brought about the emergence of modern ethnicities and nation states. These developments also initiated the spread of photography in Africa [5] and the inception of other forms of social and visual practice, [6] as well as widespread conversion to Islam

or Christianity, alongside the persistence and development of local traditions (ritual, material, aesthetic, social, etc) received from the past. The agents of colonial rule, wittingly or unwittingly, fetishised ethnic difference, making of it an instrument of both government and conflict. With greater wisdom and perspicacity these agents might have recognised ethnicity as an evolving and negotiable form of local identity contingent upon the particular circumstances that forced people to review their need for self-definition.

These engagements between 'Africa' and 'Europe' did not suddenly begin in the mid-nineteenth century, of course. Coastal trading relationships with sub-Saharan Africa had been initiated in the fifteenth century, and there had been indirect access to the area via the Sahara, the Nile and the Indian Ocean before that. Mali was the major source of gold in Europe until the 'discovery' of the Americas. Nevertheless, there is little doubt that the period since about 1850 has been one of radical change and development. Local modernities were constituted in the practicalities and particularities of eclectic gatherings together of local and longer-distance elements in the ever-evolving syntheses that characterise given places and times; and within those modernities we cannot overlook the continuities with the past, often manifested in practices unique to Africa, which have provided the frameworks of reference that enable domestication of initially alien forms within local terms.

Once we begin to see Africa in this way, some cherished assumptions turn out to be rather empty, at best misinformed. One is the idea that everything is so different that we can never understand it. From time to time we all want to see ourselves as utterly unique from everyone else; but the simple fact is that there are some things in Africa that are not like things in Europe, and some things that are. The parameters of identity and difference, in art as in other forms of social practice, within and between continents, have something of the shifting colours and shapes of a kaleidescope. This is particularly true of the apparent contrast between sculpture and painting in the histories of world art; for the privileging of sculpture as the African art is no more than an artifact of the practicalities of nineteenth-century collecting taken together with the ignorance and atavistic nostalgia of the art-hungry savages of the Western world. One cannot deny the truly remarkable qualities of that sculpture, but it must be seen (if we are to understand its originary qualities) in a context of practices that also includes dress, fashion, textile design, masquerade, mural painting, built form, installation, public art, chiefly ceremonial, funerary and ancestral commemoration, and so much more. The sculptural art world imposed upon Africa by some European connoisseurs was not Africa's only art world.

Then there was the idea that either African sculpture or the social environment of its making were 'primitive' or 'primal', representing traditions of a 'timeless' authenticity. These were interpretations for which there was neither evidence nor justification beyond the ideologies of European colonialism, interpretations which have been largely rejected as factually and intellectually untenable, and morally disreputable. The history of art in Africa is a history of innovation and development;

7.
See Ikem S. Okoye,
'Tribe and art history',
in *Art Bulletin*,
LXXVII, 4, 1996,
pp. 614–15.

and while there is much that has changed since about 1850, there is much that has either not changed or which has been adapted to current circumstances while retaining its particular qualities and values, that continues to inform current visual practice across all the available art technologies irrespective of whether they were initially introduced from Europe, or were of local inception. The question of where this engagement happens, between past and present, between local practices and things from further away, is art-historically significant. Sometimes it is the work of a charismatic individual, but in the twentieth century, in Africa as elsewhere, this process is more often the collective intellectual work of the tertiary-level art academy. Sometimes the charismatic innovator works within the academy, and sometimes not. It is impossible to give precise rules for the innumerable developmental trajectories that might describe this artist, that technique, this patron, that masked event, this kind of education, that tradition, this beginning, that coming to an end, this revival, and so on. There is no one paradigm that will do as the basis of an explanation for a history of art in Africa at whichever place or period.

Insofar as an 'international' art world has been dominated by Europe and the USA, it seems to have promoted a narrowing of the idea and field of art. There are and always were many kinds of art making in Africa (and there is nothing new about installation, not in Africa);[7] so there are many ways into visual practice, and diverse trajectories within a chosen practice. None of this is necessarily unique to Africa, just as there is no uniquely African idea of art or of the artist; but there are uniquely African versions of it all. Perhaps, then, the most important point to be grasped in the context of *Africa Remix* is that the modernisms of African visual practice did not begin as an imposition from Europe, but rather because African women and men chose to master the new technologies and media, beginning with photography as from the 1850s, and turn them into practices of local relevance within the evolving local modernities of the continent. These modernities do not represent a complete break with the past, sometimes because they initiate documentation of that past, sometimes because that past is celebrated in the new visual media, sometimes because the past provides formal and intellectual resources which inform the new developments, and sometimes because the inheritance of the past simply maintains its relevance providing its own interpretation of those developments. Moreover, African modernities were invariably framed within the resistance movements that had their origins at the very same time as the imposition of colonial rule. Within the conditions and institutions of local modernity, therefore, modernism in visual practice and resistance as political practice have a common history.

AH-FREAK-IYA

CHALLENGING PERCEPTIONS OF AFRICA'S CONTEMPORARY SOUNDS

LUCY DURÁN

Music is arguably the most conspicuous, dynamic and vibrant of all cultural expressions of the African continent. The contribution of Africa to the creation of some of the world's greatest popular musics is well known. Africans introduced melodies, rhythms, musical instruments, aesthetics and a multi-dimensional approach to music-making to the New World, a legacy clearly visible in such genres as jazz, rock-and-roll, blues, son, salsa, samba, calypso and funk. Meanwhile, on the African continent itself, new forms of music have constantly been created and invented in response to new social, economic and political contexts, alongside (and interconnecting with) the continuation of many older musical traditions associated with ritual and life-cycle events.

The creative, provocative and eclectic nature of contemporary African visual arts, as seen in *Africa Remix,* has a clear counterpart in African music. The plastic and the performing arts are rarely placed together side by side. Yet the work of Congolese artists such as Chéri Samba (cat. 112–14, pp. 200–01), with their ironic humour and colourful story-lines that interrogate Congo's history and society, are mirrored perfectly in the powerful rhythms and narratives of Congolese rumba – the most pan-African of all African dance musics. The self-questioning gaze of North African artists such as Zineb Sedira (cat. 116, p. 83), revisiting the colonial history, has its musical counterpart in such styles as *rai* from Algeria and *hawul* from Mauritania, which fuse world dance rhythms with centuries-old local instruments and melodies.

Despite their obvious parallels, contemporary visual arts in Africa have been slower to gain acceptance as a valid art form in the international market than African contemporary music, which has been a major player in the world music scene for the last two decades. Several African artists, such as Youssou N'Dour and Mory Kante, have achieved crossover hits in the European charts, and instruments like the *kora* (harp) and *jembe* (drum) have been used in various musical forms far beyond their original setting, from jazz to modern classical, flamenco and DJ culture. While some parts of Africa have produced relatively little outside the local context, others have developed a powerful music industry both at home and abroad, and keep up with the latest global musical fashions. This has stimulated the growth of new urban

sounds and young emerging talents who re-interpret styles such as hip-hop in their own languages and idioms.

Although a celebration of visual arts, *Africa Remix* ironically derives its title from a trend that has transformed the way in which popular music around the world is produced and consumed. 'Remix' is, in its strictest sense, a musical product that is created in the studio, resulting from multi-track recording technology in use since the 1980s, and is primarily aimed at the dance floor. It involves the manipulation of existing track(s) and/or samples as one element in the production of a sometimes entirely new piece of music. It is an increasingly common – and controversial – way of introducing and communicating musical structures and textures to new audiences: controversial, because of the dislocation and decontextualisation of the sounds by producers who often have no connection with the original 'product' or performing artist. 'Other' sounds are triggering the imagination of producers who are willing to appropriate them in order to provide their audiences with a different, exotic, experiential and musical adventure.

It is through this system of osmosis that many new audiences have been introduced to African artists via the 'remix' medium. But remix can also be seen as one more step in a long-standing approach to the creative process: appropriation, reclaiming, eclecticism, quoting, paraphrasing, borrowing, all of which are intrinsic to popular music in Africa.

Ah-Freak-Iya is a selection of tracks played on the *Africa Remix* jukebox within the exhibition. The name is a light-hearted play on *Ifriqiya* – the Arabic term from which the name for the African continent is derived – an outsider's name given to a continent so often portrayed as 'other'. Hence, Ah and Freak – a word also associated with the 1970s era of American pop music, which was also very influential in Africa, along with Latin styles such as son and salsa, and many other Caribbean and North American genres. The return of these genres to the African continent dates back as early as the nineteenth century; and they were a major impetus in the development of urban African styles, hence the third element in the title, Iya, the Yoruba word for mother, reflecting the view of Africa as the 'motherland'.

The *Ah-Freak-Iya* tracks provide a musical counterpoint to the visual exhibition, representing a cross section of music from around the continent almost all of which has been released in the new millennium. The selection takes its inspiration from *Africa Remix* and therefore is not encyclopaedic. Nor does it in any way duplicate any published compilation of music from the continent.

Most of the tracks are by musicians who were born in Africa and have lived there for a good part of their lives. Some of the tracks are indeed remixes in the strict sense of the word. The working process of some of the most interesting of these remixes is collective, an encounter between musicians living in the West and in Africa. Thus the jukebox takes a look at how African music is doing on the mainstream dance floors alongside other genres of dance music. But the remix is only one of several trends occurring around the continent and reflected in the jukebox selection.

Other trends include a strong 'back to roots' and acoustic movement, a prominent tendency in countries like Mali and Senegal which have strong local music industries. Included in this are some virtuosic musicians who take traditional instruments like the *kora* or *mbira* and create new styles in response to the concert hall. There are also revivals of older popular styles such as the Afro-Cuban sound from the early days of post-independence, and the regrouping of older generation musicians, such as Orchestra Baobab. Others such as Malouma from Mauritania explore the common territory between their own powerful (and little exposed) musical culture and that of rock music. North African music such as Rai and Gnawa provides especially rich ground for collaborations; this is another feature of recent work from Africa. And in the midst of all of this creativity and boundary-pushing, certain forms of ritual music continue to be performed in much the same way that they have for centuries.

The author would like to thank SAI SAI productions for their contribution to the essay.

IDENTITY & HISTORY

IDENTITY & HISTORY

SIMON NJAMI

Identity could be defined in terms of one's sense of being in the world. Indeed, this is the usual approach to it. Yet identity does not just refer to the individual. Identity cards may well give our names, forenames and distinctive features, but they are used less to say who we are than where we come from. This type of identity refers to a sameness, an identification with a whole of which we are one of the elements – a nation. This concept was integral to the construction of modern African nations emerging from the turmoil of the twentieth century. Hence the obvious – today's Africa is the fruit of a history altered by others. It is impossible to separate the construct of Africanness from its historical context, impossible for Africans to have been able to think of themselves in any other way than as a reaction to others – in this case the colonisers.

The construction of an identity that met with the aspirations of the young African nations was a direct consequence of decolonisation and illustrates the challenge which the continent, and the creators within it, had to face. In the early days of the African independences, this identity crisis seemed easy to overcome. Having been deprived of their personalities for so long, the African nations took refuge in pan-African theories of nationalism. This was a time when identity did indeed merge with identification or sameness, when the question was not about asserting oneself individually, but collectively, as part of a single whole driven by the same impulse. Assertion of an African or Arab identity seemed to be the watchword. The idea was to invent original ways of conceiving society, of inventing other policies – economic, social and cultural. A 'third way', of a kind.

This tendency reached its apogee in the art festivals of Dakar (1966), Algiers (1970) and Lagos (1977), the first being a festival of black art, whereas

the others turned into pan-African festivals. But since these glorious pioneering days of an African renaissance, the continent has slipped into much more localised identity quests – or, in the case of artists, individual ones. Once the pan-African model died out, the new generations started looking for new ways to define themselves – not just in relation to the world, but within their own societies too. This search was, in fact, entirely conditioned by history because, as Raymond Aron wrote, the only way of thinking history is subjective, i.e. personal. History only has value if we can directly apply it to our own context: 'History, a combination of spiritual destinies or existences, does not lend itself to impersonal comprehension.'[1]

But while impersonal comprehension may have triumphed in the 1960s and 1970s, the 1980s brought a much more existentialist period, when African artists started to confront a visual language that was heralding the onset of globalisation. The issue was no longer about establishing a definition of post-colonial Africa, it was about defining the role of the African as an individual on the international stage. This complex definition of an Africa on the move was coupled with sometimes contradictory difficulties: firstly, the status of artists in a society that is seeking its equilibrium is marginal; secondly, the end of isolationism forced Africans to stop defining themselves exclusively in relation to their milieu and start doing so within the more global framework of international contemporary creation. They had to define their humanity, determine an aesthetic code and establish a set of references that would make it recognisable. This involved a permanent state of introspection, but also a necessary confrontation with contemporary and pre-colonial history. And as identity and history are linked to memory, Africans had to draw themselves a new destiny, more in tune with what they had become.

An opposition thus appeared between a collective memory that sealed their sense of belonging and laid down roots, and a personal memory

where a jumbled combination of sexuality, politics, feminism, race and origins all confronted each other. Each artist was forced to consider their own particular destiny.

African artists have no choice but to accept the fact that in one way or another they will always be foreigners. They are then left with the freedom to position themselves as ironic observers enjoyably deconstructing the clichés on which world society has been built. They turn themselves into ethnologists. They play with clichés and turn against others the weapons that had been used on them. They become the memorialists of a culture in which they are ensconced but which is not their own. Construction of personal identity is naturally linked to identifying one's milieu; finding one's place in the scale of time and history, and analysis of the relationships one nurtures lead to recognition from the other.

The other option left open to these schizophrenic personalities is to cloud the issue by plunging back into the torments of personal memory – a frequently painful memory which they start to question in a kind of unofficial psychoanalysis. One by one they dissect each element that was a prelude to their existence, bringing that existence, a causality over which they have no influence, into contrast with the essence, i.e. what they know they are. Gathering together the scattered pieces of a fragmented personality, they decide, as though elaborating a puzzle, to assemble the elements of an unconscious whose workings they cannot seem to master. It is this fragility, this quality of being a perpetual multi-faced Janus, that is illustrated by the artists in this section.

Translated from the French
by Gail de Courcy-Ireland

1.
Raymond Aron, *Introduction to the philosophy of history*, Paris, Gallimard, 1962.

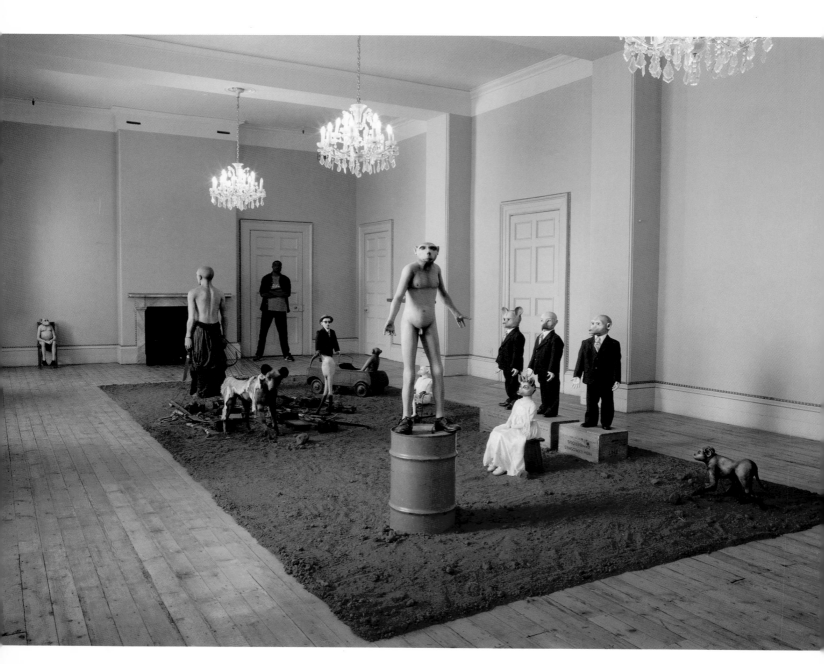

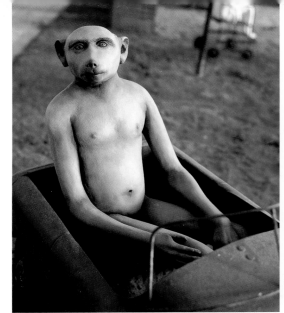
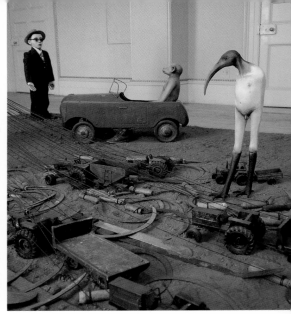
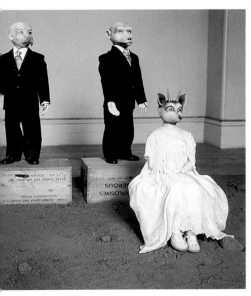
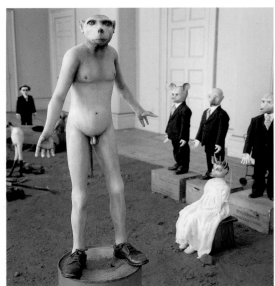
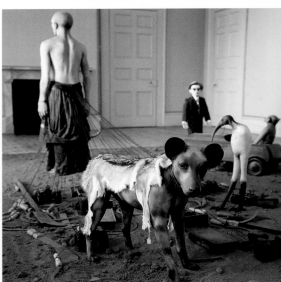
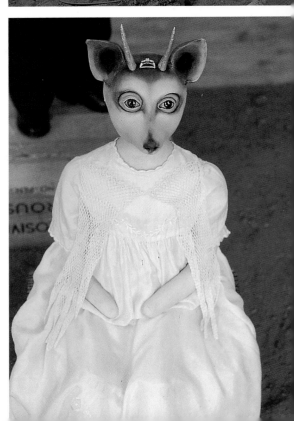

African adventure, 1999–2002 [4]
Mixed media and bushsand

FERNANDO ALVIM

We are all post exotics, 2004 [8]
Canvas, pencil lettering, mirror

Camouflage –
Washington Oyé, 2004 [7]
Acrylic printed on fabric

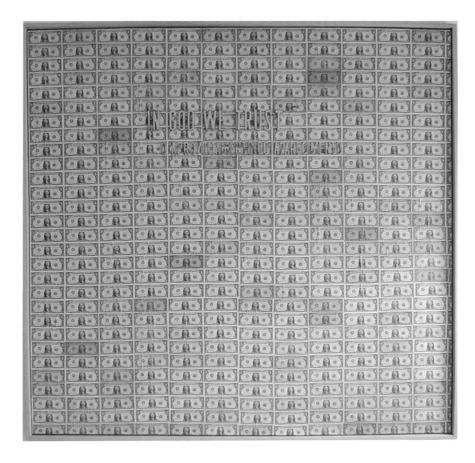

Camouflage –
In God we trust, 2003 [6]
Canvas, collage of US Dollars,
bronze lettering

Belongo, 2003 [5]
Belgian flag with sewn lettering

Shish Kebap, 2004 (stills) [16]
Video installation, mixed media

All images from the series **Hublot**
(Porthole)

Arrêt de bus, Casablanca, 2002
C-print photograph, 100 x 60 cm

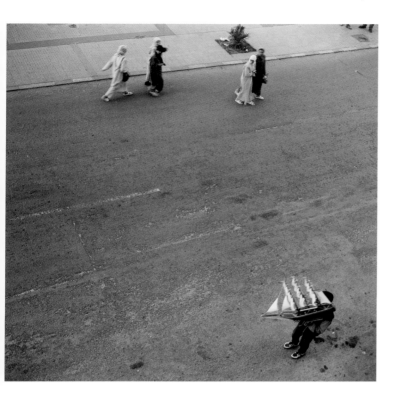

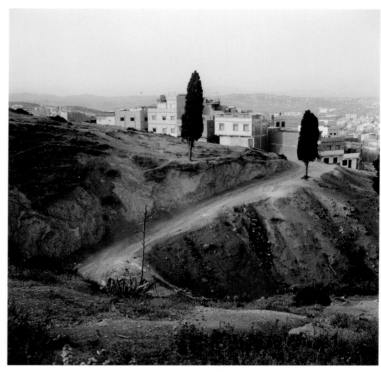

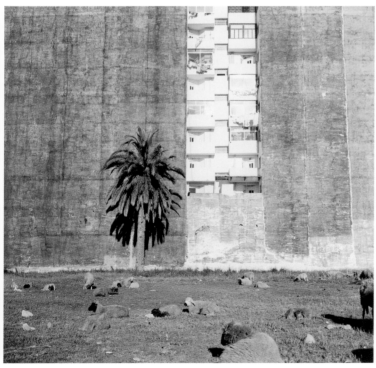

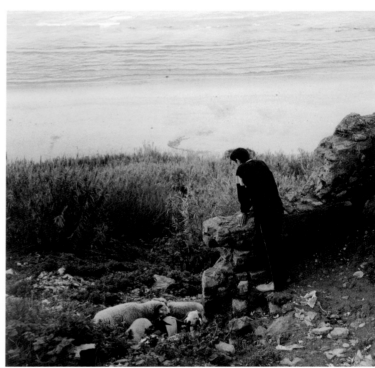

Le détroit (usine 4), Tanger, 2000
C-print photograph, 60 x 60 cm

Terrain vague, Tanger, 1999
C-print photograph, 60 x 60 cm

Colline du Charf, Tanger, 2001
C-print photograph, 105 x 105 cm

Pastorale, Tanger, 2001
C-print photograph, 125 x 125 cm

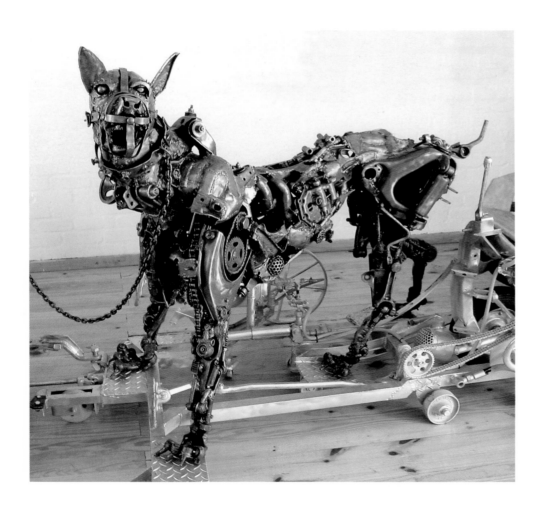

For those left behind, 2003 [22]
Recycled metal

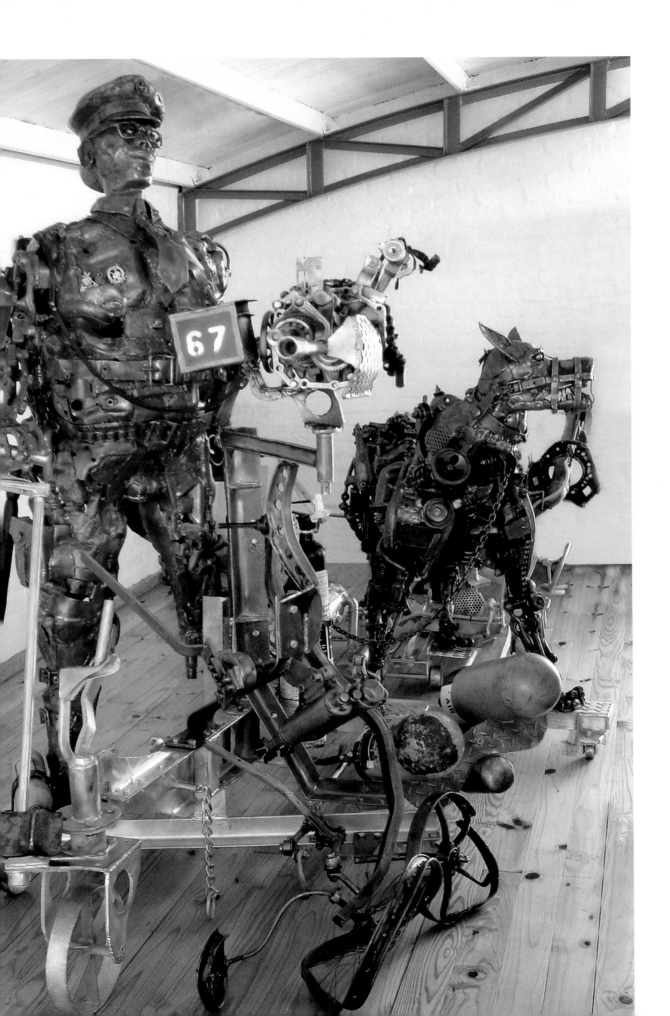

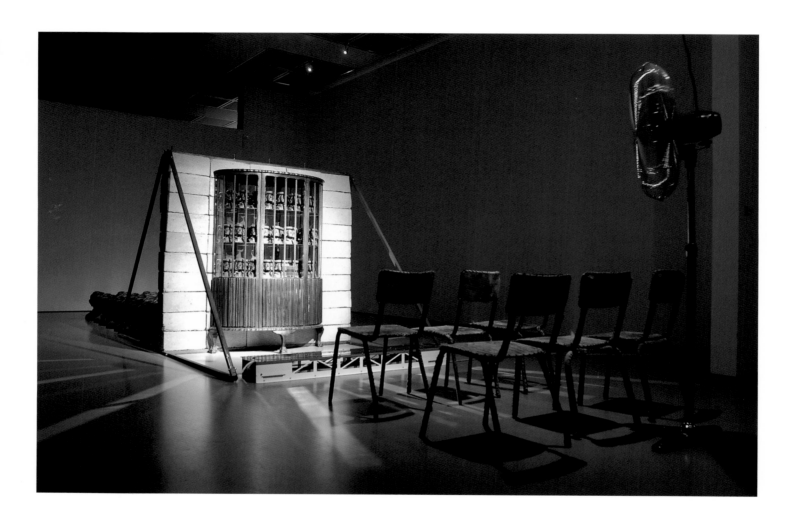

History has an aspect of
oversight in the process
of progressive blindness,
2004 [25]
Mixed media

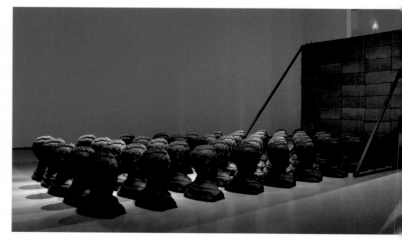

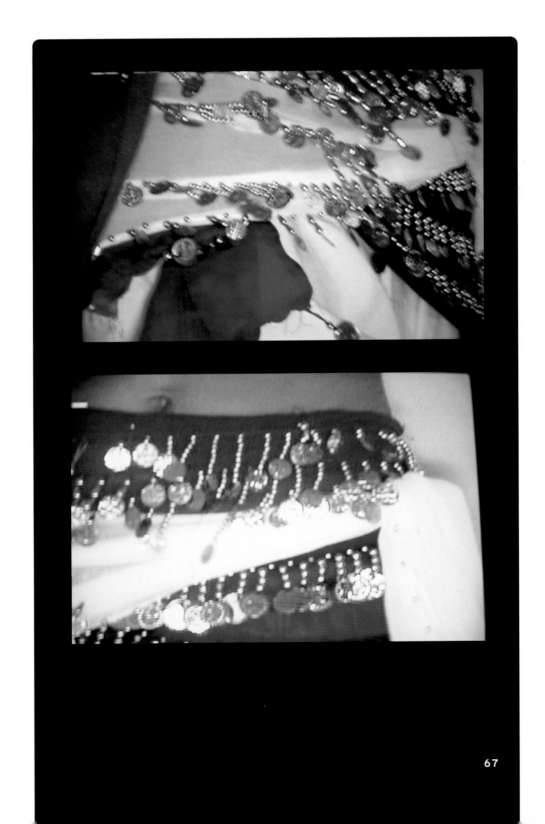

Dansons, 2003 (stills) [27]
DVD

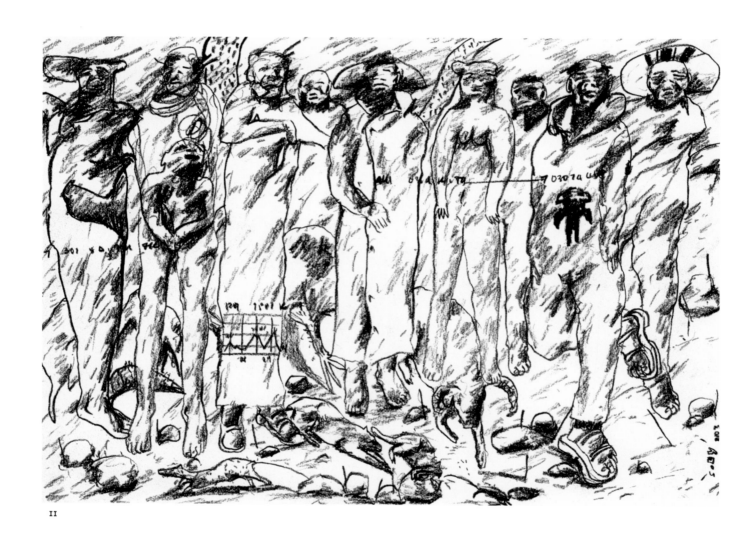

II

Sheets II, VII and VIII from
the series **Monde perdu I – XVI,** 2003 [37]
Charcoal on paper

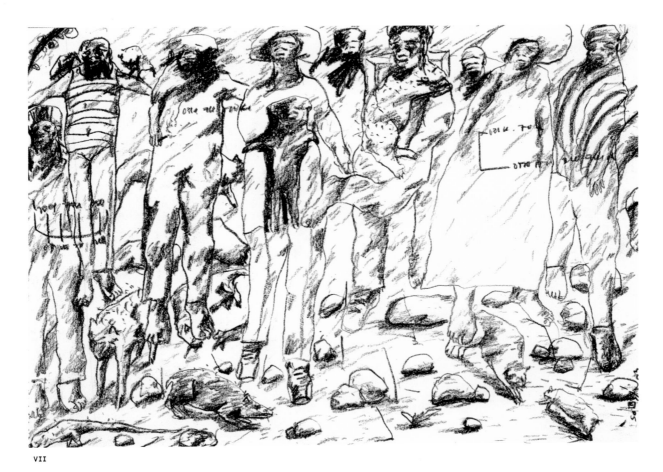

VII

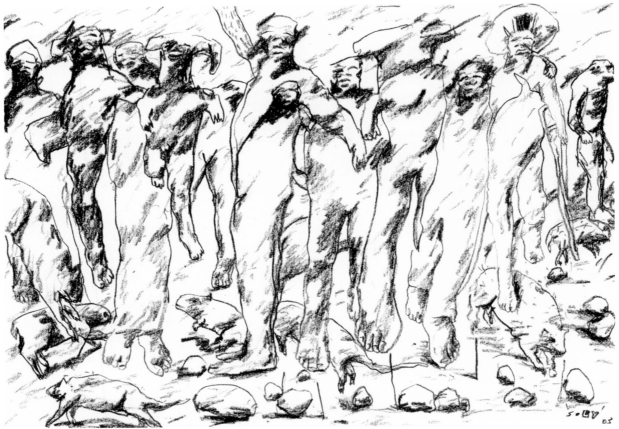

VIII

69

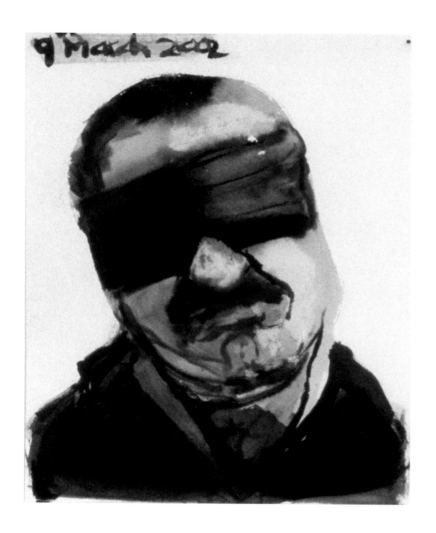

Blindfolded, 2001 [42]
India ink and washed ink
drawings on paper

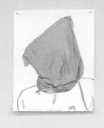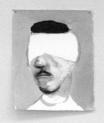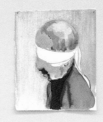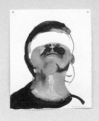
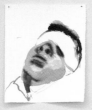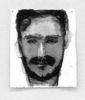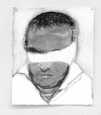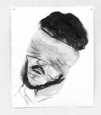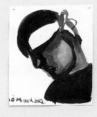
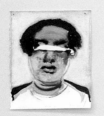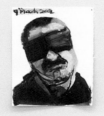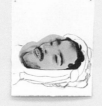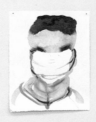
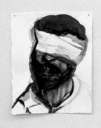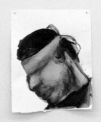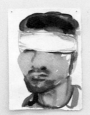

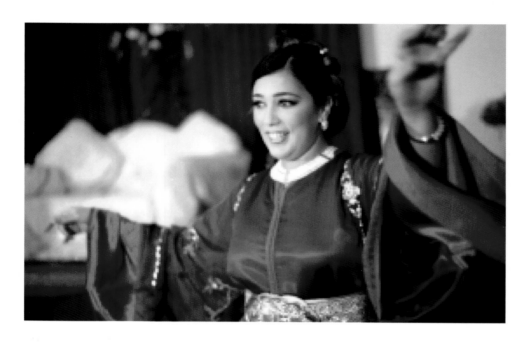

Un ange passe, 2003 [43]
C-print photographs on aluminium

MESCHAC GABA

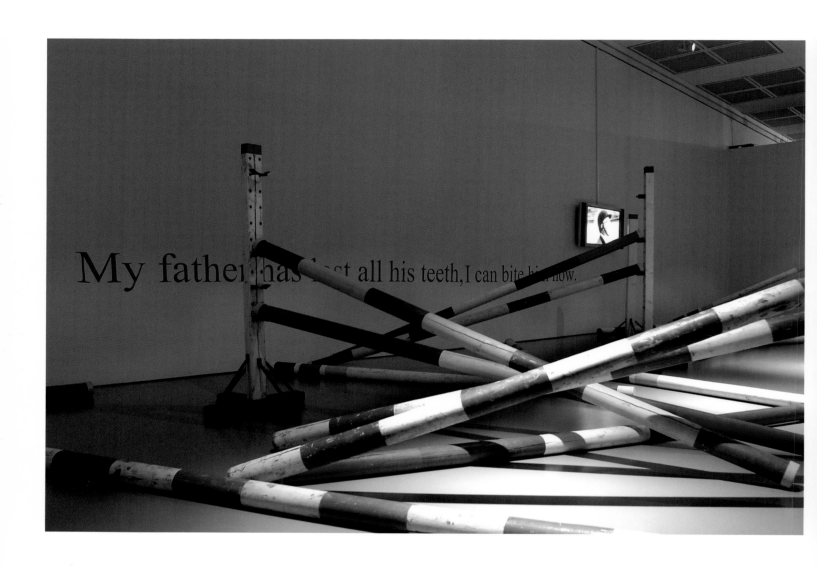

Obstacles, 2003 [44]
Mixed media

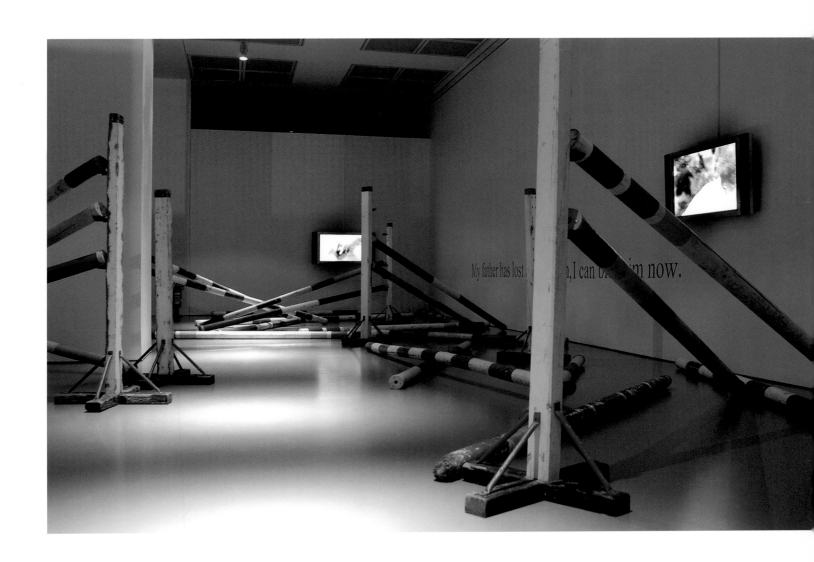

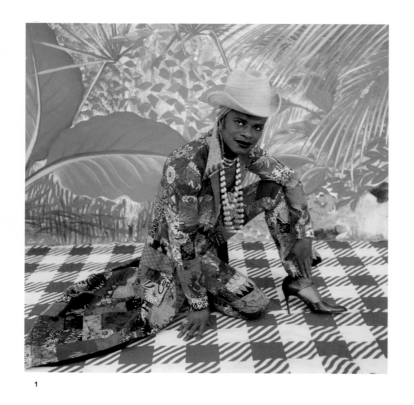

1

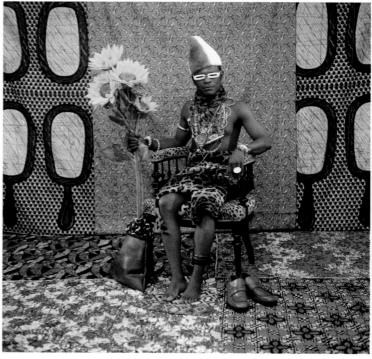

2

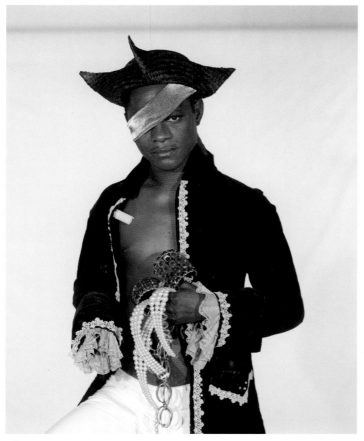

3

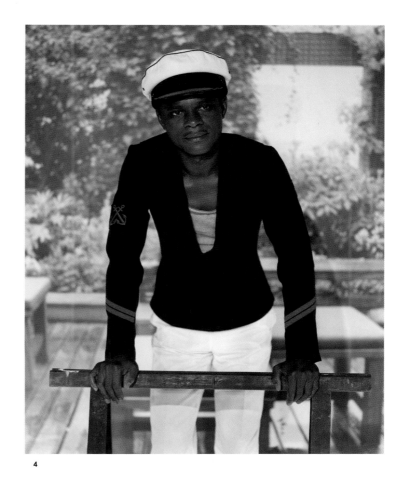

4

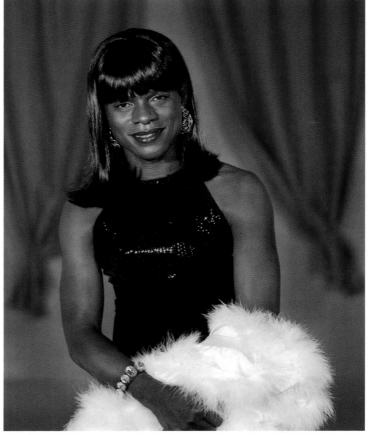

From the series
Série Tati, autoportrait I – V, 1997 [46]
C-print photographs

1 La femme américaine libérée
 des années 70
2 Le chef: celui qui a vendu
 l'Afrique aux colons
3 Le pirate
4 Le marin
5 La bourgeoise

5

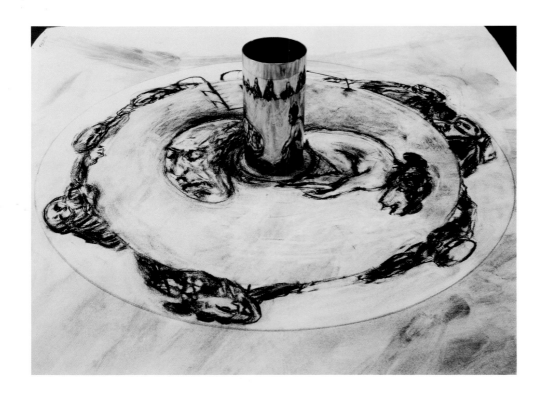

Untitled (anamorphic drawing), 2001 [57]
Charcoal on paper, mounted on table,
metal cylinder

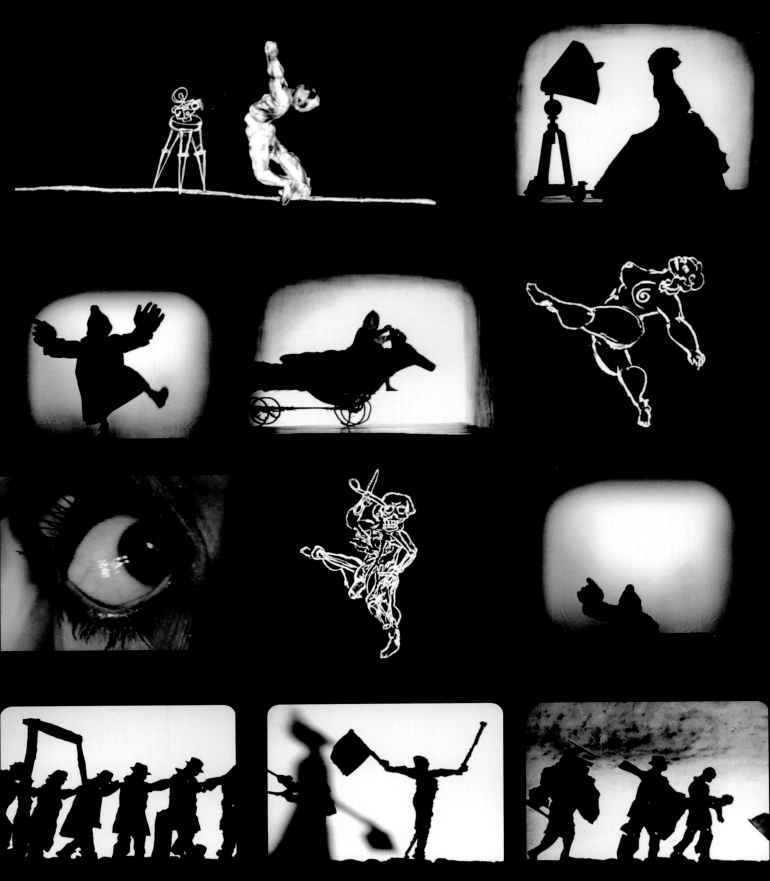

Ubu Tells the Truth, 1997 (stills) [56]
Animated film on DVD

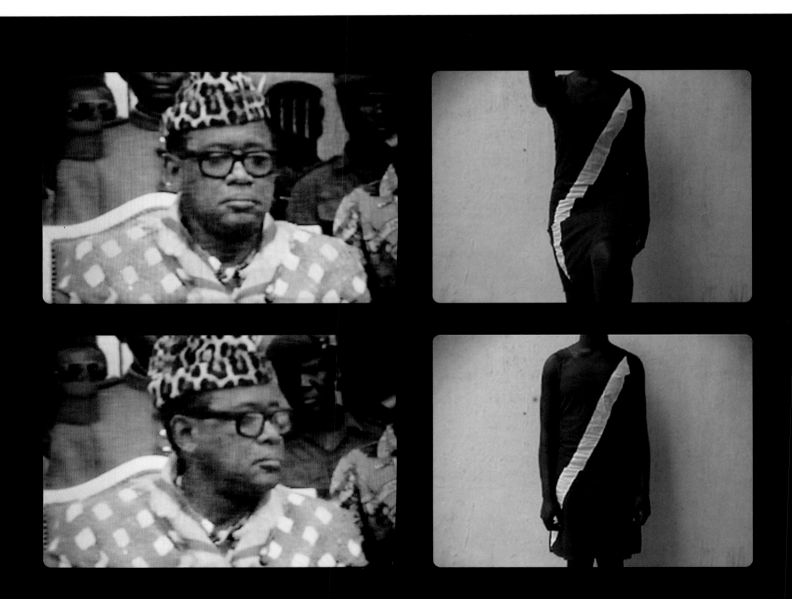

Oyé Oyé, 2002 (stills) [76]
2 DVDs, continuous loop

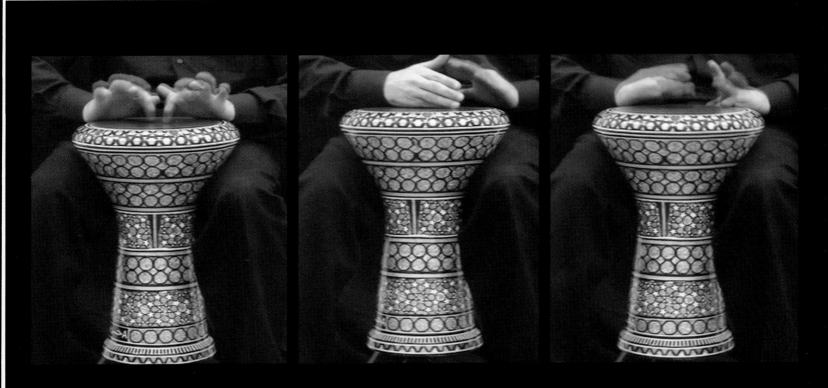

Tabla, 2003 (stills) [95]
DVD projection, c.100 tablas
(various sizes)

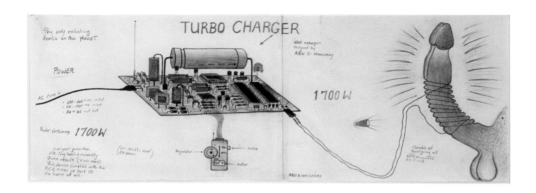

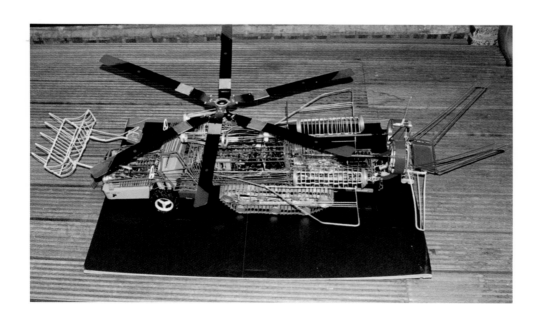

Turbo Charger, 2003 [82]
Pen, pencil, crayon

Masterpiece, 2000 [77]
Steel wires, cables, copper wires,
batteries, aluminium plates

They were wearing white aprons, like butchers' aprons, covered with blood.

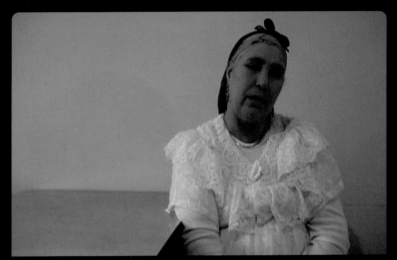

They got him wet, then hooked him up to the electricity. They made him drink soap so he'd confess.

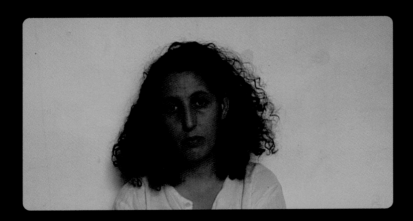

Mother, Father and I, 2003 (stills) [116]
3 DVD video projections (1 without sound)

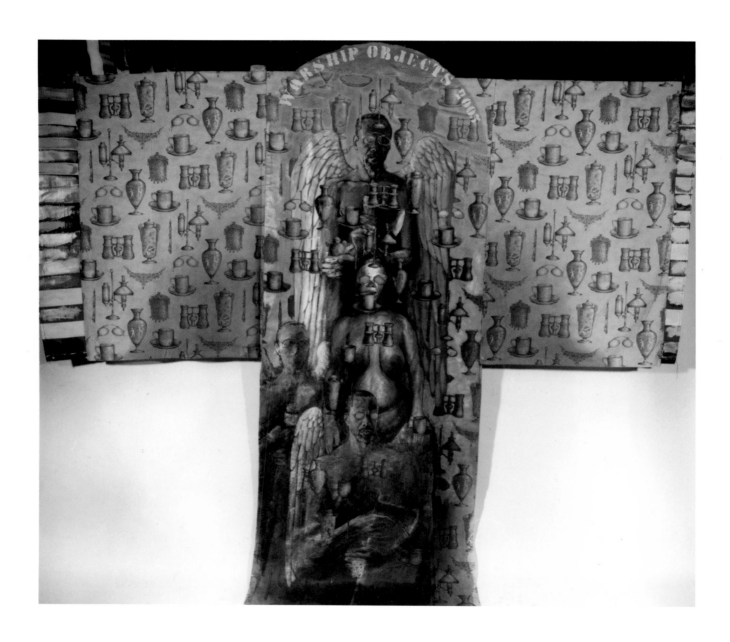

Worship objects, 2003 [89]
Ink on textile

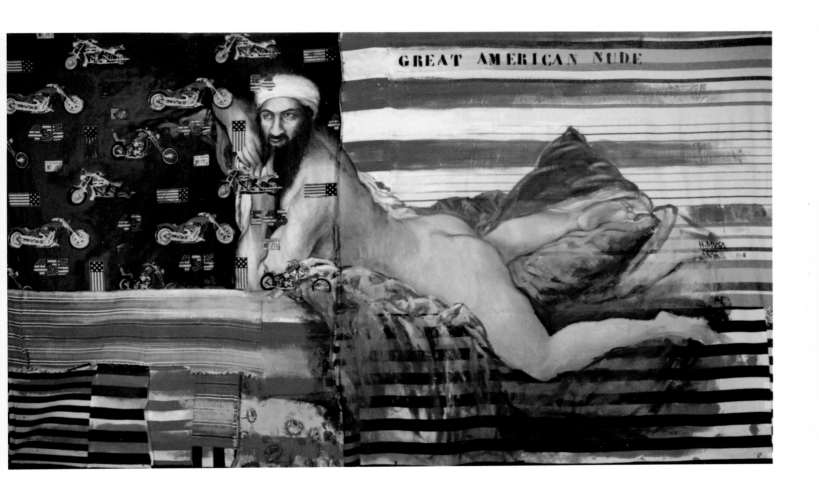

Great American Nude, 2002 [88]
Ink on textile

Down by the river, 2001 (still and installation shot) [93]
DVD installation, soil, metal cylinder, spotlight

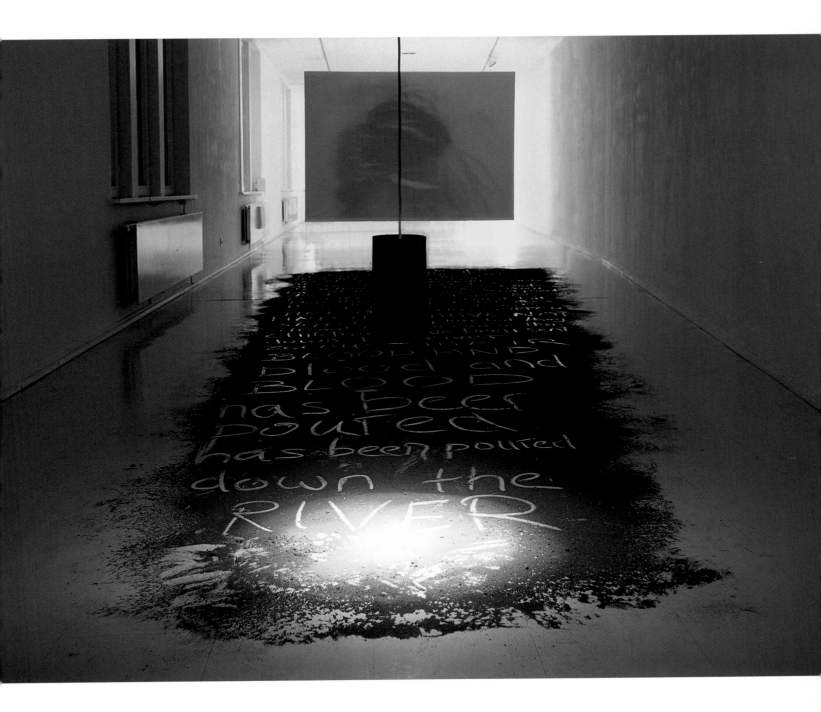

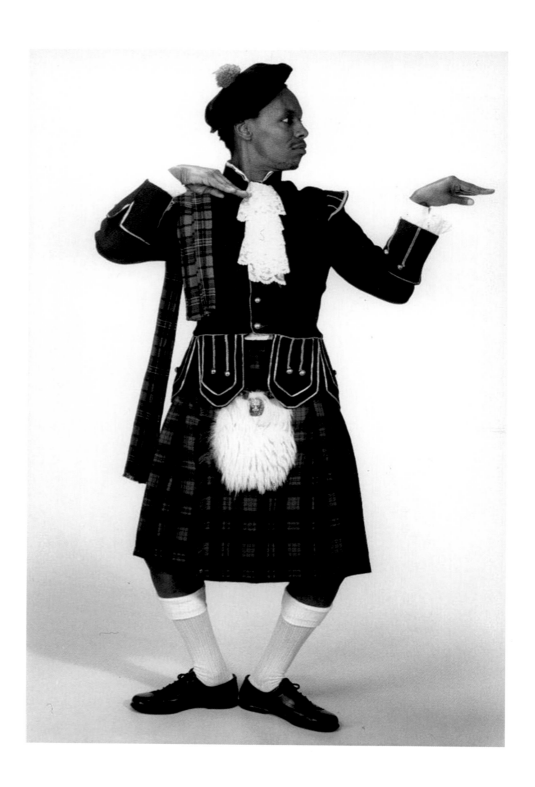

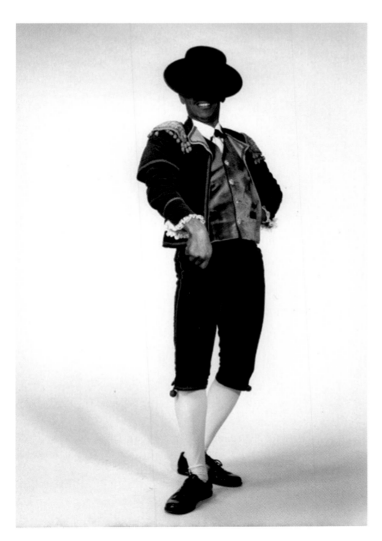
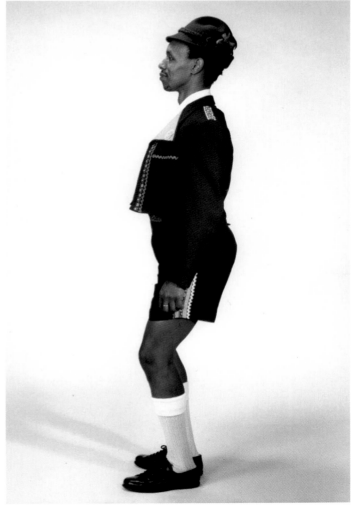

WIR, 2003 [99]
3 C-print photographs

YINKA SHONIBARE

Victorian Philanthropist's Parlour, 1996–97 [119]
Mixed media

90 IDENTITY & HISTORY

Money & Matter, 2002 [131]
6 of 9 photographs, inkjet on vinyl

1 Riches & Restraint
2 Currency & Constraints
3 Assets & Anxiety
4 Funds & Force
5 Investment & Innocence
6 Profits & Proficiency

FATIMAH TUGGAR

1

2

3

4

5

6

BODY & SOUL

BODY & SOUL

SIMON NJAMI

The works in this section are concerned with repres-
entation. It associates body and soul because these
two entities are here inseparable.

The body is the instrument of the soul –
through it artists express themselves and present their
intimacy. But while the body cannot survive without
the soul, the soul may exist without the body, despite
the fact that, even in the most 'spiritual' works in this
section, the need to embody remains.

Christian thinkers have always clearly
separated bodies from souls, rather like the separation
between the sacred and the profane. The soul is the
nobleness of an individual. For Christians, it is a force
that lives on after the individual. But what is meant
here by soul clearly has little to do with the Christian
soul and all its symbolism, but more with a secular
soul, i.e. a soul of the mind. The body may well be an
instrument, but it is still the only means by which we
appear to others. As soon as it becomes an element
of artistic creation, it stops being the matter that we
perceive and becomes something else.

There is no need here to go back over re-
ceived images or racial typology, because the 'African
body' we are focusing on in *Africa Remix* is multiple –
Caucasian, Arab and Negro. To envisage the reality
of an 'African body' we must give it a substance. The
African body is only African because it is asserted as
such. It is therefore not the body that delivers a mes-
sage, but the way in which the artist portrays and uses
that body. It becomes the materialisation of an idea,
an instrument of communication and mediation
through which the artist speaks to the Other, that
Other who looks and cannot help qualifying. For the
body is the first concrete element through which we
are perceived. It is the seat of a permanent conflict
where the contradictory question of perception is
played between the image we send out to others and

the image that others perceive of us, an image that relates to appearance. Mastering this twofold image means instantly imbuing it with your soul – to avoid the underlying misunderstandings behind every 'first gaze'. Here we enter the field of representation, where we project and present ourselves to others, where we negotiate the conditions of our belonging to the world.

But the Other is multiple, made up of all that is not self. Outside a tight circle of family and (possibly) friends, we are victims of permanent misunderstandings. Going out into the world supposes a deep knowledge of one's self and how one wants to be perceived. The question that faces the African artist is the question of the multiplicity of all these Others, for it is impossible to select the message and make it universal, i.e. accessible to all in the same way. Hence the necessity to weigh the body down with a load which exceeds its owner, and make it the emblem of a certain spirituality. After all, what is this offered body if not the incarnation of the statues and masks whose meaning escaped their initial appearance? The reference, or at least the referent, is often foreign – the Other. We describe ourselves for those who are far from us, not those who are close – those who perceive an image of us that does not correspond to the one we want to project.

It is neverless impossible to completely master the way in which one's image, or the image one wants to project, will be perceived or received, no matter how carefully it is constructed. We exist only in the eyes of the Other, said Jacques Lacan, and that Other can in many cases be ourselves. Or we ourselves are at least part of this vast Other. For artists are both the shapers and the contemplators of their own image. The body may then become an intercessor, an intermediary between ourselves and another unconscious world.

It is in this mediumistic operation that the body bows entirely to the spirit, or rather, the sacred status of the soul. Unlike European monotheism, African religious traditions – animist and monotheist alike – have preserved a direct relationship to the sacred, a magical and transcendental dimension. For Vodun, Soufism or the Gnawa in southern Morocco, trance is a determining element of the rite and the communion with God: that special moment when you lose awareness of your self.

This is how Jackson Hlungwani (cat. 53–54, pp. 118–19) could assert that he was not the author of his sculptures, but an instrument in the hands of God. We therefore see the extent to which the seeing body, whether operating in a sacred or profane manner, is at the heart of the transubstantiation at work in the artistic creation illustrated in this section. For the immanent and the transcendent suddenly become one, and the frontiers evoked by Kant ('We shall call the principles whose application is confined entirely within the limits of possible experience immanent, and those which transgress these limits, transcendent.'[1]) are abolished in a fusion between the carnal and the spiritual.

Translated from the French
by Gail de Courcy-Ireland

1.
Immanuel Kant, *Critique of pure reason*, J.M.D. Meiklejohn (trans.), New York, Prometheus Books, 1990.

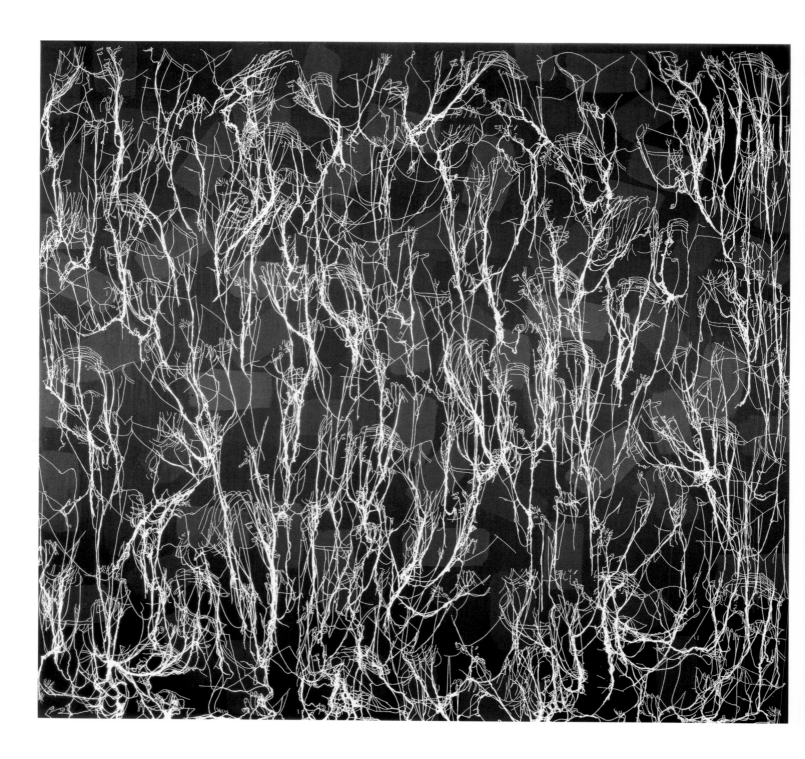

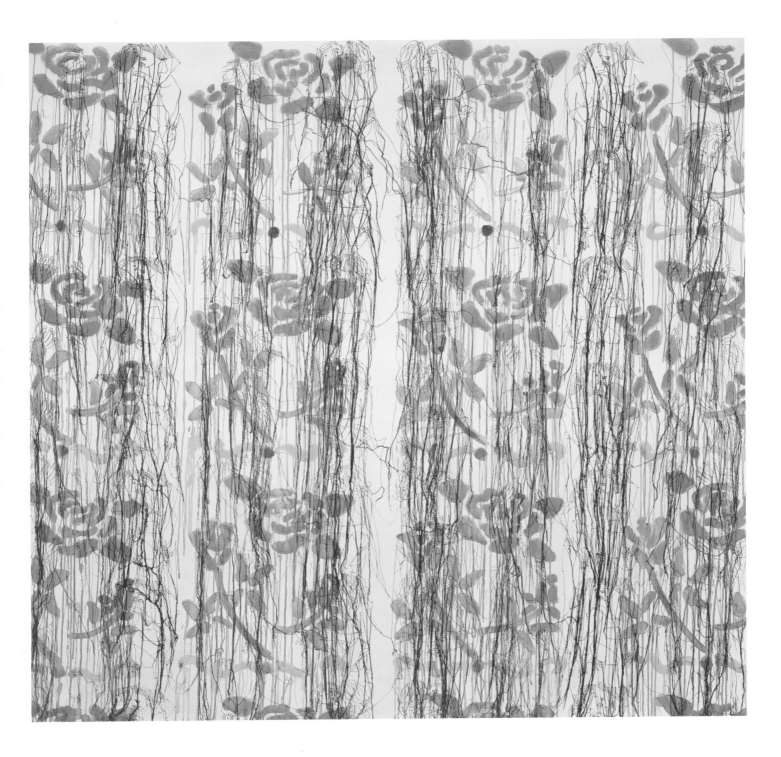

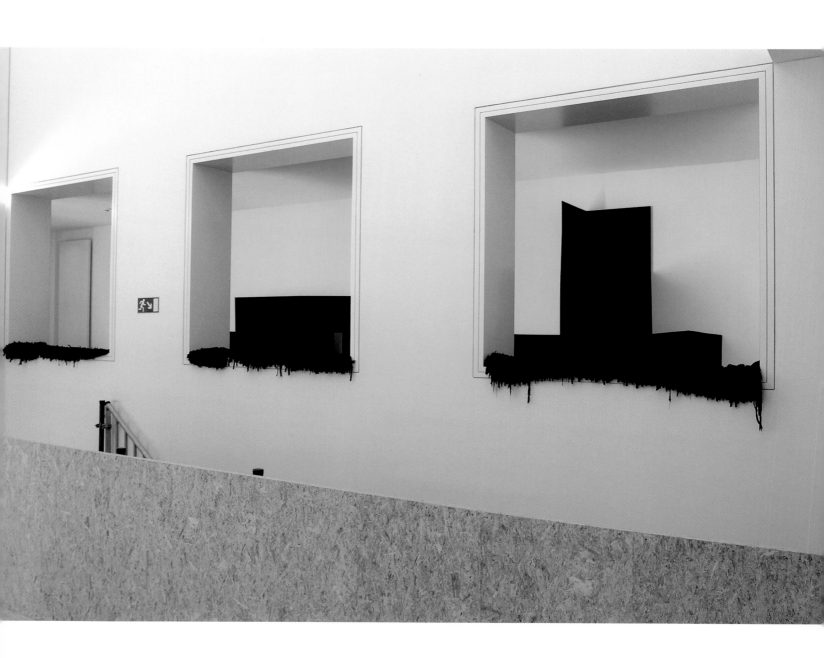

Paravents, 2004 [14]
Textiles, cardboard

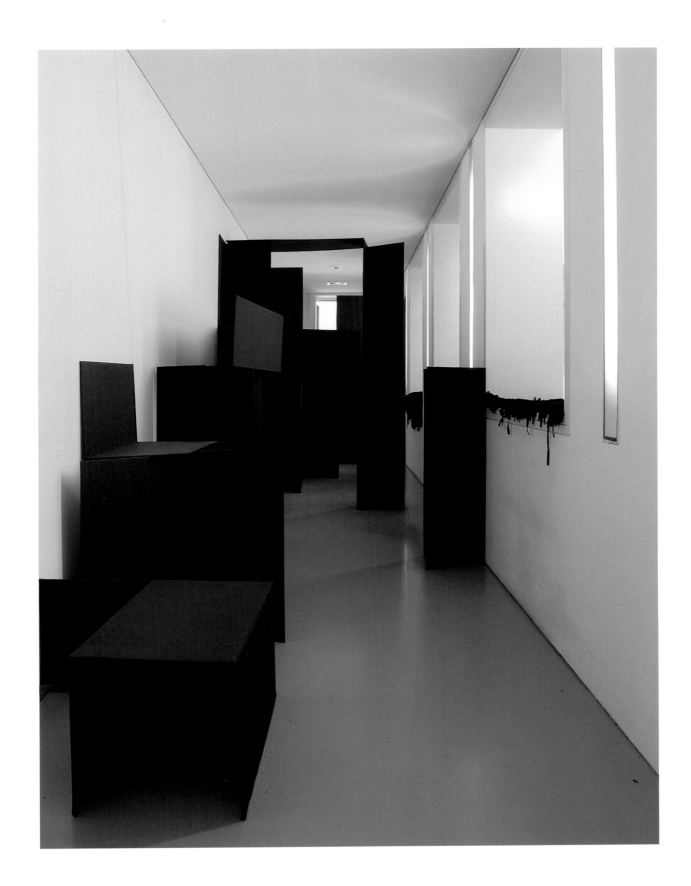

HICHAM BENOHOUD

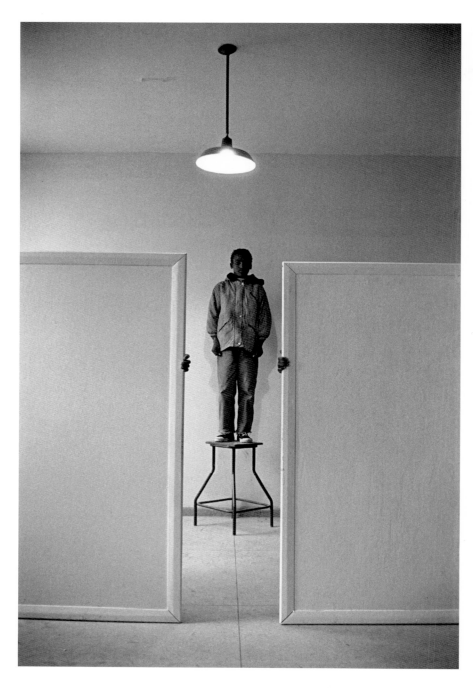

La salle de classe, 1994–2001 [20]
Black-and-white photographs
on aluminium

1-4 Version soft, 2003 [21]
Photographs on aluminium

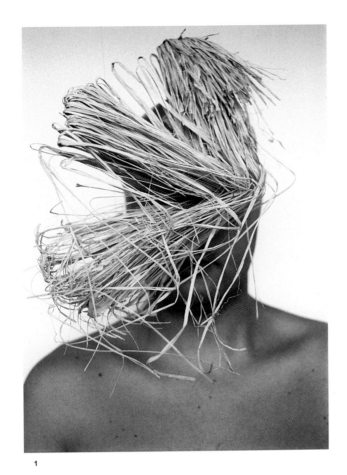

1

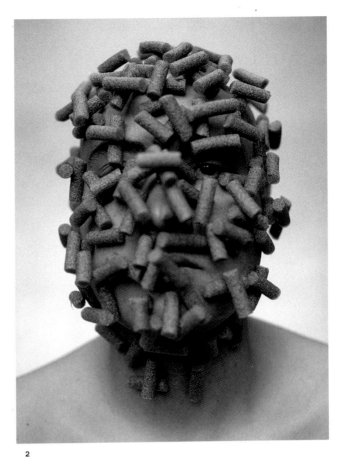

2

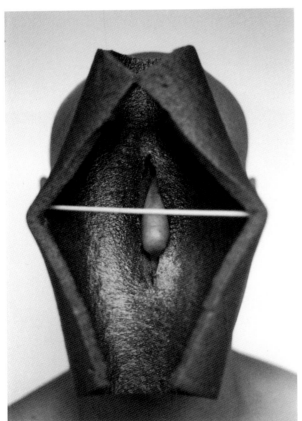

3

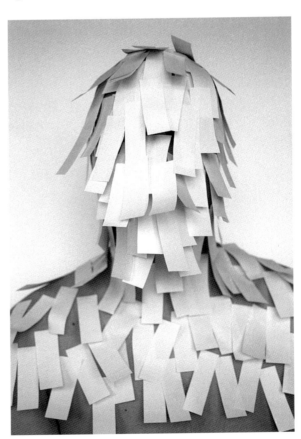

4

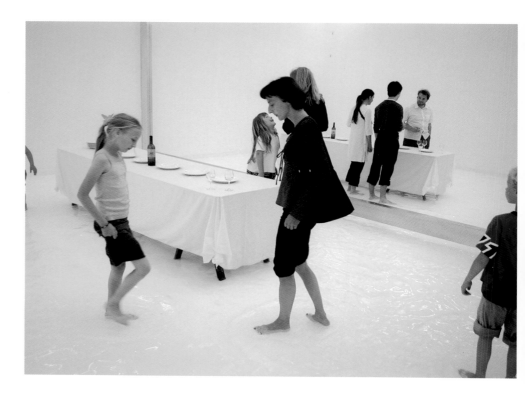

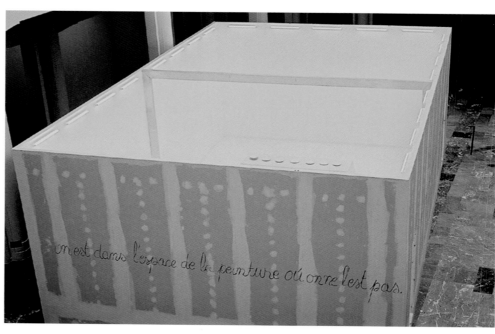

The Room of Tears / Pédiluve #4, 2004 [24]
Video-sound installation

FRÉDÉRIC BRULY BOUABRÉ

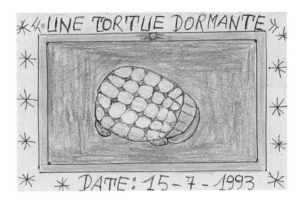

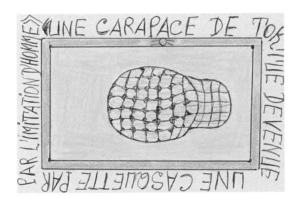

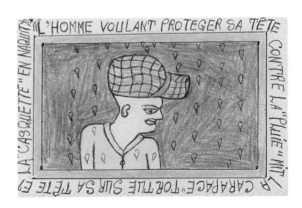

L'Invention de la Casquette, 1993 [28]
Crayon, felt pen on paper

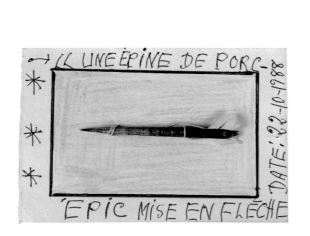

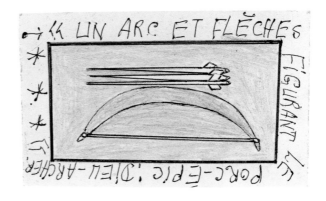

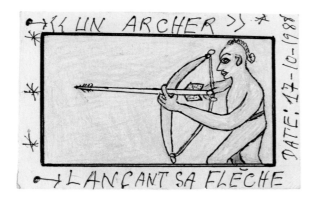

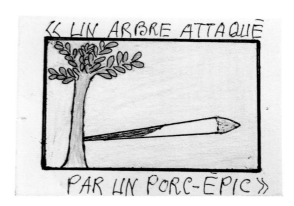

Genèse du missile, 1988 [31]
Crayon and ballpoint pen drawings
on cardboard

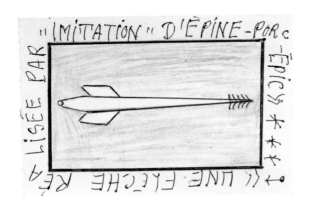

« LE DESSIN D'UNE ÉPINE
DATE: 27-10-1988
DE PORC-ÉPIC MISE EN EN FLÈCHE »

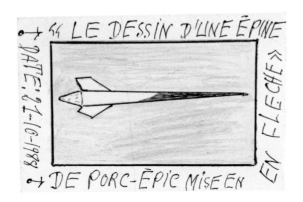

« IMITATION » D'ÉPINE-PORC-ÉPIC »
LISÉE PAR RÉA « UNE FLÈCHE

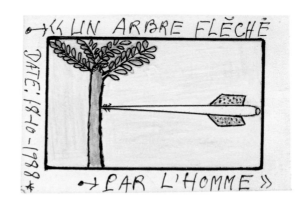

« UN ARBRE FLÉCHÉ
DATE: 18-10-1988
PAR L'HOMME »

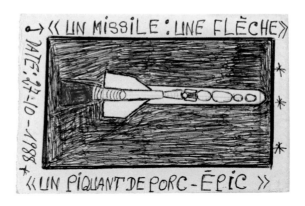

« UN MISSILE : UNE FLÈCHE »
DATE: 27-10-1988
« UN PIQUANT DE PORC-ÉPIC »

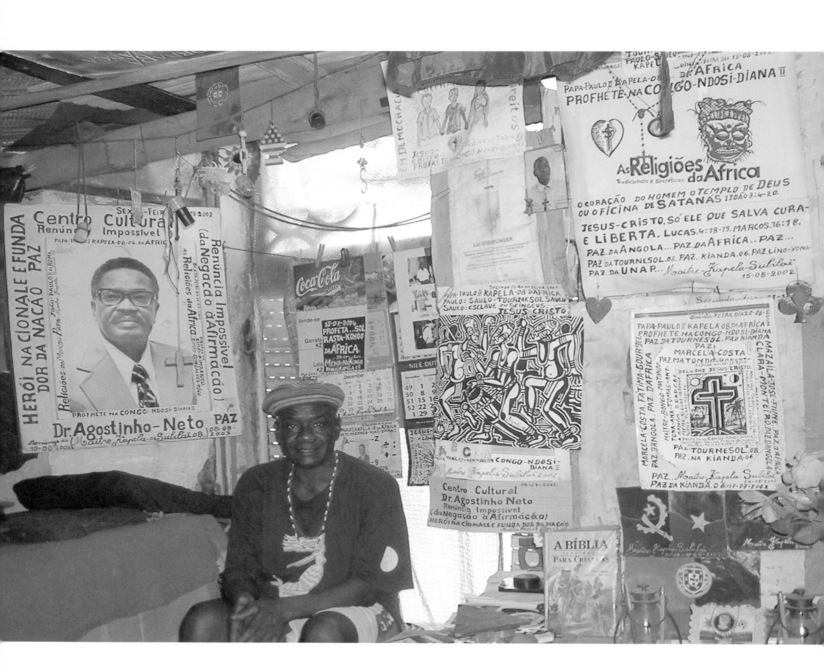

Che Guevara, 1999 [33]
Mixed media

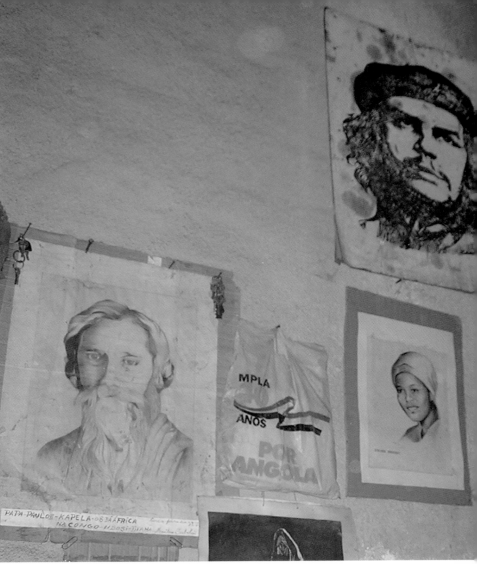

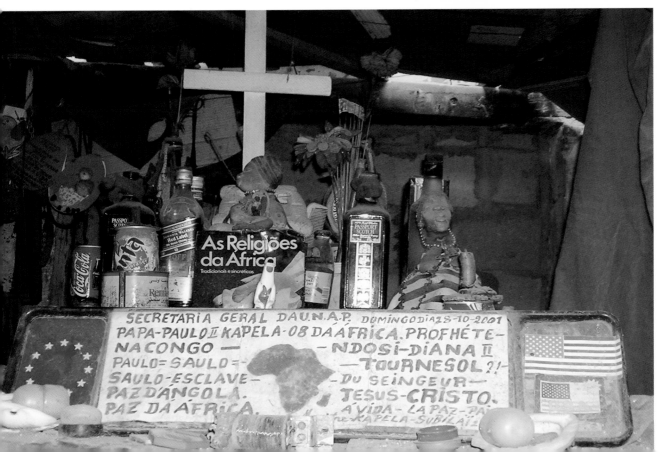

LOULOU CHERINET

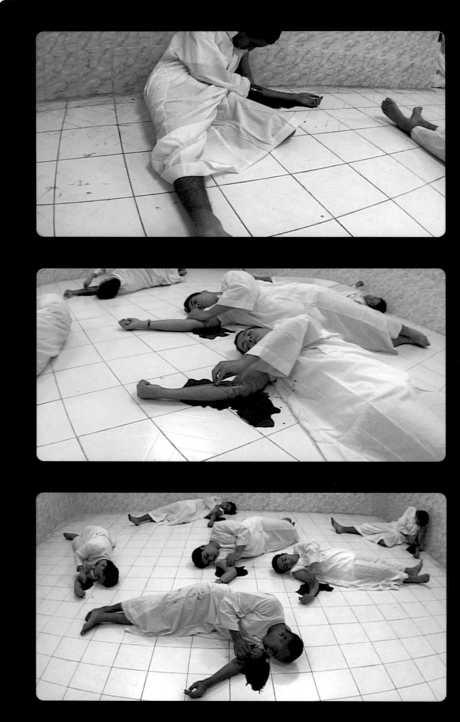

Bleeding Men, 2003 (stills) [35]
Projection, autoloop on DVD

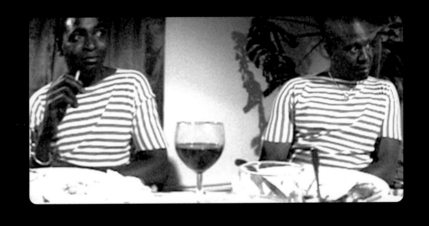

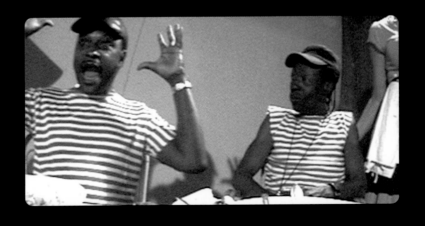

White Women, 2002 (stills) [36]
Projection, autoloop on DVD

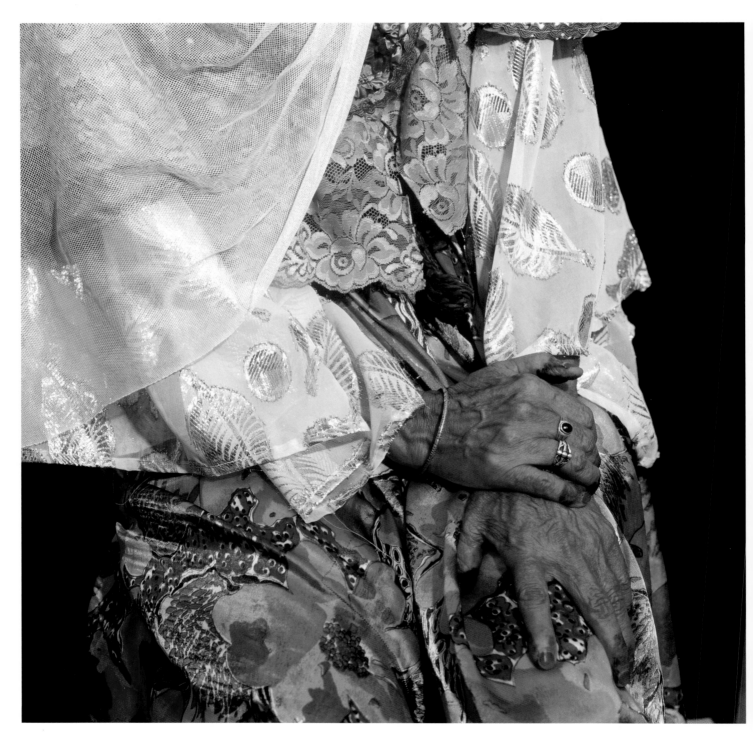

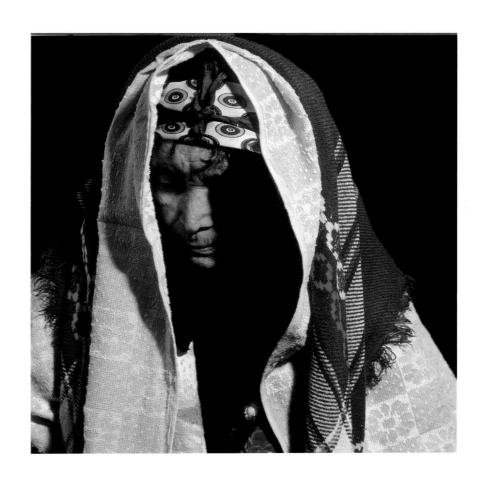

Algérie, Portraits [38]
C-print photographs

1

2

3

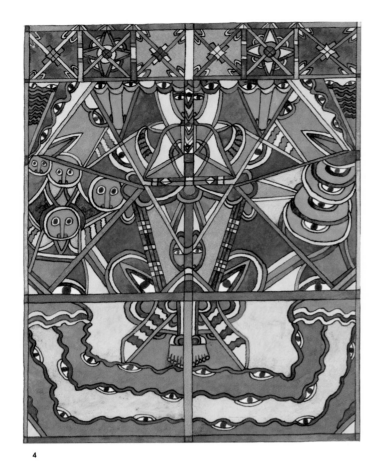

4

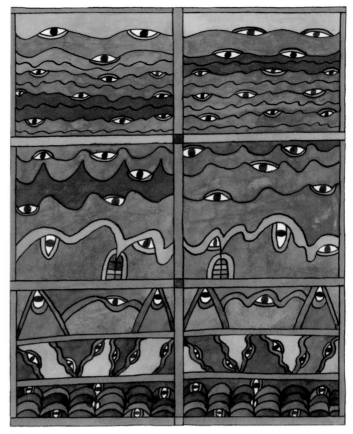

5

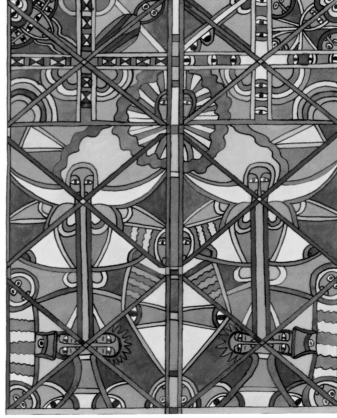

6

From the series **Cahiers V–VII, juillet – octobre 1975** [49]
Crayon and ink on paper

1 Serpent de mer, 1975
2 Couronne des martyrs, 1975
3 Le voyageur du monde, 1975

4, 6 Untitled, 1984, from the book
Livre des mystères du ciel et de la terre, 1984 [50]
Crayon and ink on paper

5 Untitled, 1984, from the series
L'Apocalypse de Jean
Crayon and ink on paper
32 x 24 cm

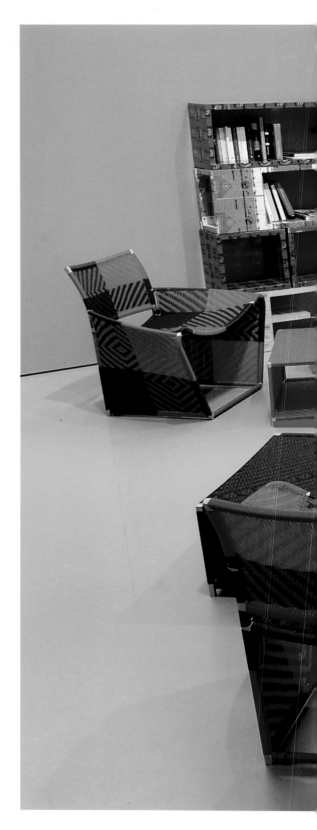

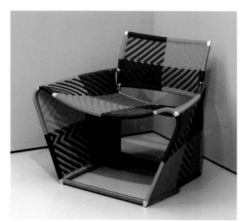

Reading Room for Africa Remix, 2004 [40]
Metal, recycled material and plastic

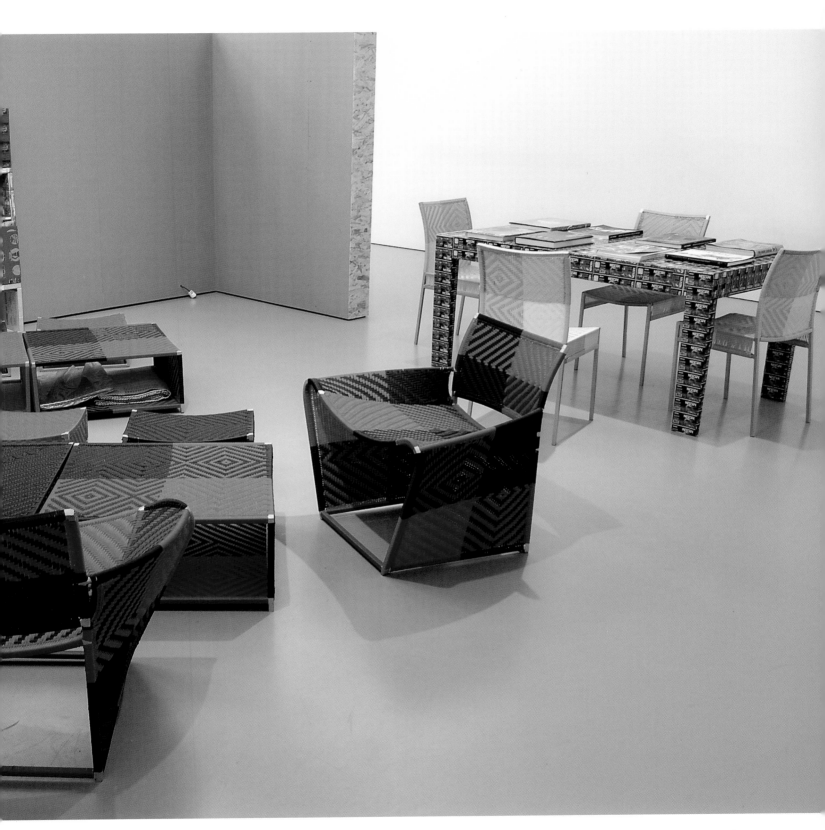

Adam and the birth of Eve, 1985–89 [53]
Wood

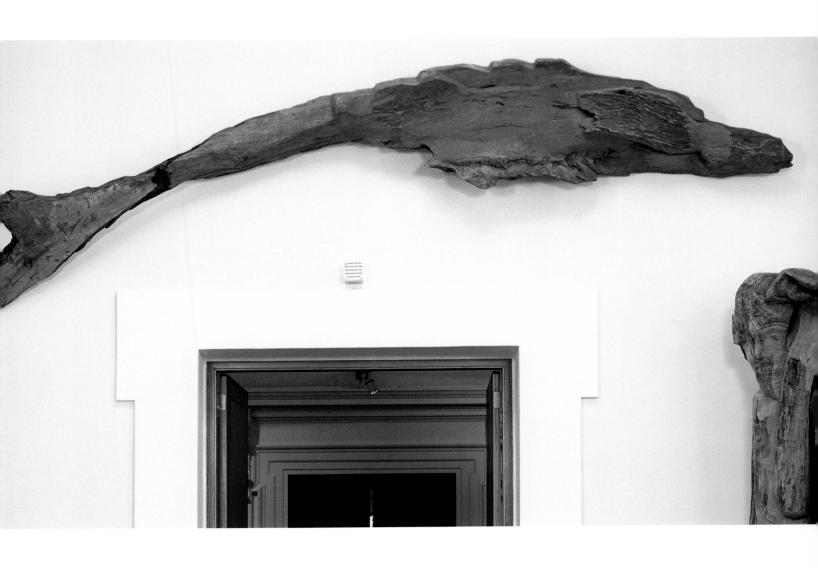

Tiger Fish (III), 1987–89 [54]
Wood

ABD EL GHANY KENAWY AND
AMAL KENAWY

Once the light was for me but it faded away when the depths
of my heart were flooded..by blood.. I stopped breathing.
I try to seek it in my prayer.
I try to excerpt in God's acts.
God is all light .. God is all light

Frozen Memory, 2003 (still) [55]
Video installation

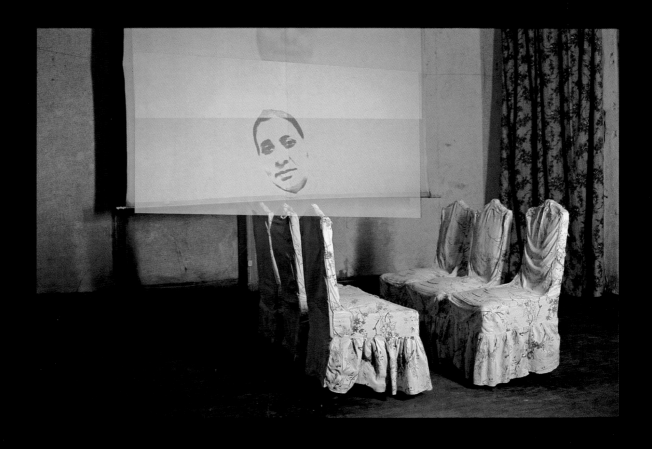

The tree of my grandmother's house,
The Dialogue, 2001
(installation shot and stills) [97]
DVD installation

 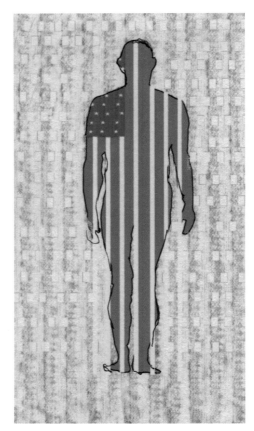 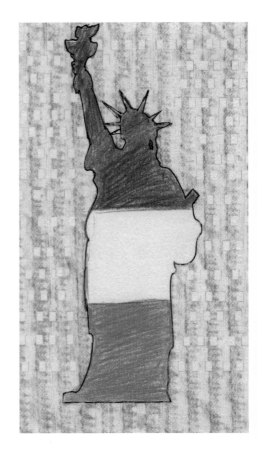

L'initiation, 2004 [59]
Textiles, mixed media

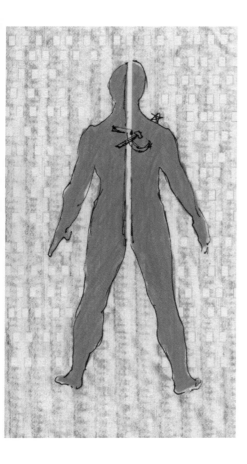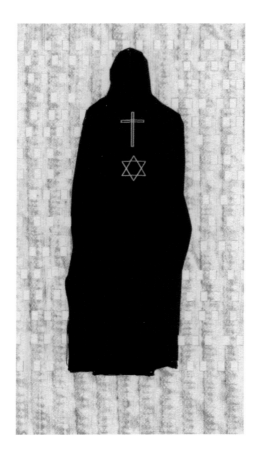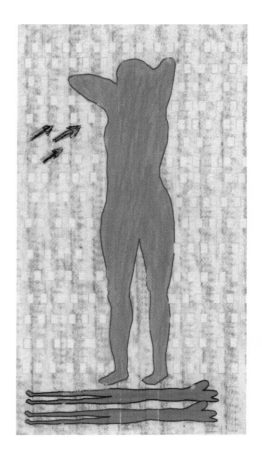

Dancing with the Moon, 2002 [62]
DVD projection, mirrors, blue light, fan

GEORGES LILANGA
DI NYAMA

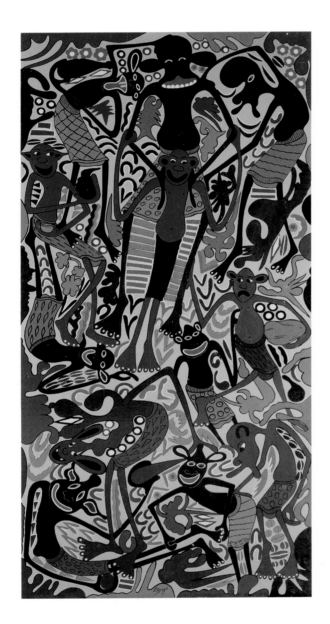

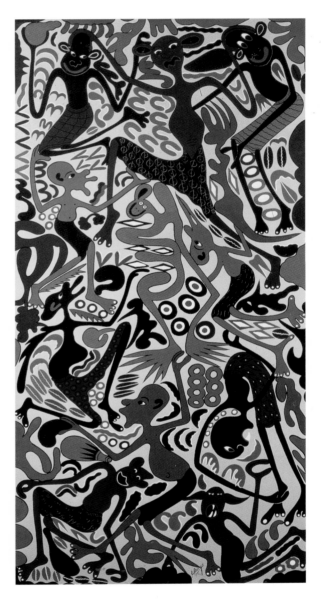

Have good relations with neighbours, they will help
you when you are in need, 1992 [64]
Acrylic on wood panel

A town is people, without people it is not a town,
we are people as you are, 1992 [63]
Acrylic on wood panel

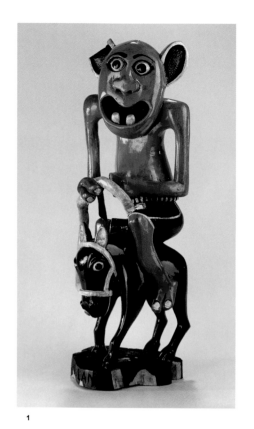

1

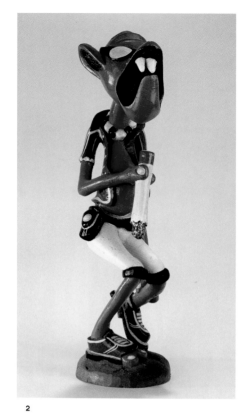

2

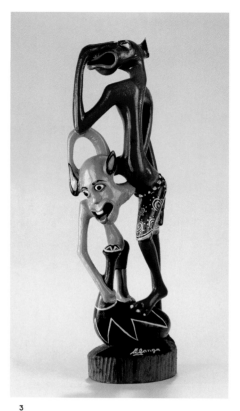

3

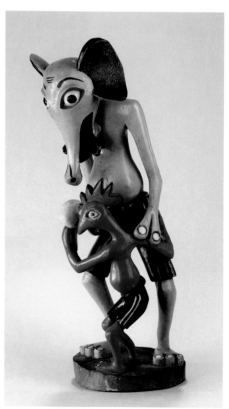

4

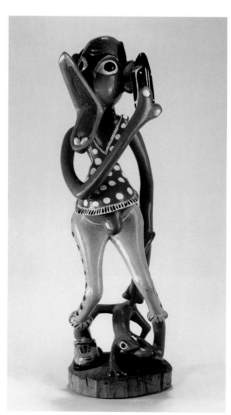

5

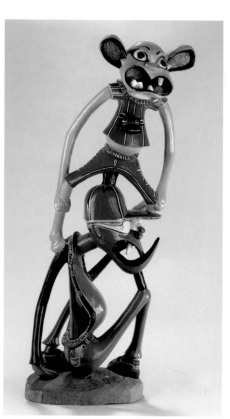

6

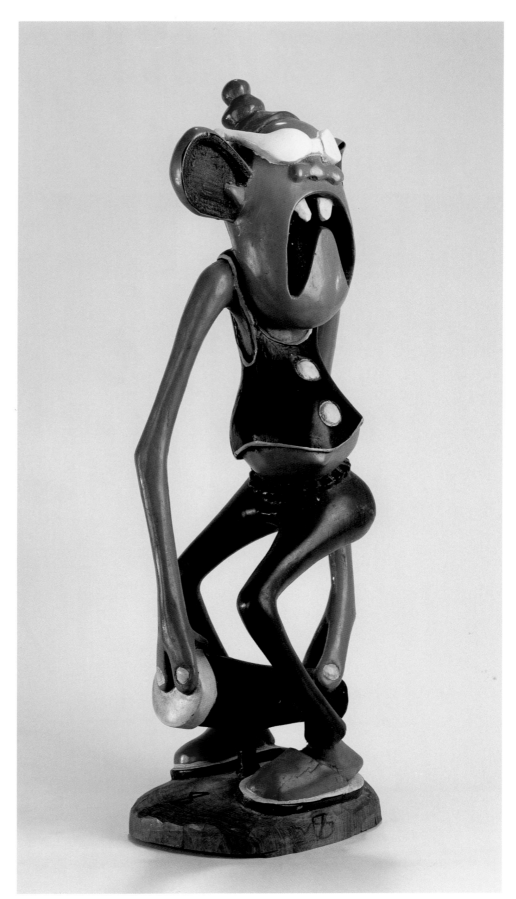

1 Donkey Rider, 2000 [65]
 Painted wood

2 Bhang smoking, 2002 [66]
 Painted wood

3 Looking for water in
 the village, 2002 [68]
 Painted wood

4 Old Katembo and
 Mr Chicken, 2002 [69]
 Painted wood

5 Trying to get assistance
 through cellular phone, 2002 [71]
 Painted wood

6 Life in the ghetto, 2002 [67]
 Painted wood

7 Sindimba ngoma player, 2002 [70]
 Painted wood

7

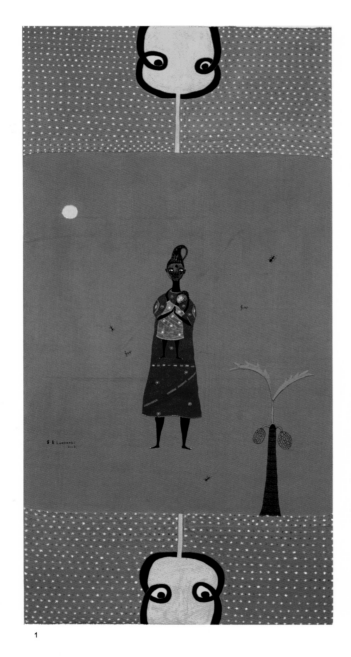

1

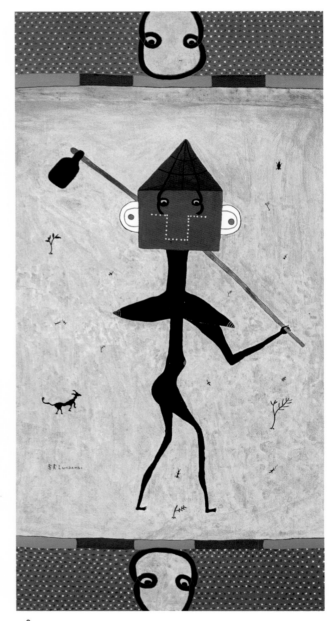

2

1 Femme à l'enfant, 2003 [72]
Mixed media on canvas

2 La Maison de Sens, 2003 [73]
Mixed media on canvas

MYRIAM MIHINDOU

Folle, 2000 (installation shot and stills) [85]
DVD video projection

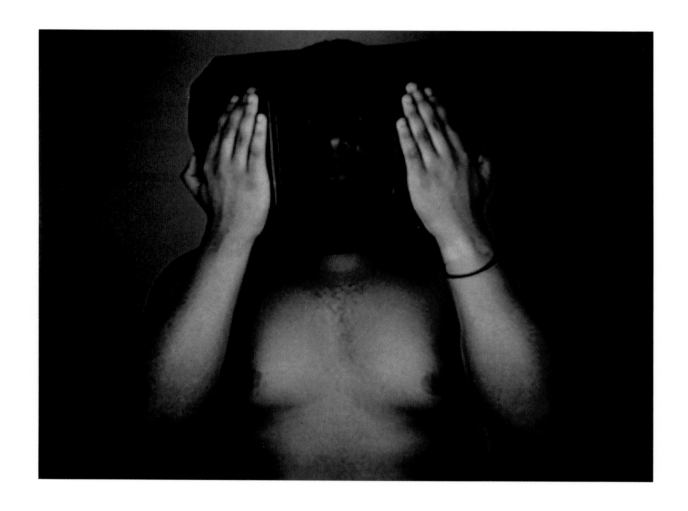

Cosmogónicos. Masks I–III, 1997 [90]
C-print photographs on aluminium

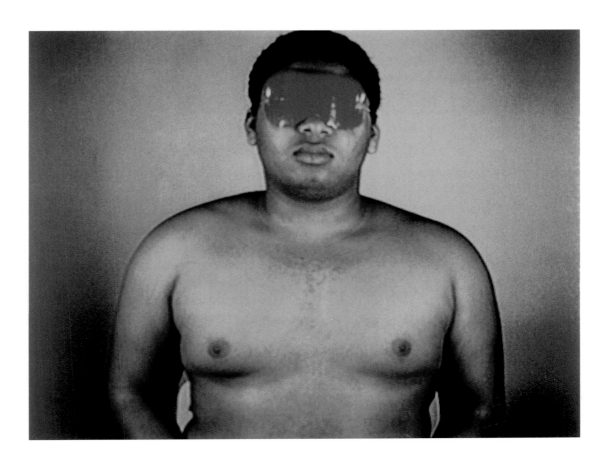

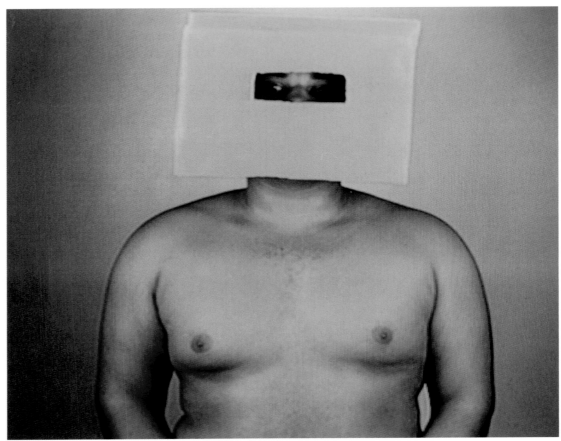

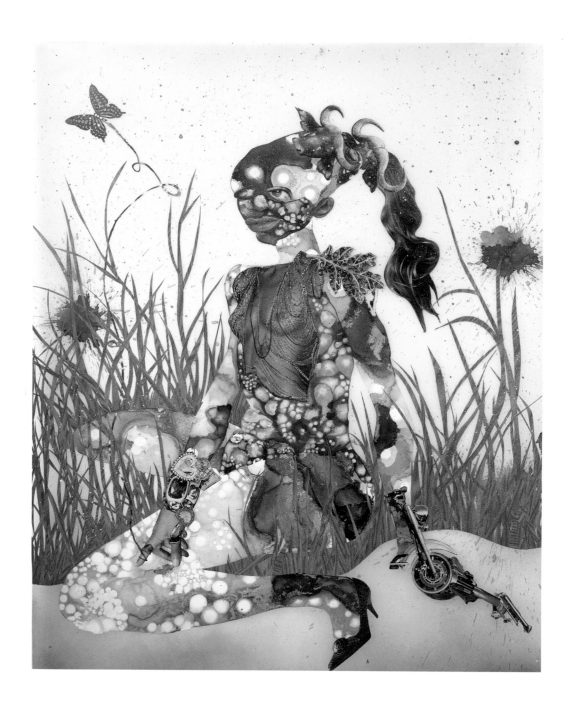

In killing fields sweet butterfly ascend, 2003 [92]
Ink and collage on Mylar polyester film

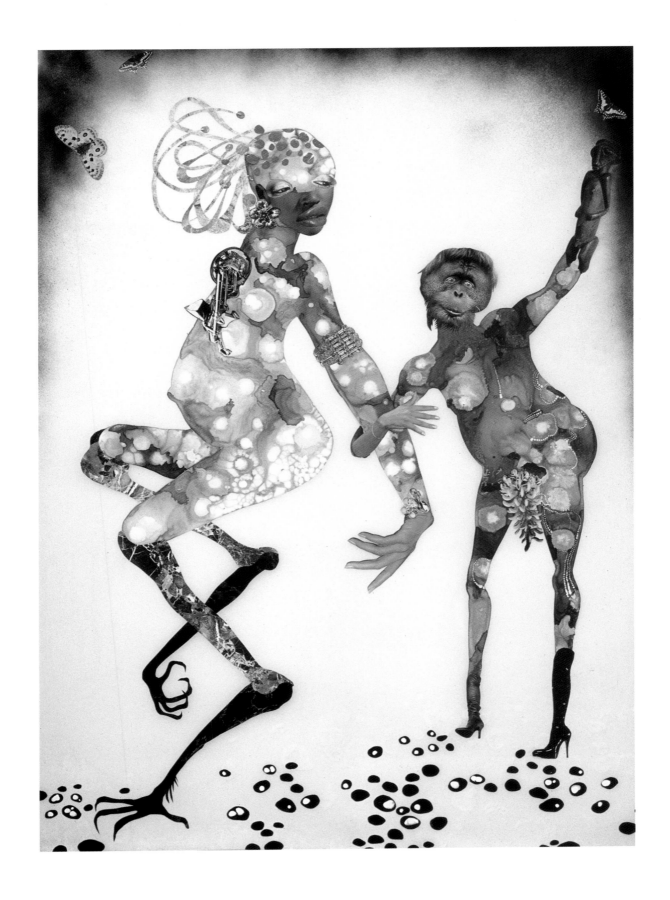

A passing thought such frightening ape, 2003 [91]
Ink and collage on Mylar polyester film

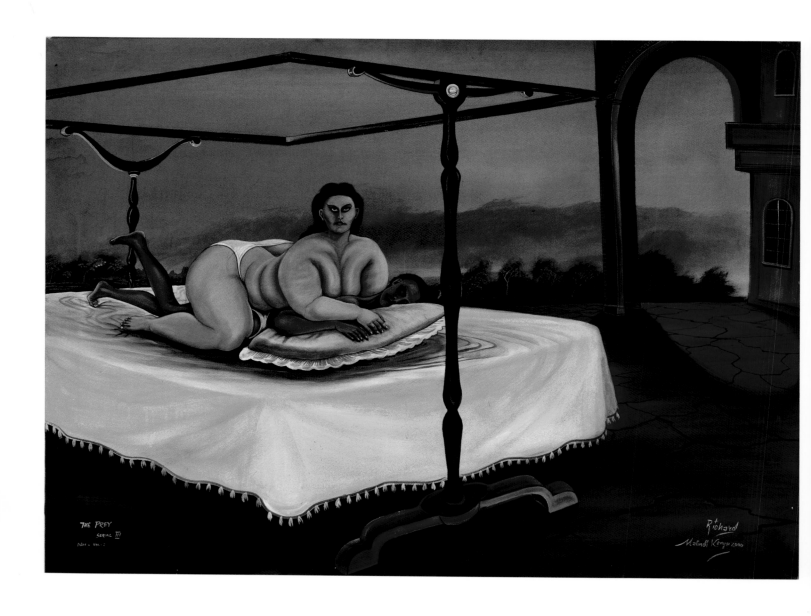

The Prey.
Serial III – Vol II – D&M, 2000 [101]
Oil on canvas

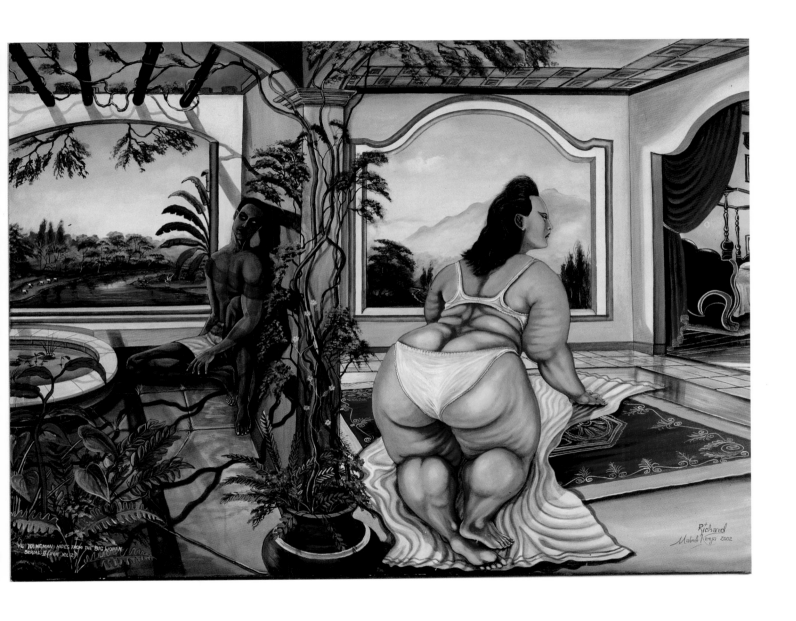

The young man hides from the big woman.
Serial II – Vol II – D&M, 2002 [102]
Oil on canvas

1 **Mouvement N° 33,** 2004 [103]
Acrylic on canvas

2 **Mouvement N° 35,** 2004
Acrylic on canvas
190 x 250 cm

3 **Mouvement N° 39,** 2004 [104]
Acrylic on canvas

1

2

3

EILEEN PERRIER

139

TKO,
2000 (stills) [111]
DVD video
projection with
sound on free
hanging screen

140

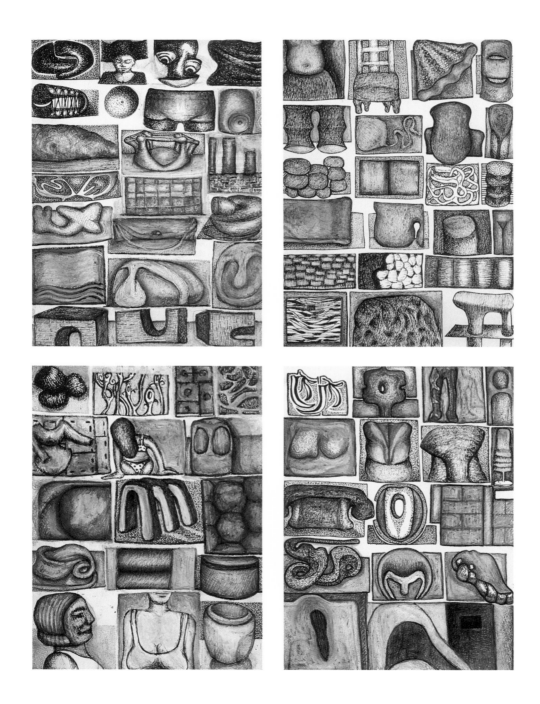

Untitled, 2003–04 [118]
Felt-tip pen and oil crayon drawings
on paper

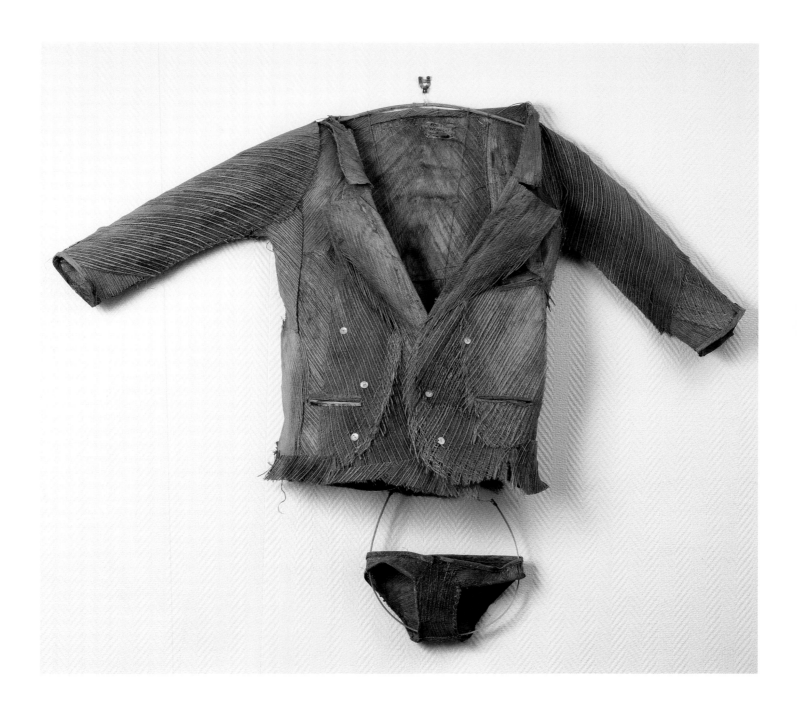

Costume du Nègre [132]
Coconut fibre

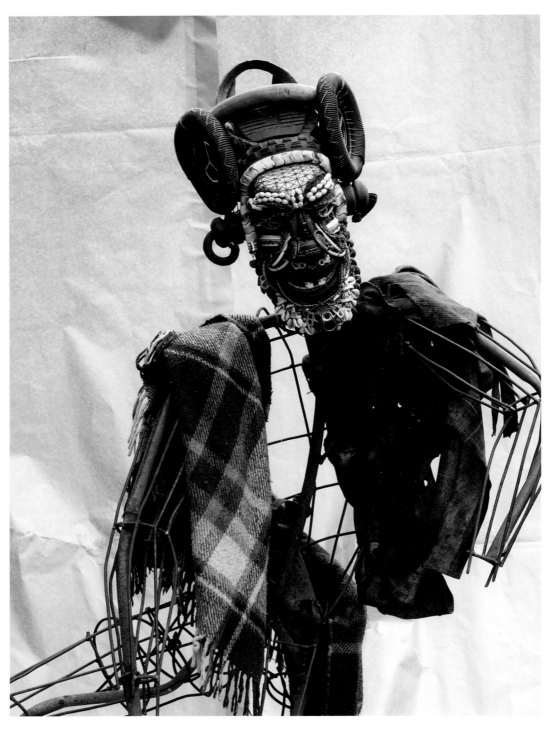

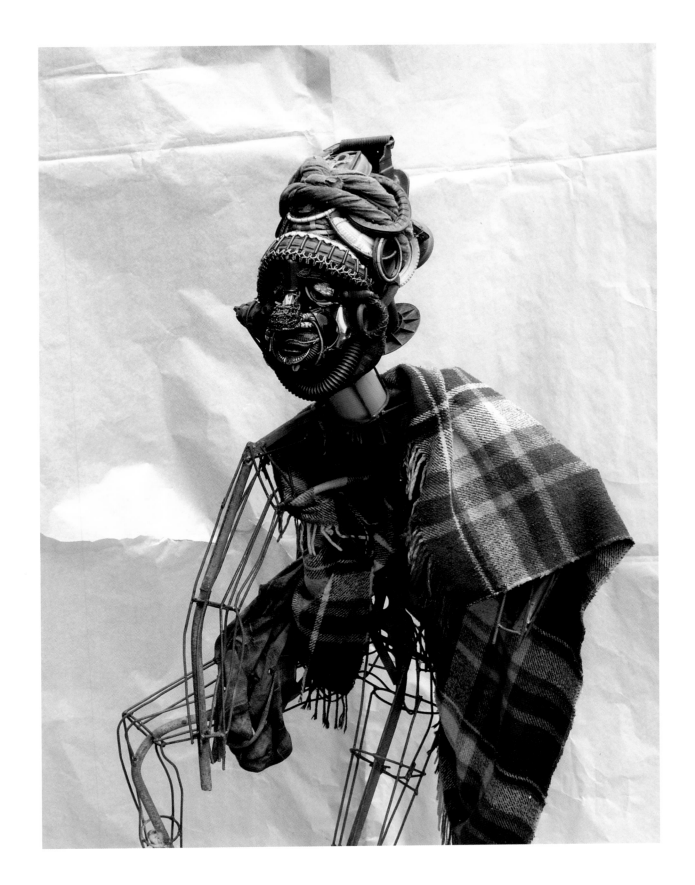

Les 9 Notables, 1992–04 [123]
Mixed media (2 of 9 metal figurines and
assemblage of different recyclable materials)

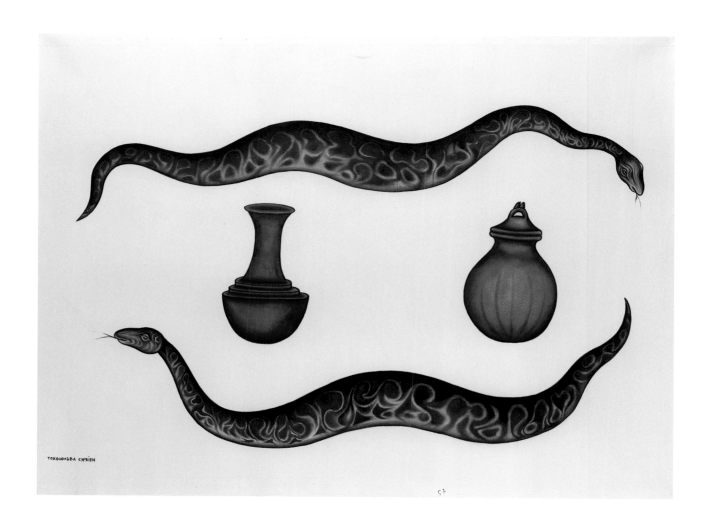

Voudoun Dangbe, 1995 [129]
Acrylic on canvas

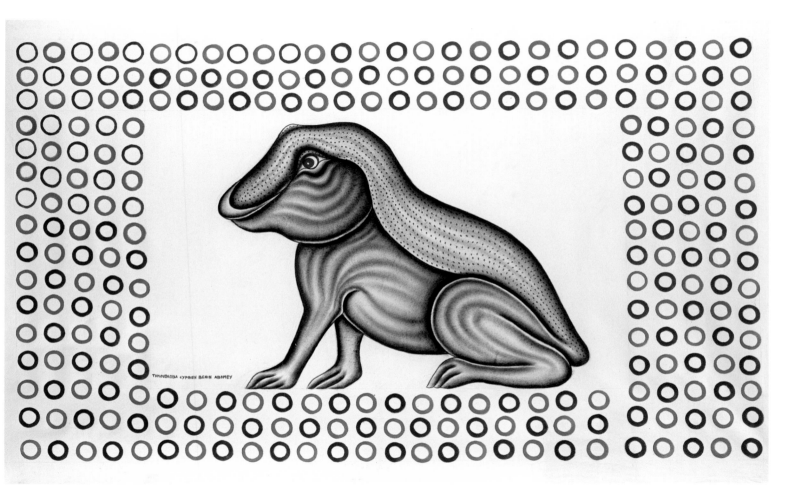

Grenouille – emblème du
dieu de l'eau Tohoussou, 1998 [130]
Acrylic on canvas

CITY & LAND

CITY & LAND

SIMON NJAMI

Here, as in the previous sections, two apparently contradictory notions are presented. Yet once again it appears that the contradiction is purely formal and that, while city and land are often opposed – with one linked to modernity, chaos and promiscuity, and the other to ancestors and traditions – this division is artificial, in Africa more than elsewhere, perhaps. Hence the choice of the word *land,* with all its ambiguity. For land signifies many things. While we claim to separate it from city, it nonetheless remains every city's foundation. Yet despite being complementary and intrinsically interdependent, land and city each have specific functions: a symbolic, metaphorical function for land; a material, concrete and administrative function for the city. Paradoxically, these separate functions fulfil the same role, for they both ensure feeling of unity: political unity, because the city brings together all the parts of a nation, and moral unity, because land is the best symbol of homeland, an atavism beyond the realm of country.

The city is a recent concept in Africa – a colonial import. Before that period, the traditional notion of the Roman *civitas* prevailed, with its social organisations and fixed districts. Today's city still has districts and neighbourhoods, but its organisation is administrative and rational, not social. It has divisions, of course, but they are now economic – wealthy areas, administrative and commercial centres, working-class neighbourhoods. In countries like South Africa or Namibia, former Rhodesia (now Zimbabwe) and, to a lesser degree, in the former Portuguese colonies, these divisions were above all racial.

The political changes that took place in Africa in the latter part of the twentieth century (and which are in several countries still ongoing) have transformed the traditional face of its cities. A certain delinquency, unknown just a few decades ago, is

taking root. For some of the younger generation, the city is still an artificial paradise in which everything is possible. But for many of its inhabitants, the city is now just a means to an end: a place where you work and have access to commodities not available in the countryside. Beyond these sociological considerations, however, the city still contains an essential form of magic that drives the imagination. It remains the place of all possibilities – not of personal realisations, but of sudden improbabilities, of adventure. In Africa, bar a few exceptions like South Africa, Cameroon and the North African countries, only the capital generally fulfils the organic functions of the city. Which is why migratory flows inevitably lead to the same spot, making the African city a conglomerate of sensibilities, personalities and perceptions, a place where you find Europeans, foreigners and people from villages who, for one reason or another, decided to move there. A move which, like a move abroad, is never seen as permanent, simply as a necessary parenthesis. Though many of these parentheses last a lifetime.

The city thus constitutes an abstraction, a free zone where the individual blends into the masses and tends to forget the distinct customs he had lived with before – free of all roots and past. The city is the place where memory is lost. So while the city, the capital, is the gathering point for the nation regardless of fortune or ethnic origin, it is also the no-man's land where everyone is uprooted and anonymous. The city is a fabricated décor; hence the malaise and nostalgia it sometimes engenders and the need it creates to return to one's roots. That's what the weekend is for in Africa: an occasion to return to the village and recharge your batteries in places where you know the limits, where every face is familiar.

The artists of the new generation are mostly urban. Many are wayward and rootless, save for the roots of their inspiration. They adhere to the organised chaos of the city. They can melt into the crowd. The work in this section is inspired by the hustle, the bustle, the surprises and haphazardness of this promiscuity that heralds the radical changes in society. The artist, an attentive entomologist, is both inside and outside the phenomenon he observes.

Showing the city is never gratuitous. The artists who do so draw us into metaphor. Their cities are always abstract, never real; imaginary cities through which they say the unsayable, translate a familiar language into a now-glowing, now-sordid utopia. They feel the right to manipulate this volatile, unsettled matter. Photography and installations appear to be the media most capable of portraying a complexity that sometimes eludes even the artists themselves. The works in this section bear witness to this. Land, or nature, is a permanent totality while the city is fragmentary. This confirms the special relationship that each person builds with their land. For whether they live in or out of the city, the artists here all revert to a form of modesty and respect when it comes to the land they identify themselves with – that timeless (mother) earth.

This is where they feel the melancholy of a former time and realise that they are like wandering peasants, nostalgic beings craving an elsewhere they have lost: the magic land of their birth. The cemented, tarmacked city cannot represent that land. Symbolically, the land must be palpable, black and wild; and the sky above as transparent as the immaculate dawns. Artists who have stayed close to the land do not have the exuberance of their younger city counterparts. They work internally, silently, in immanence and communion, while urban artists, more articulate, often work with words: quickfire, playful, city words. The city encourages the emergence of a global, indistinct world; land and countryside cultivate differences and particularities. Yet it takes little for city-dwellers to re-discover their initial ties to land. Suddenly there is no longer one nor the other, only a native land where all melds into one – a return to the initial balance. The land that becomes your country, lodged in your memory like a childhood song.

Translated from the French
by Gail de Courcy-Ireland

Downtown, Cairo, 2003
from the series **Cairo: Masr**, 2003 [1]
Gelatin silver print

AKINBODE AKINBIYI

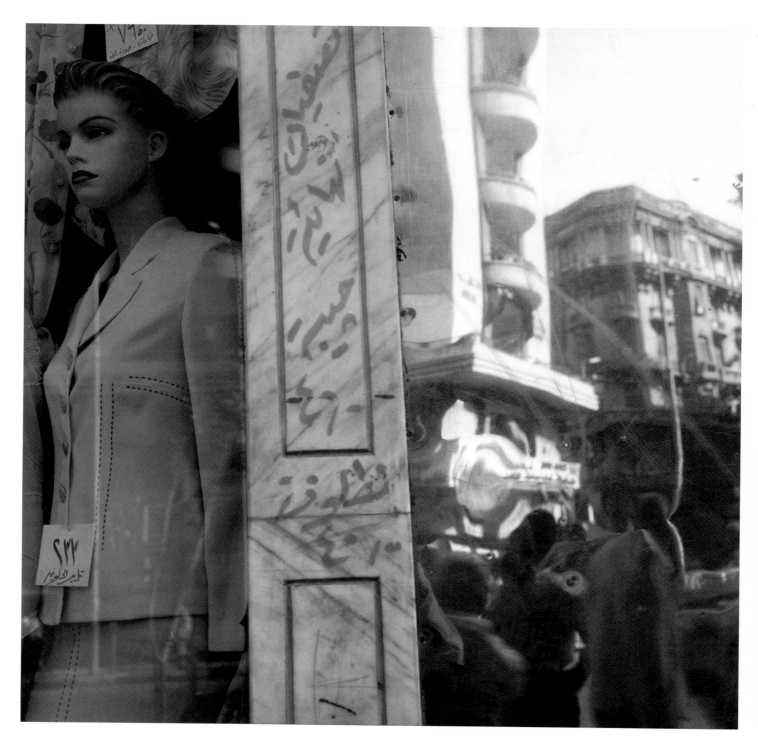

Surulere: Lagos, 2003
from the series **Lagos: all roads,** 2003 [2]
Gelatin silver print

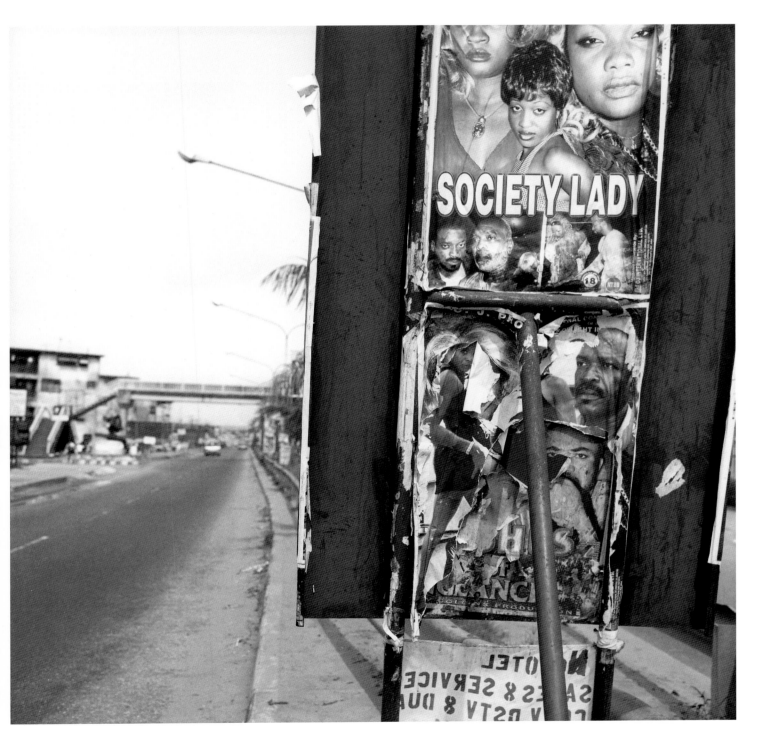

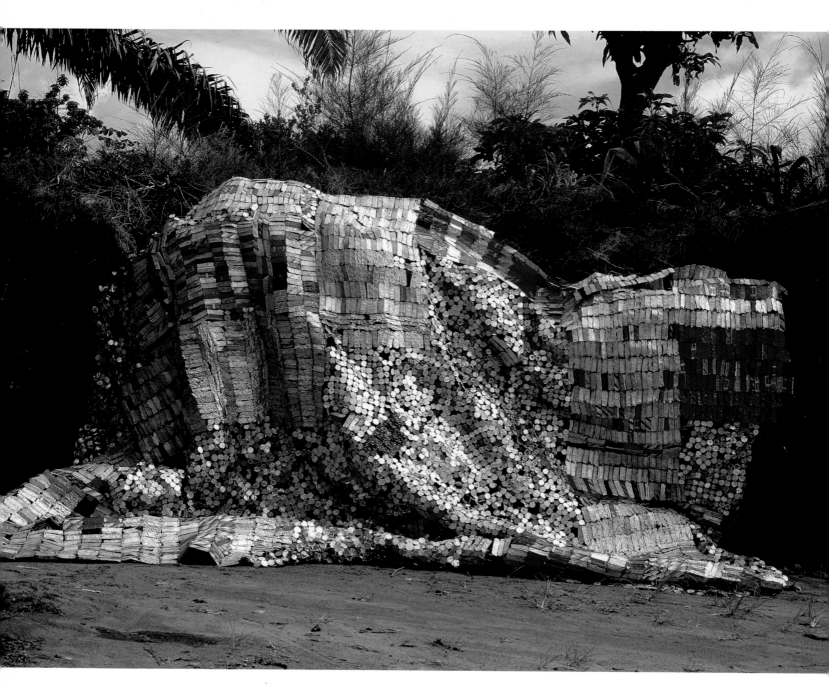

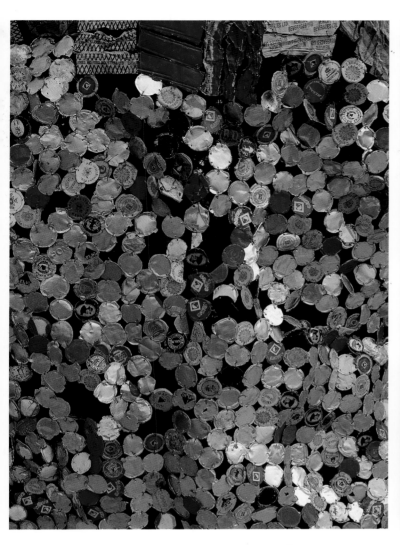

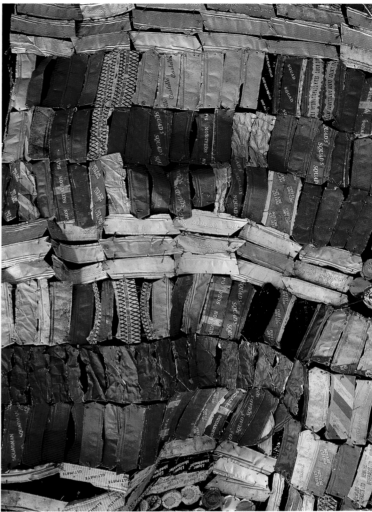

Sasa, 2004 [13]
Aluminium and copper wire

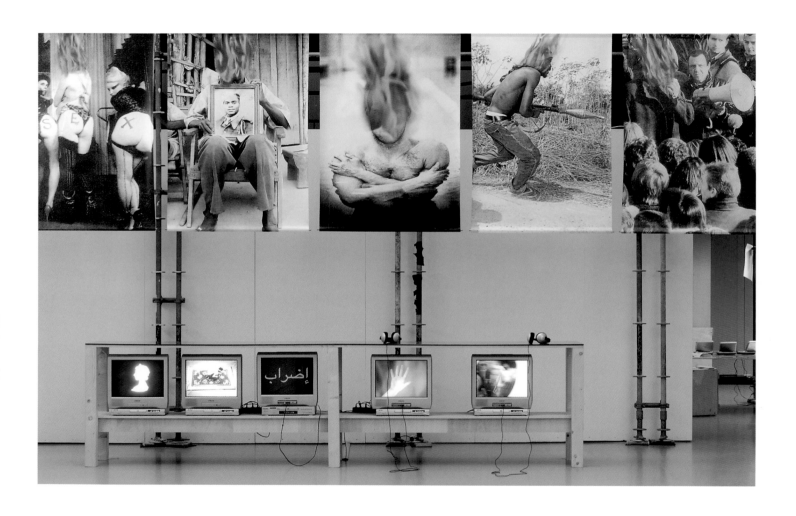

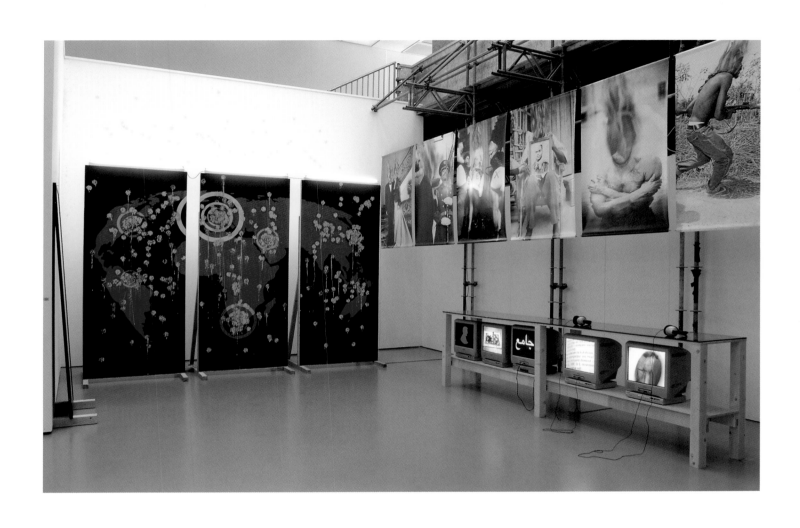

Bricoler l'incurable. Niquer la mort /
Love supreme, 2004 [19]
Mixed media

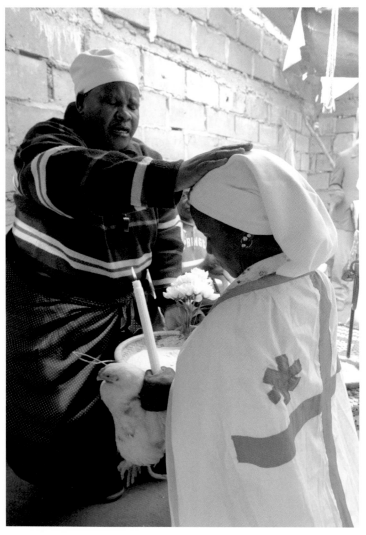

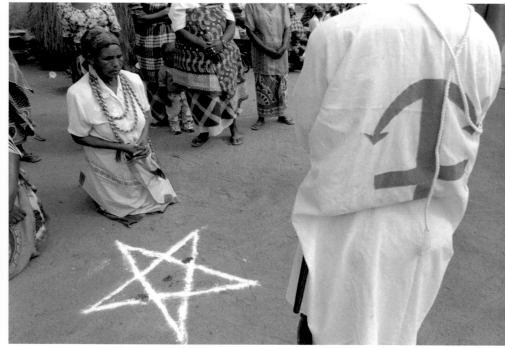

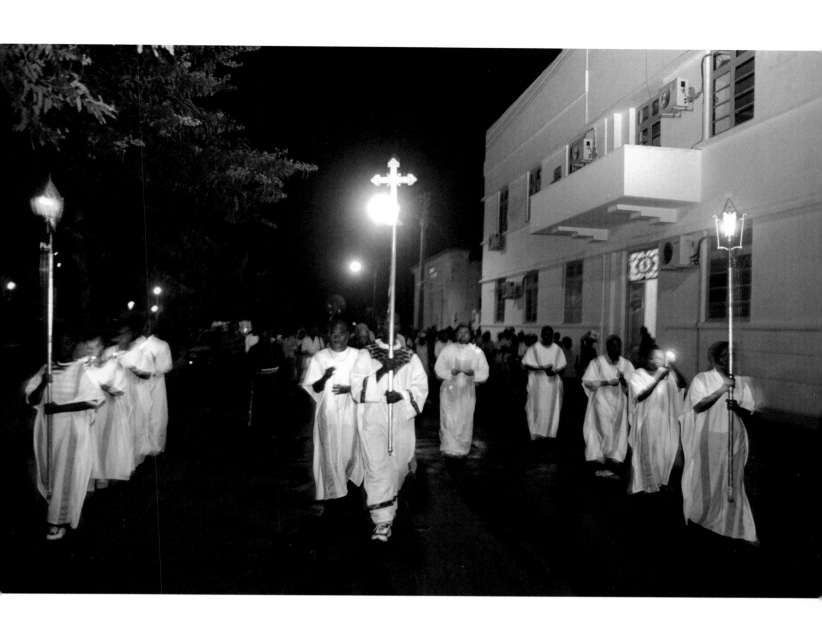

Religion in Mozambique, 2003 [15]
4 of 6 gelatin silver prints

1

Maputo, 2003 [18]
Fibre-based photographic prints

1 Portrait feira popular, Maputo, 2002
2 Portrait feira popular, Maputo, 2003
3 JJ Downtown, Maputo, 2003
4 Sleeping I, 2004
5 Noiva, Maputo, 2003
6 Chapa 100, Maputo, 2002
7 Garaginha, Maputo, 2002

2

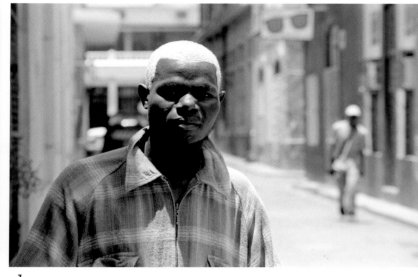

3

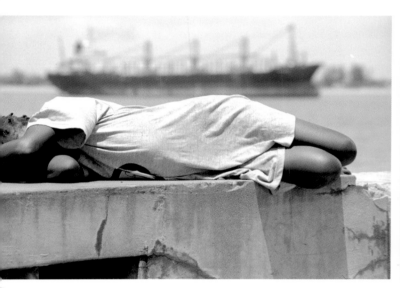

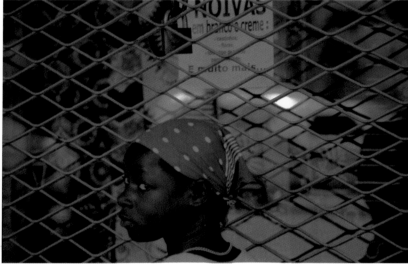

5

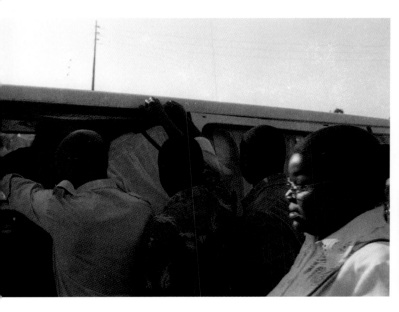

7

BERRY BICKLE

Swimmer, 2004 [23]
4 laminated photojet prints

6 MESES

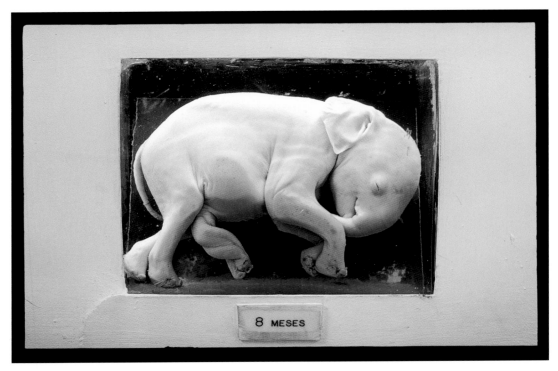

8 MESES

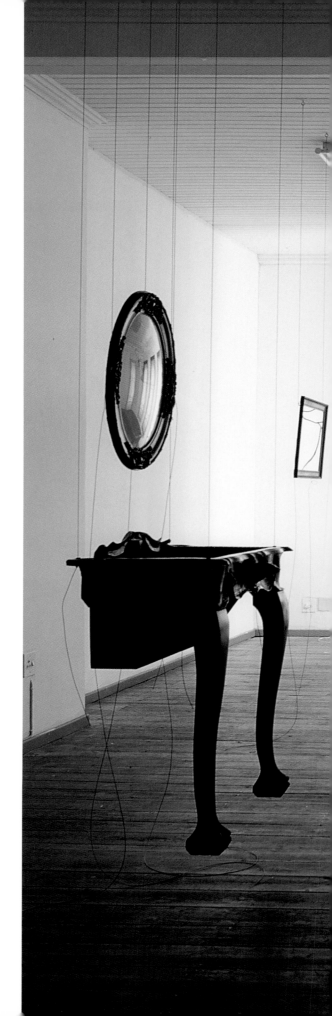

WIM BOTHA

Commune: Onomatopoeia, 2003 [26]
Mixed media

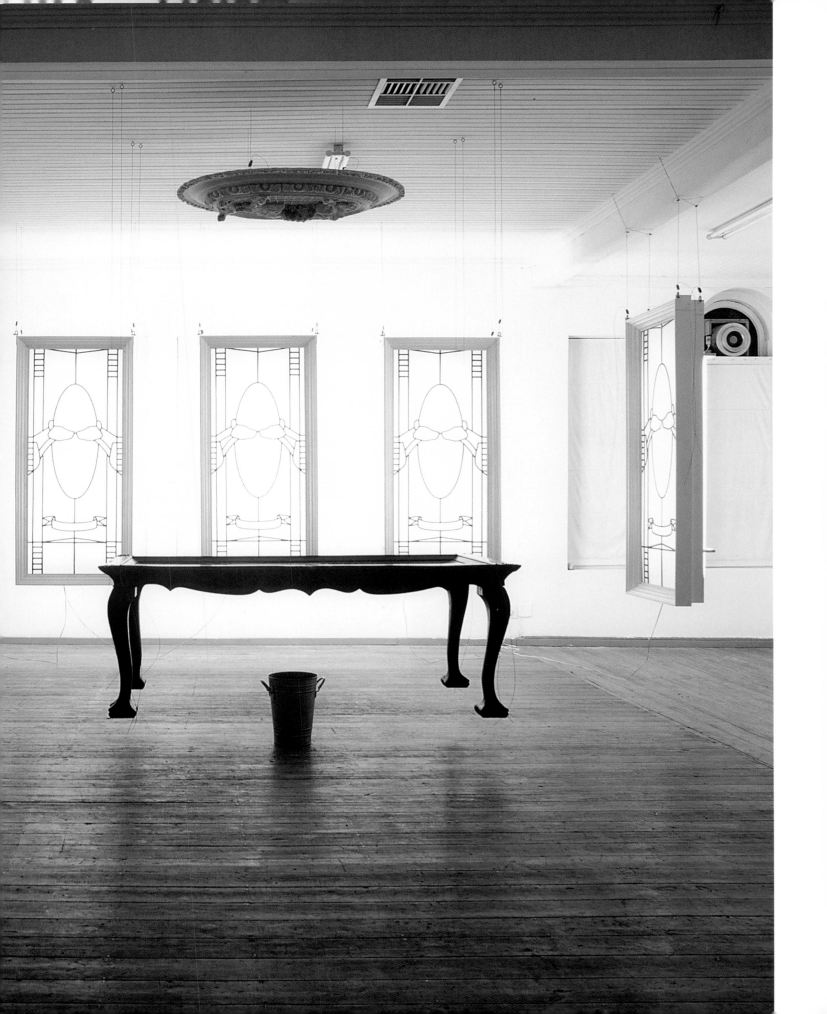

EarthWorks, 2001–04 [39]
Black-and-white photographic prints

1 Priscilla Matom, Ntombi Mthandeki, Linda Simpasa, 2003

2 Jafta Hendricks, 2004

3 Winnie Fischer, 2004

4 Albert Klaasen, 2003

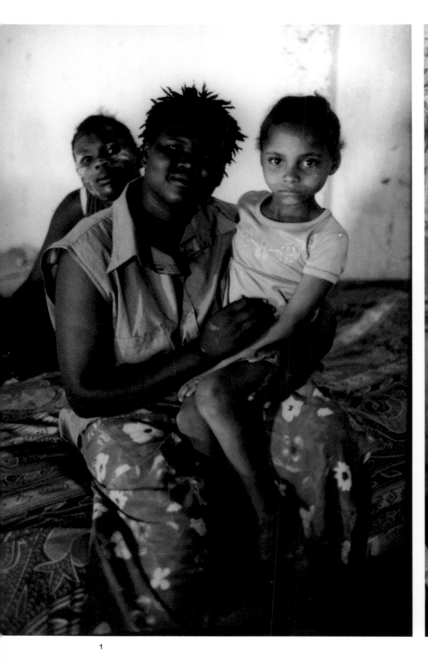

1

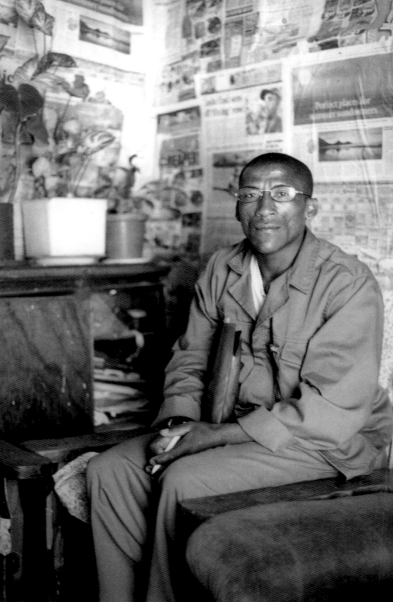

2

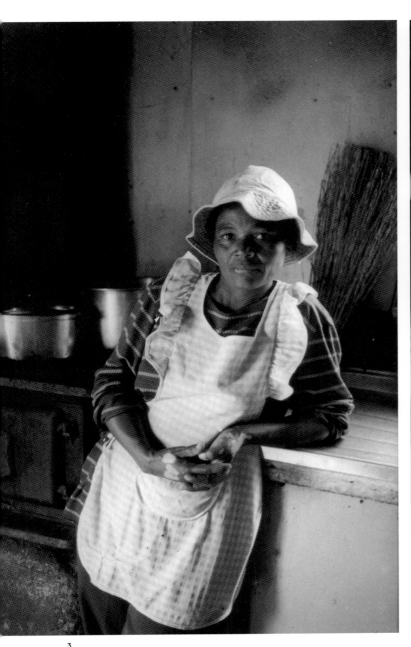

3

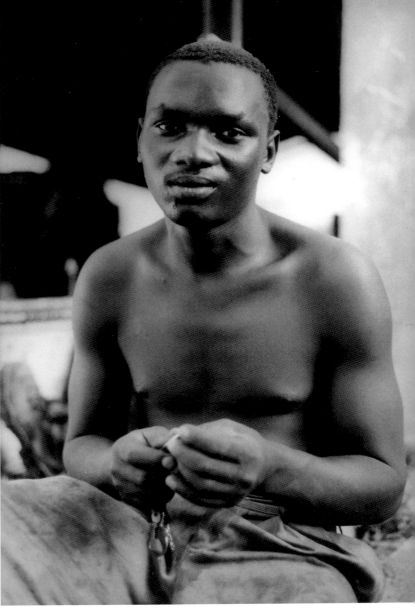

4

DILOMPRIZULIKE

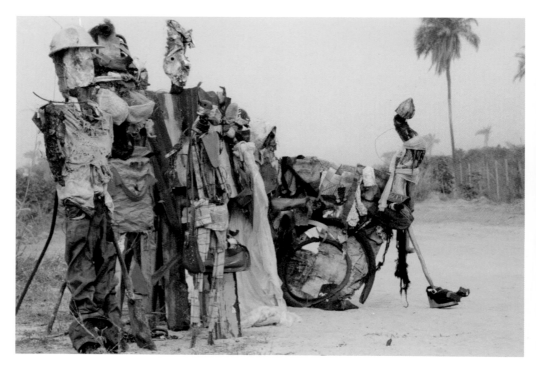

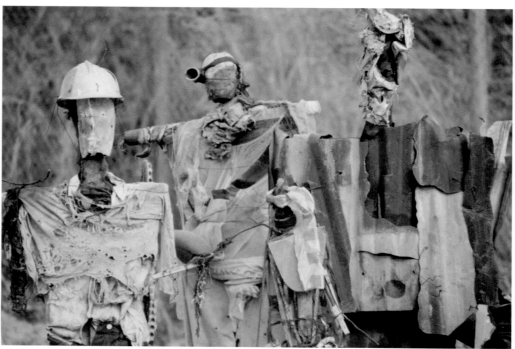

Waiting for bus, 2003 [41]
Metal, textile, wood, mixed media, video

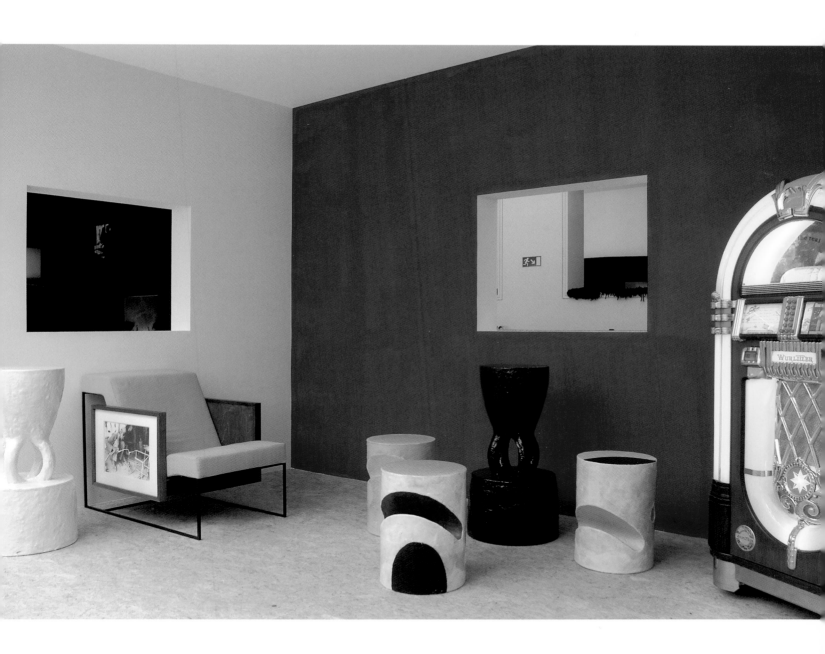

Music Bar for Africa Remix, 2004 [45]
Mixed media

Eclipse n°1, 2001 [48]
Gelatin silver prints mounted
on aluminium

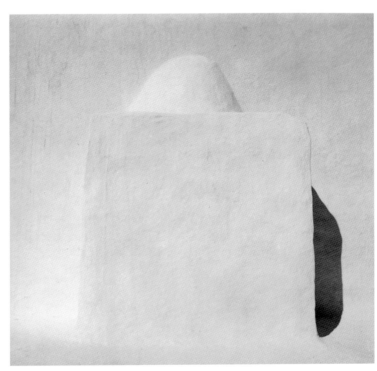

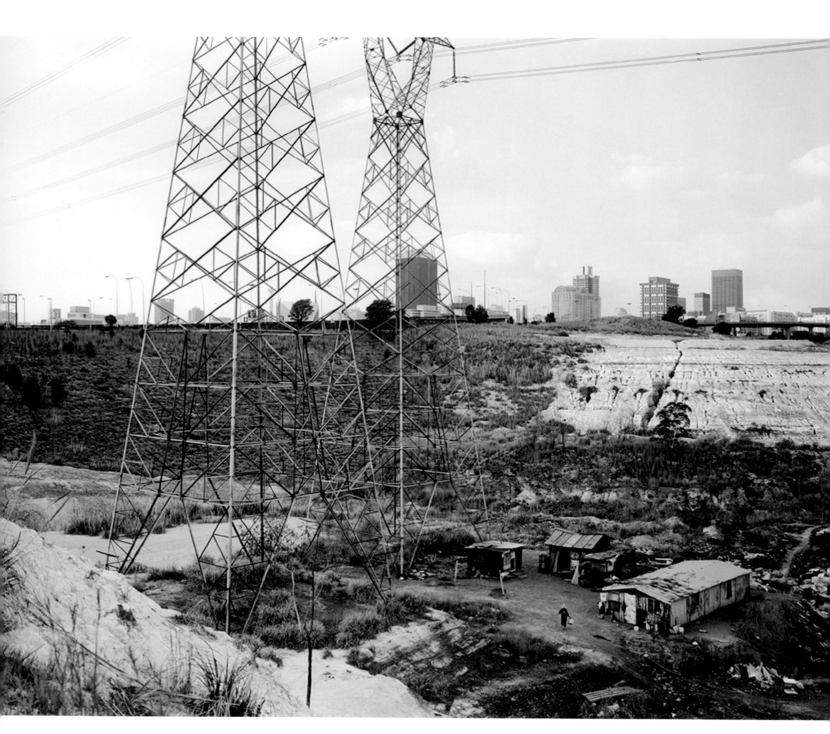

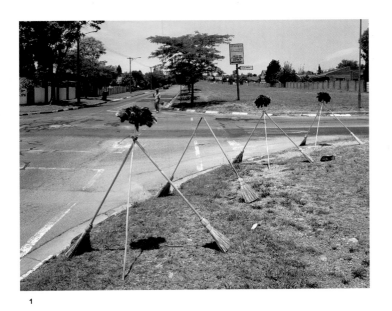

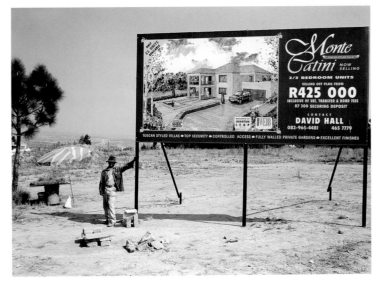

1 Brooms for sale, Elm and First Avenue,
 Edenvale. 22 November 1999 [51]
 Digital print

2 George Nkomo, hawker, Fourways,
 Johannesburg. 21 August 2002 [51]
 Digital print

3 Alexandra Township and Sandton,
 Johannesburg. 11 May 2003 [51]
 Digital print

4 Digging a ditch at the portico to
 Saranton Private Estate, Fourways,
 Johannesburg. 3 April 2002 [51]
 Digital print

5 Waiting to sell food to construction
 workers from 93 Grayston office park,
 Sandton, Johannesburg.
 14 November 2001 [51]
 Digital print

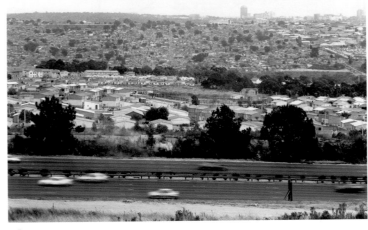

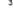

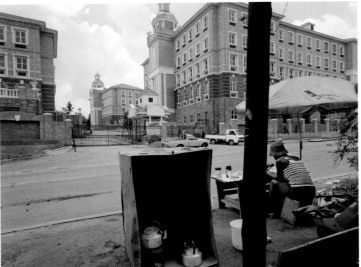

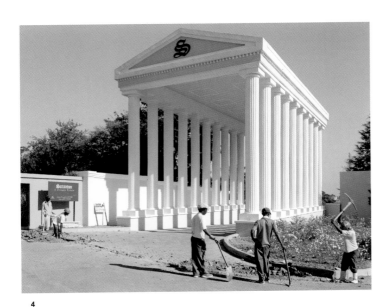

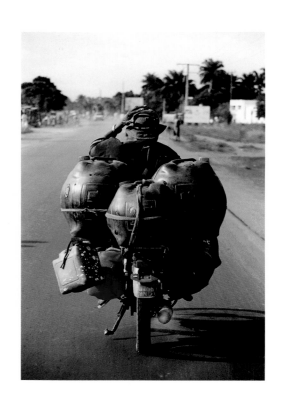

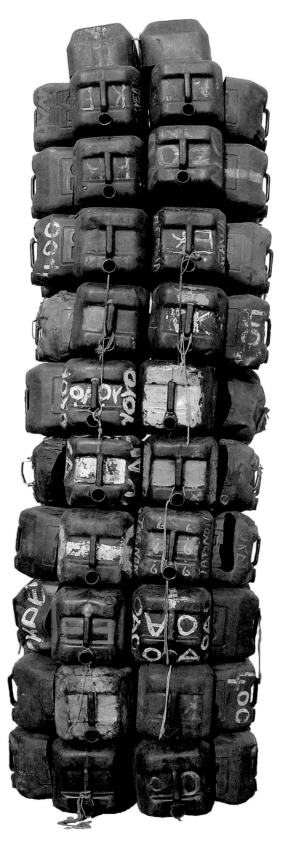

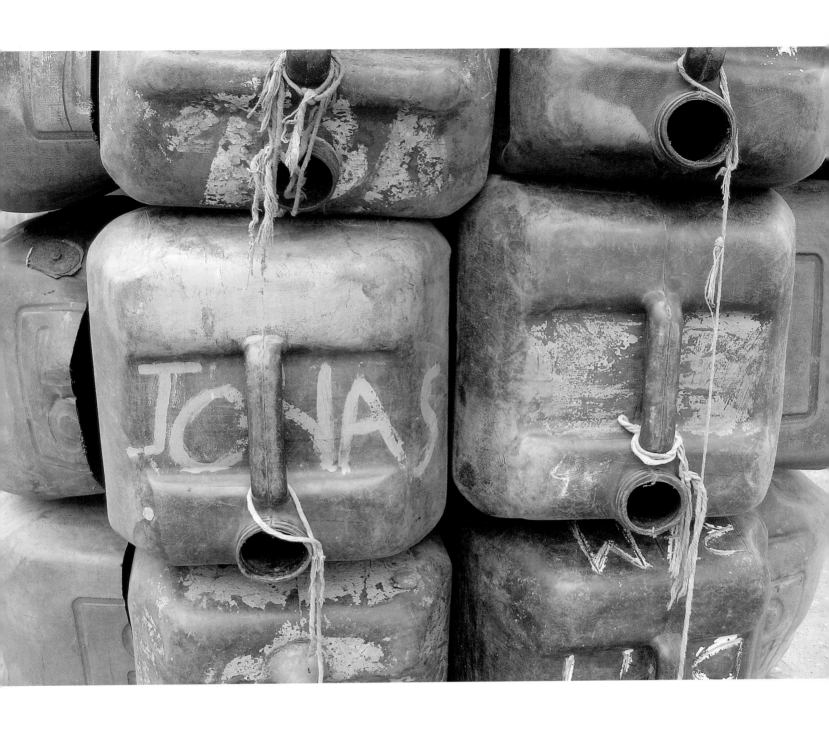

Bidon Armé, 2004 [52] (p.175: detail)
Mixed media, photograph

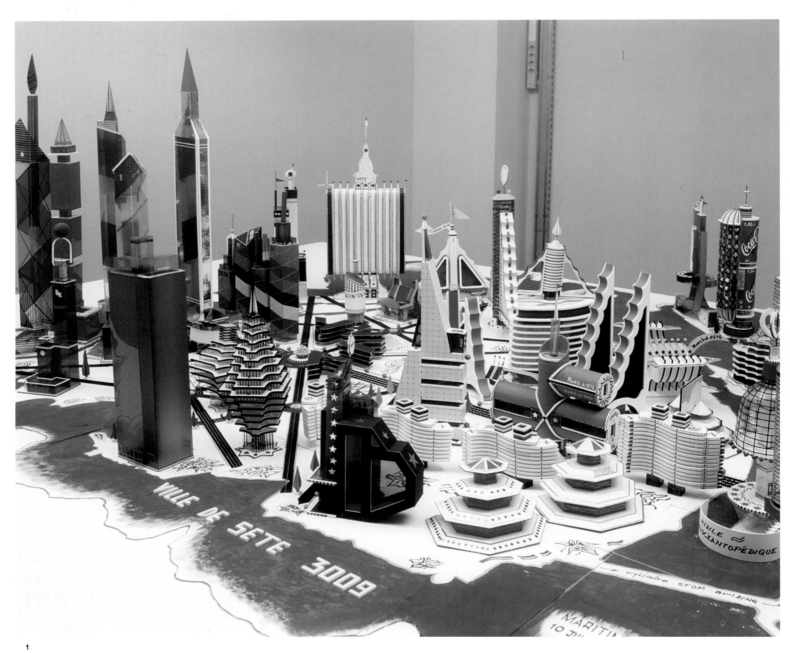

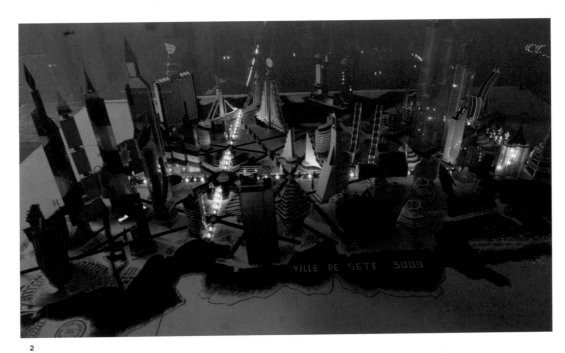

2

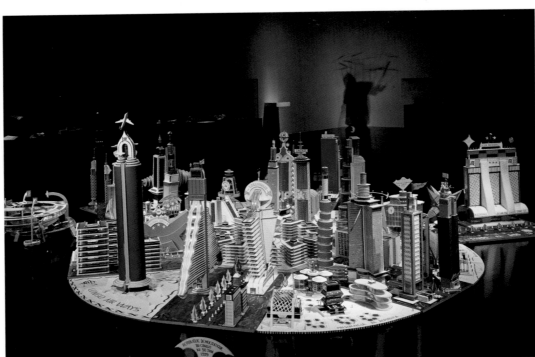

3

1, 2 **Sète en 3009,** 2000 [58]
Mixed media

3 **Projet pour le Kinshasa
du troisième millénaire,** 1997
Mixed media
Diameter: 332 cm; height: 100 cm

Collapsing Guides, 2000–03 [60]
Adhesive tape and collage
on plastic film

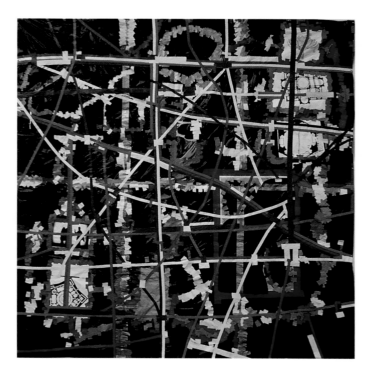 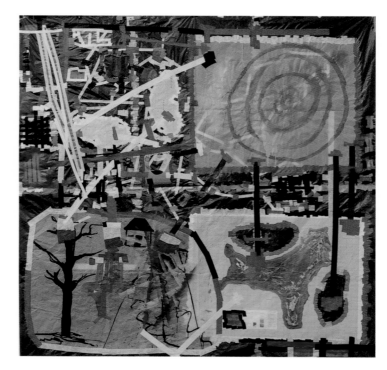

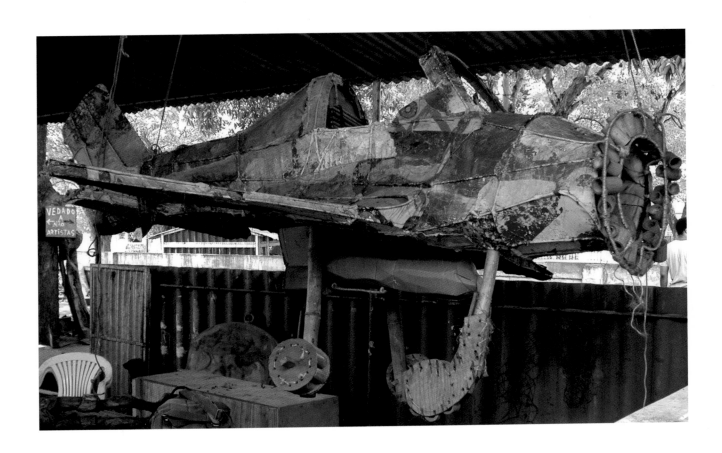

Plane, 2001 [127]
Mixed media (wood, bamboo, rubbish)

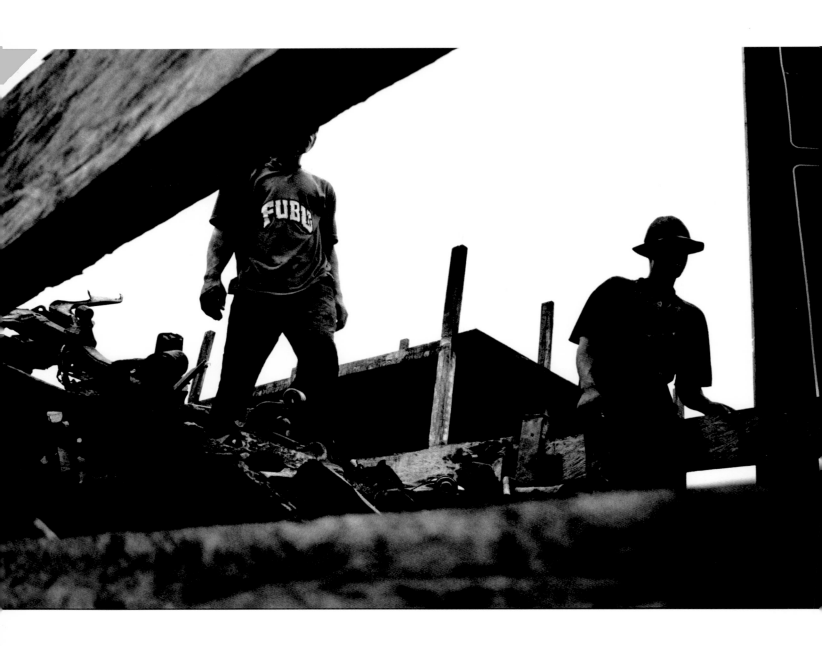

Peregrination 1, 2001–04 [61]
Gelatin silver prints

GONÇALO MABUNDA

Eiffel Tower, 2002 [74]
Metal, recycled weapons

Chair, 2003 [75]
Metal, recycled weapons

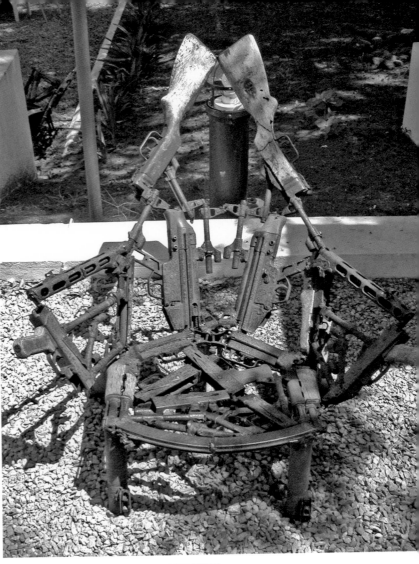

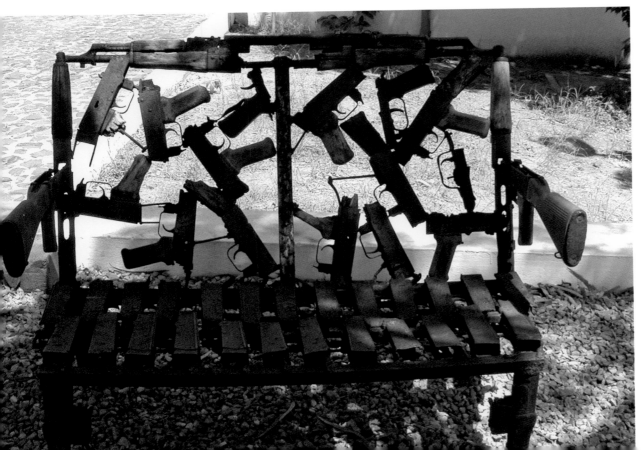

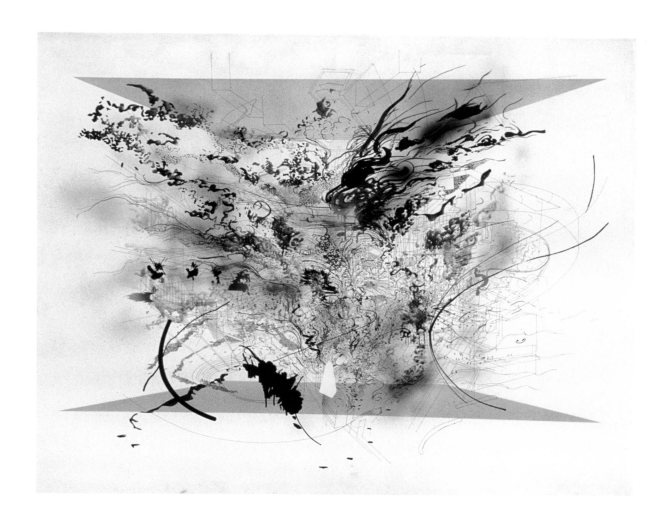

Enclosed Resurgence, 2001 [83]
Ink and acrylic on canvas

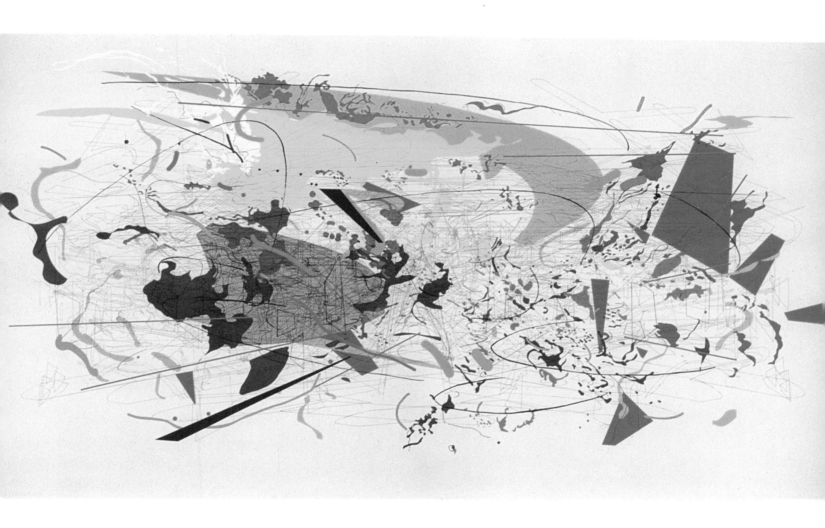

Ruffian Logistics, 2001 [84]
Ink and acrylic on canvas

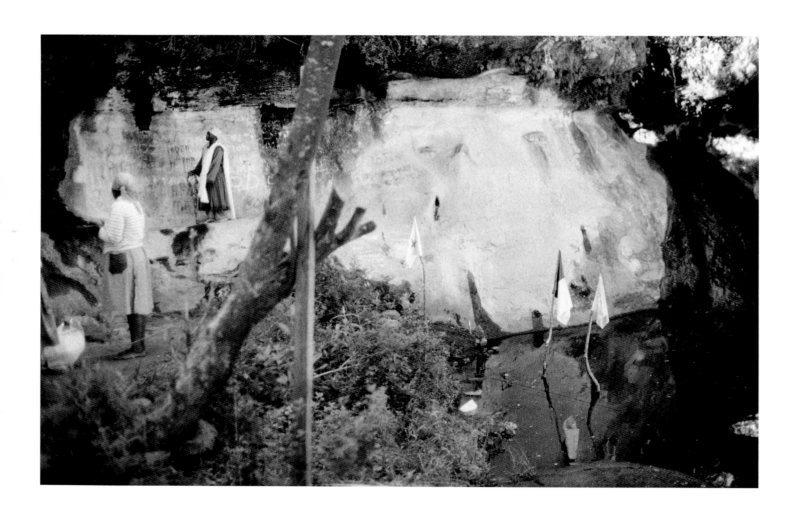

Rethinking landscape, 1996–2002 [86]
Gelatin silver prints

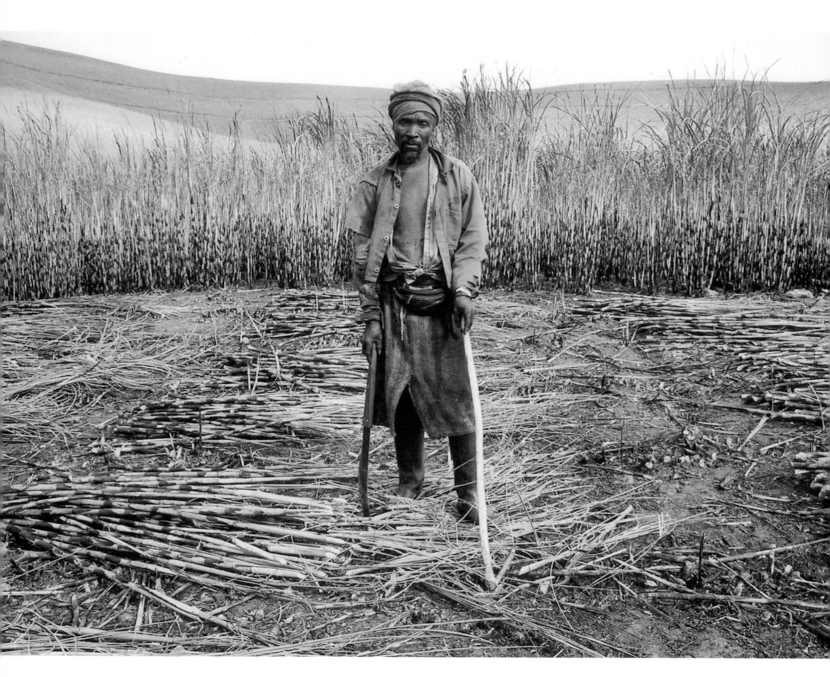

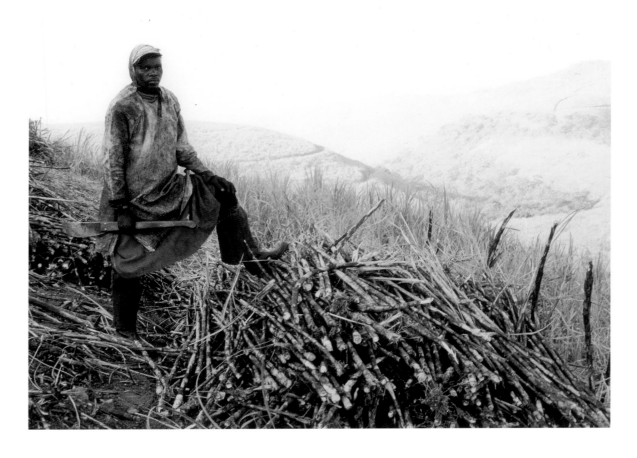

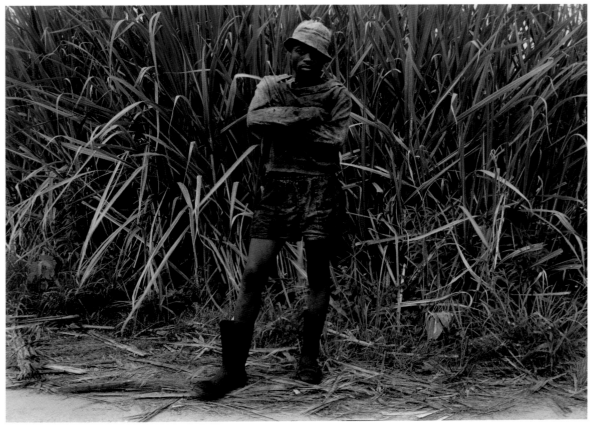

Cairo Noises, 2004 [94]
Painted photographs on canvas
and newspaper relief

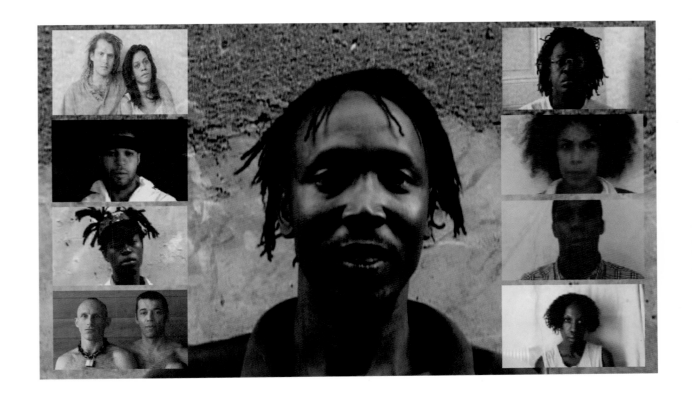

Fin de Cycle, 2000–01 [125]
Video-sound installation; 3 DVDs, mirror

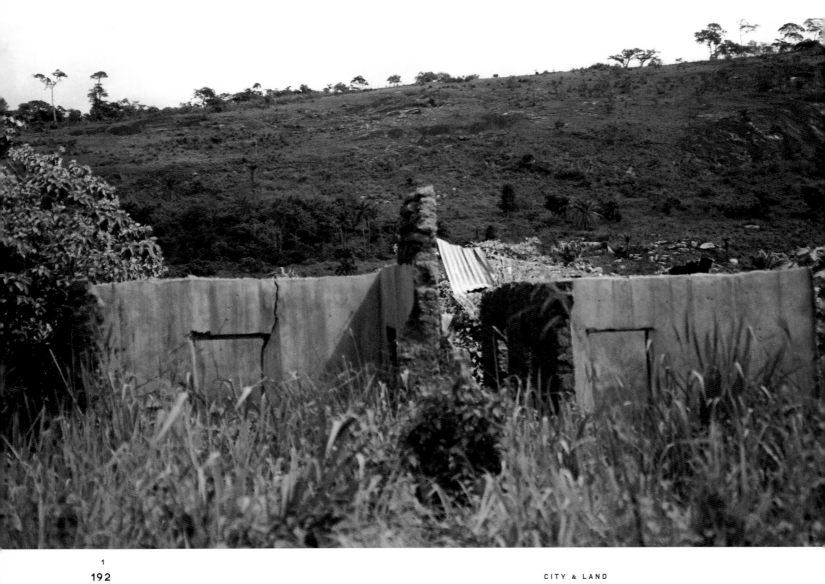

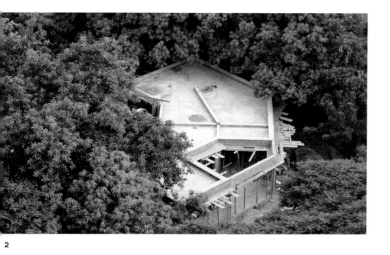

2

3

4

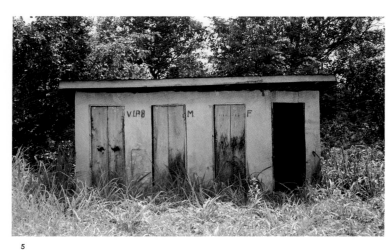

5

Stripped Bare, 2003 [96]
5 C-print photographs

1 Stripped Bare II, 2003
2 Stripped Bare V, 2003
3 Stripped Bare VIII, 2003
4 Stripped Bare IX, 2003
5 Stripped Bare X, 2003

ANTONIO OLE

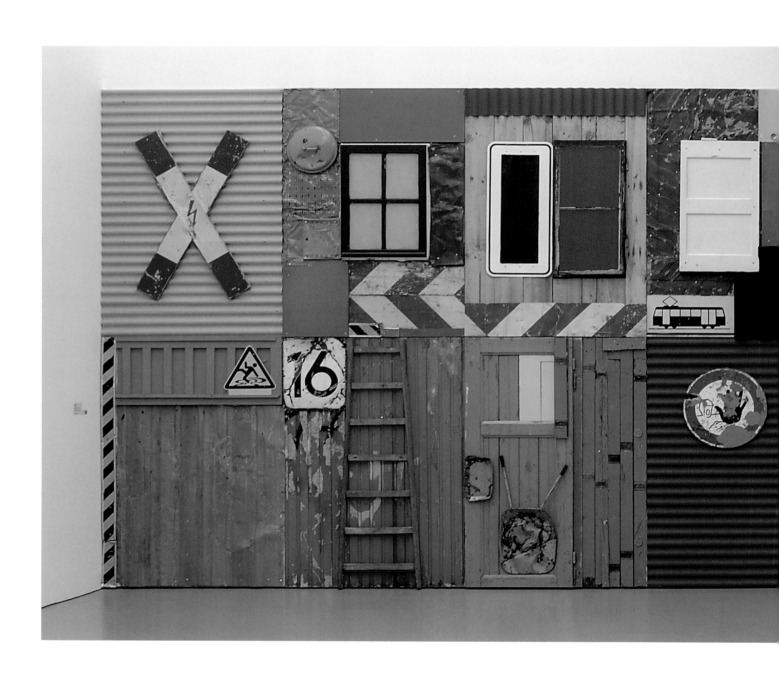

Townshipwall No. 10, 2004 [100]
16 parts, mixed media (found materials)

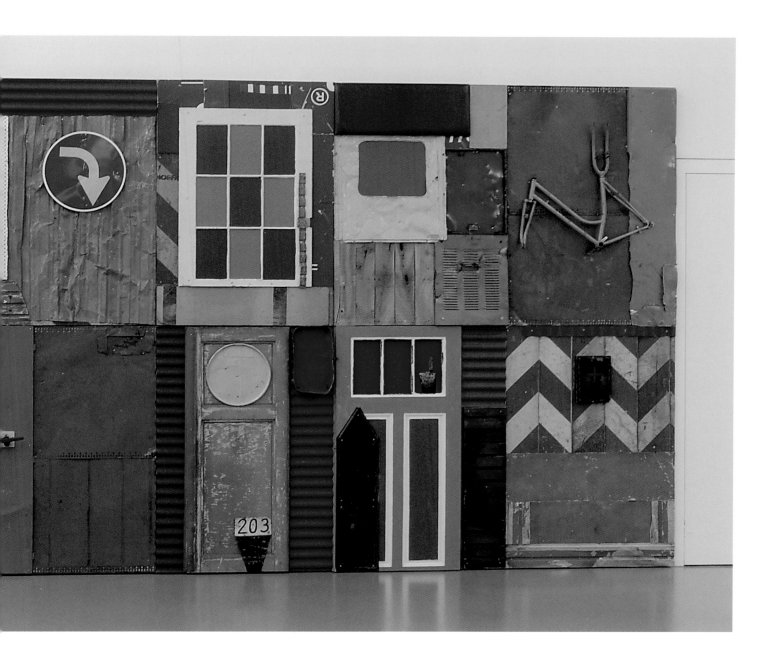

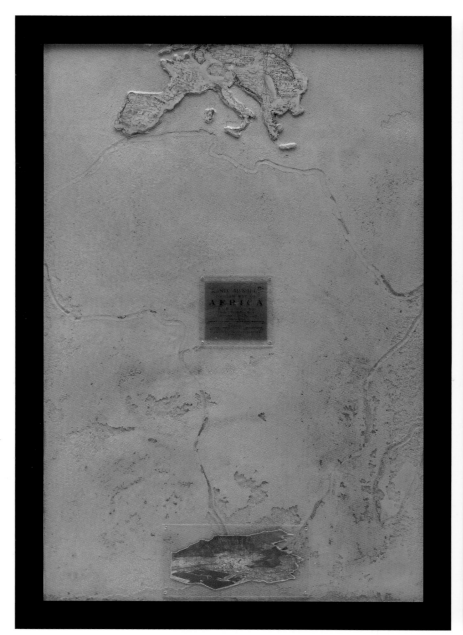
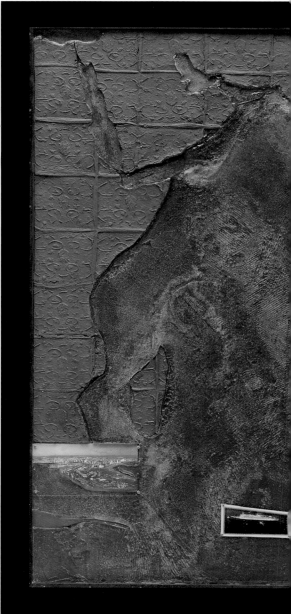

Three Cities Triptych
(Cape Town, Johannesburg, Durban), 2002 [106]
Mixed media in resin

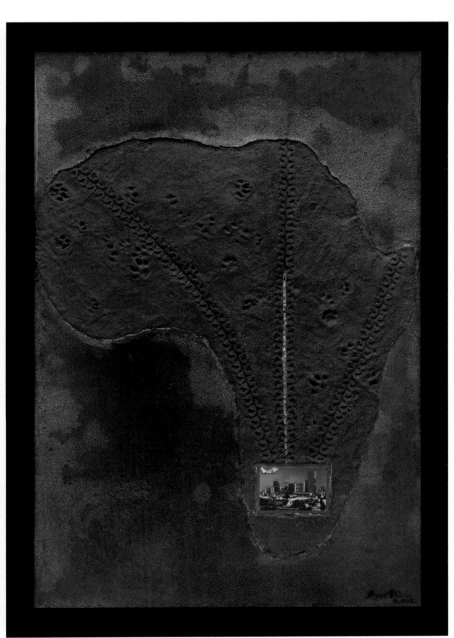

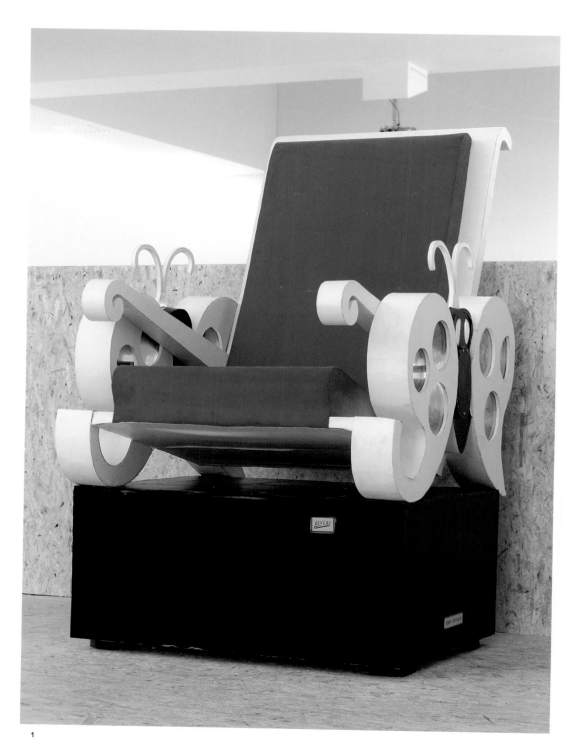

1

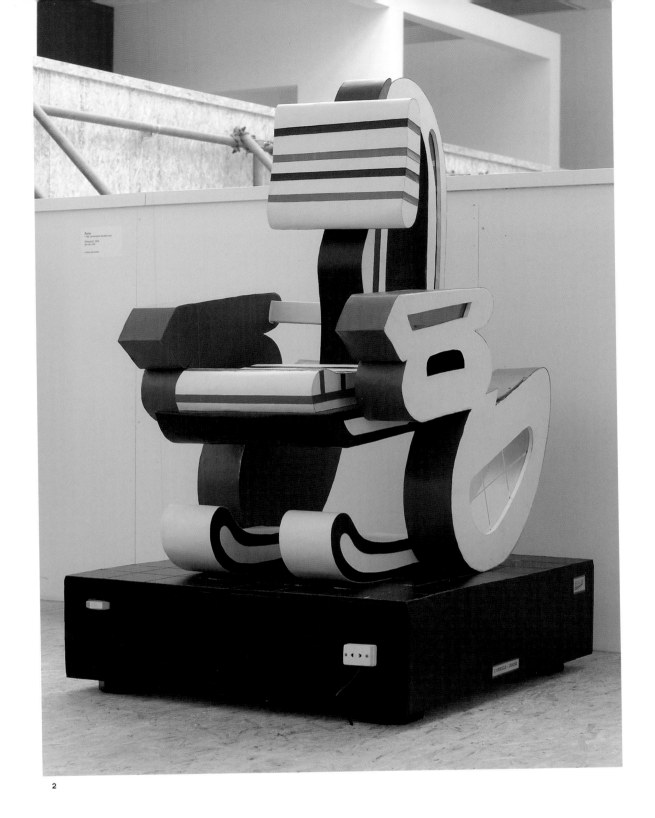

2

1 Papillon chair, 2004 [110]
Mixed media
(plastic film, wood)

2 Ear chair, 2004 [109]
Mixed media (plastic,
plastic film, wood)

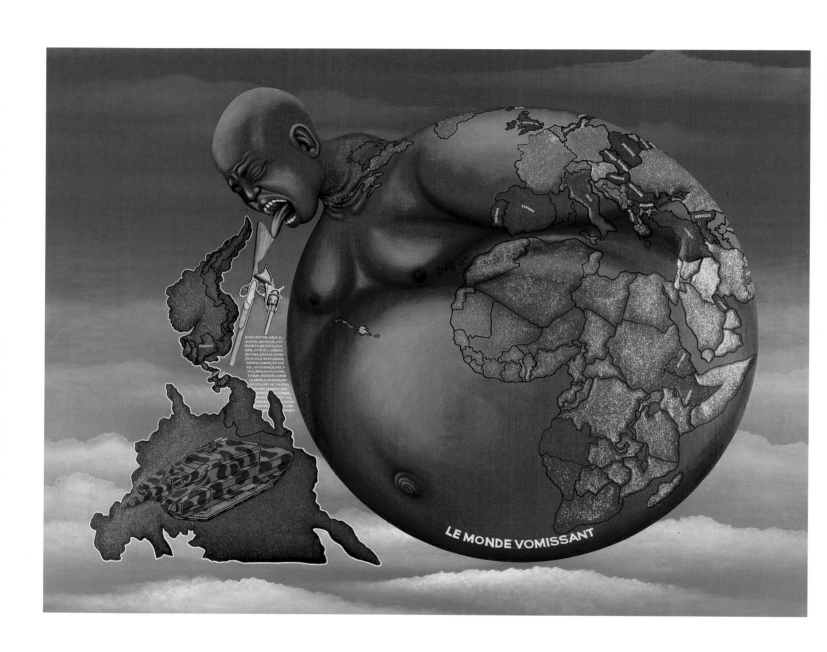

Le Monde Vomissant, 2004 [114]
Acrylic on canvas

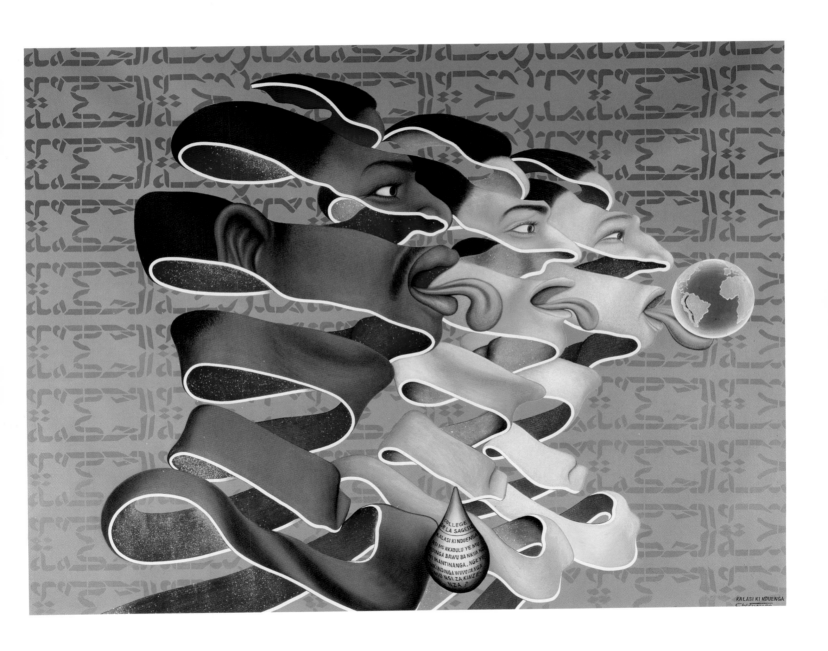

Collège de la Sagesse, 2004 [113]
Acrylic on canvas

CHÉRI CHERIN

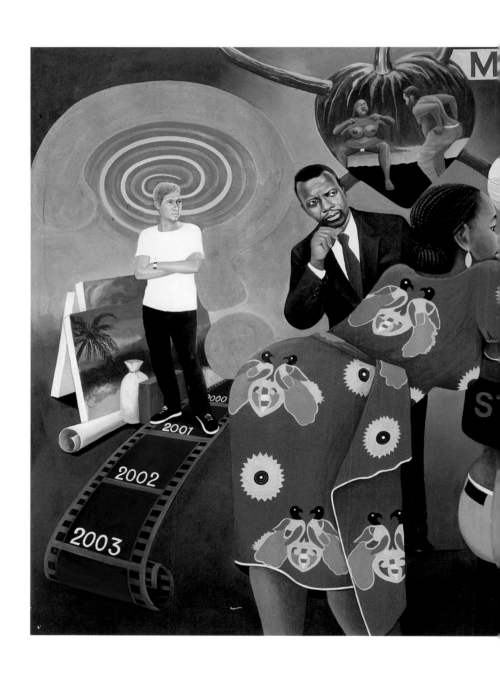

Moké: Le début de la fin
(Hommage á Moké), 2001 [34]
Acrylic on canvas

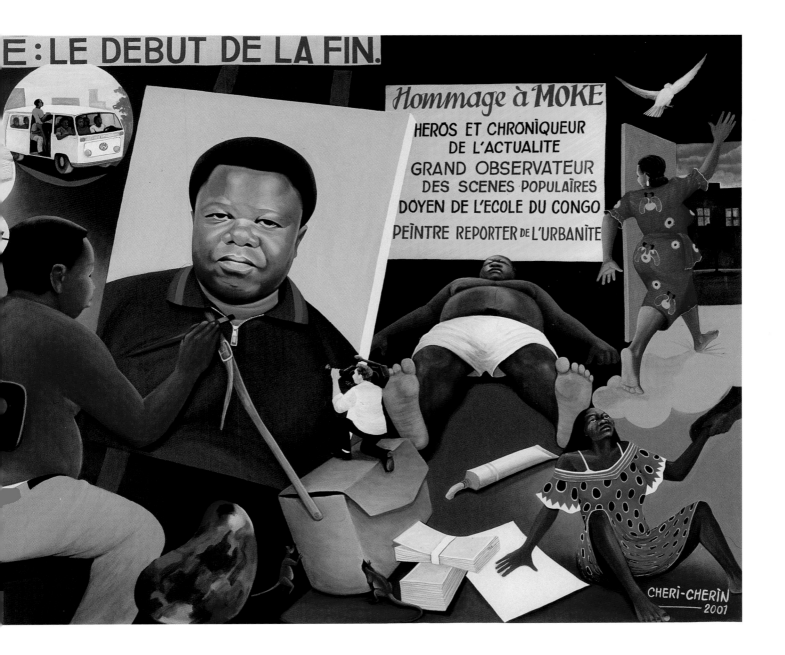

SÉRGIO SANTIMANO

1

2

3

A blurring of the world, a refocusing seconds,
minutes, hours, days, maybe years later,
with everything put together differently,
in ways he doesn't understand, 2001 [120]
C-print photograph

The Goncourt brothers stand
between Caesar and the Thief
of Bagdad, 2003 [122]
C-print photograph

Everything west of
here is Indian Country, 2003 [121]
C-print photograph

L'urbanité rurale, 2004 [124]
Mixed media (4 DVDs,
5 C-Print photographs
on wood, tool wall with
different objects)

1

Kunhinga Portraits [126]
C-print photographs

1 Sophia Salala and Ermalinda Chinhanala

2 Mateus Chitangenda, Fernando Chitala
and Enoke Chisingi

3 Rosalina Nahamba holding baby
Filomena Lasinda. Her daughter,
Rosali Sindali holds baby Guerra

4 Brothers Bernado Sayovo and
Horacio Chikambe

5 Albertina Natatu and Amelia Catembo

2

3

4

5

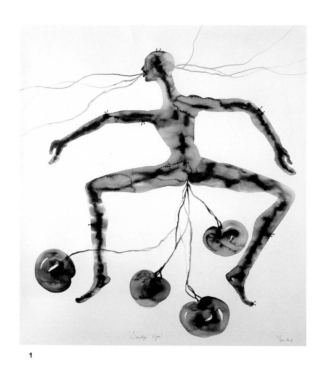

1

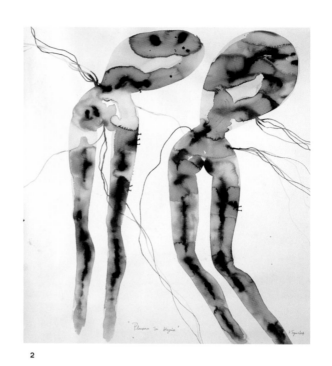

2

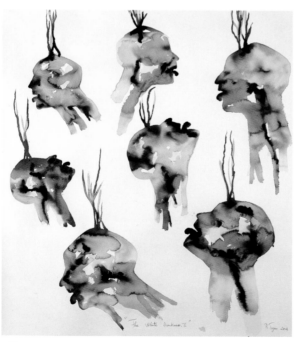

3

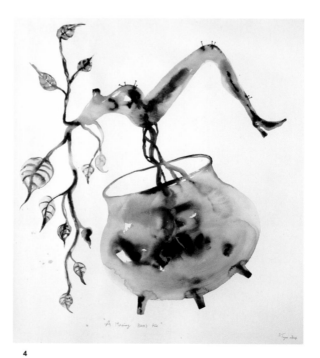

4

Dream Catchers, 2004 [128]
Watercolours

1 Sneaky Eyes
2 Pleasure in Disguise
3 The White Darkness, II
4 A Morning Bum's Kiss

5 The Bug's Orchestra, II
6 Fading Beauty
7 A Feather is Blowing Away, II
8 The Chameleon's Doubts, II

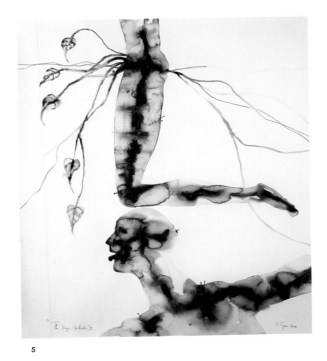

5

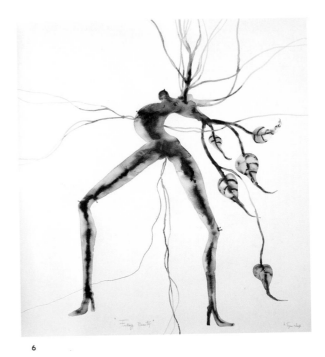

6

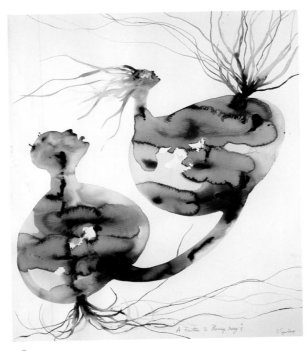

7

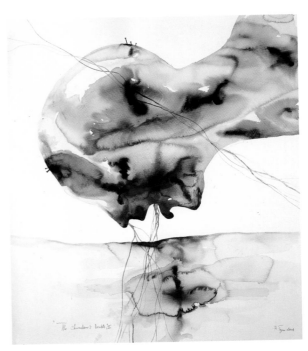

8

BIBLIOGRAPHY

BOOKS

Wijdan Ali
Modern Islamic Art. Development and Continuity, Gainesville, University Press of Florida, 1997.

Petrine Archer-Straw
Negrophilia. Avant-Garde Paris and Black Culture in the 1920s, London, Thames & Hudson, 2000.

Friedrich Axt and El Hadji Sy (eds.)
Bildende Kunst der Gegenwart im Senegal | Anthologie des Arts Plastiques Contemporains au Senegal | Anthology of Contemporary Fine Arts in Senegal, Introduction by Lépold Sédar Senghor, Frankfurt/Main, Museum für Völkerkunde, 1989.

Karin Barber (ed.)
Readings in African Popular Culture, Bloomington, Indiana University Press, and Oxford, Oxford University Press, 1997.

Gilbert Beaugé and Jean-François Clément (eds.)
L'image dans le monde arabe, Paris, CNRS Editions, 1995.

Ulli Beier
Contemporary Art in Africa, London, Pall Mall Press, and New York, Frederick Praeger, 1968.

Peter Benson
Black Orpheus, Transition and Modern Cultural Awakening in Africa, Berkeley, University of California Press, 1986.

Homi K. Bhabha
The Location of Culture, London and New York, Routledge, 1994.

Elisabeth Bronfen, Benjamin Marius and Therese Stelten (eds.)
Hybride Kulturen. Beiträge zur anglo-amerikanischen Multi kultura-lismusdebatte, Tübingen, Stauffenburg Verlag, 1997.

Joëlle Busca
L'Art Contemporain Africain. Du Colonialisme au Postcolonialisme, Paris, L'Harmattan, 2000.

Joëlle Busca
Perspectives sur l'Art Contemporain Africain, Paris, L'Harmattan, 2000.

Néstor García Canclini
Hybrid Cultures: Strategies for Entering and Leaving Modernity, Minneapolis and London, University of Minnesota Press, 1995.

Katy Deepwell (ed.)
Art Criticism and Africa, London, Saffron Books Eastern Art Publishing, 1998.

Gen Doy
Black Visual Culture. Modernity and Postmodernity, London, Tauris Publishers, 2000.

Stéphane Eliard
L'Art Contemporain au Burkina Faso, Paris, L'Harmattan, 2002.

Okwui Enwezor and Olu Oguibe (eds.)
Reading the contemporary. African Art from Theory to the Marketplace. A Critical Anthology of Writings on Contemporary African Visual Culture, London, Institute of International Visual Art (inIVA), 1999.

Johannes Fabian
Remembering the Present. Painting and Popular History in Zaire, Berkeley, University of California Press, 1996.

Johannes Fabian
The Moment of Freedom: On Popular Culture in Africa, Charlottesville, University Press of Virginia, 1998.

N'Goné Fall and Jean-Loup Pivin (eds.)
An Anthology of African Art: The Twentieth Century, New York, DAP, and Paris, Ed. Revue Noire, African Contemporary Art, 2002.

Thomas Fillitz
Zeitgenössische Kunst aus Africa. 14 Gegenwartskünstler aus Côte d'Ivoire und Benin, Vienna, Böhlau Verlag, 2002.

Kojo Fosu
20th Century Art of Africa, Zaria, Gaskiya Corporation, 1986. Neuausg. Accra, Artists Alliance, 1993.

Pierre Gaudibert
L'Art Africain Contemporain, Paris, Editions Cercle d'Art, 1991.

Paul Gilroy
The Black Atlantic. Modernity and Double Consciousness, Cambridge, Harvard University Press, 1993.

Clara Himmelheber, Marjorie Jongbloed and Marcel Odenbach (eds.)
Der Hund ist für die Hyäne eine Kolanuss. Zeitgenössische Kunst und Kultur aus Afrika, Cologne, Oktagon, 2002.

Stephen Howe
Afrocentrism. Mythical Pasts and Imagined Homes, London and New York, Verso, 1999.

Bogumil Jewsiewicki
Mami Wata. La Peinture Urbaine au Congo, Paris, Gallimard, 2003.

Bogumil Jewsiewicki (eds.)
Art et Politiques en Afrique Noir[e] | Art and Politics in Black Africa, Ottawa and Québec, Association canadienne des études africai-nes/Canadian Association of African Studies, 1989.

Bennetta Jules-Rosette
The Messages of Tourist Art. An African Semiotic System in Comparative Perspective, New York, Plenum Press, 1984.

Bennetta Jules-Rosette
Black Paris. The African Writers' Landscape, Urbana and Chicago, University of Illinois Press, 1998.

Liliane Karnouk
Contemporary Egyptian Art, Cairo, American University in Cairo Press, 1995.

Sidney Littlefield Kasfir
Contemporary African Art, London, Thames & Hudson, 1999.

Jean Kennedy
New Currents, Ancient Rivers. Contemporary African Artists in Generation of Change, Washington, Smithsonian Institution Press, 1992.

Andrea Flores Khalil (ed.)
The Arab Avant-garde: Experiments in North African Art and Literature, Westport, Connecticut, Praeger, 2003.

André Magnin and Jacques Soulillou (eds.)
Contemporary art of Africa, New York, Harry N. Abrams, 1996.

Thomas McEvilley
Fusion. West African artists at the Venice Biennale, New York, Museum for African Art, 1993.

Marshall Ward Mount
African Art. The Years since 1920, Bloomington, Indiana University Press, 1973.

Wilson Jeremiah Moses
Afrotopia. The Roots of African American Popular History, Cambridge, Cambridge University Press, 1998.

Es'kia Mphalele
Africa My Music. An Autobiography 1957–1983, Johannesburg, Ravan Press, 1984.

Valentin Mudimbe (ed.)
The Surreptitious Speech: Présence Africaine and the Politics of the Otherness, 1947–1987, Chicago, University of Chicago Press, 1992.

Olu Oguibe
The Cultural Game, Minneapolis and London, University of Minnesota Press, 2004.

Simon Ottenberg
New Traditions from Nigeria. Seven Artists of the Nsukka Group, Washington D.C. and London, Smithsonian Institution Press, 1997.

Simon Ottenberg (ed.)
The Nsukka Artists and Nigerian Contemporary Art, Washington D.C., University of Washington Press, 2002.

Christopher Pinney and Nicolas Peterson (eds.)
Photography's Other Histories, Durham/London, Duke University Press, 2003.

Richard J. Powell
Black Art and Culture in the 20th Century, London, Thames & Hudson, 1997.

Tracy David Snipe
Arts and Politics in Senegal, 1960–1996, Trenton, New Jersey, Africa World Press, 1998.

Jutta Ströter-Bender
Zeitgenössische Kunst der 'Dritten Welt', Cologne, DuMont, 1991.

Sue Williamson
Resistance Art in South Africa, London, David Philip, 1989.

Gavin Younge
Art of the South African Townships, London, Thames & Hudson, 1988.

Philip S. Zachernuk
Colonial Subjects. An African Intelligentsia and Atlantic Ideas, Charlottesville and London, University Press of Virginia, 2000.

MAGAZINE ARTICLES

Elsbeth Court
'Pachipamwe II: The Avant-Garde in Africa?', in *African Arts*, 25/1, 1992, pp.38–49, 98.

Stuart Hall
'When was the "post-colonial"? Thinking at the Limit', in *The Post Colonial Question. Common Skies, Divided Horizons*, Jain Chambers and Lidia Curti (eds.), London and New York, 1996.

Elizabeth Harney
'Les Chers Enfants sans Papa', in *The Oxford Art Journal*, 19/1, 1996, pp.42–52.

Kunstforum, Cologne, 1993, Bd. 122, catalogue *Afrika – Iwalewa*.

Hassan Musa
'Qui a inventé les africains?', in *Les Temps Modernes*, 620/621, 2002, pp.46–100.

Everlyn Nicodemus and Kristian Romare
'Africa, Art Criticism, and the Big Commentary', in *Third Text*, 41, 1997/98, pp.53–66.

Olu Oguibe (ed.)
Third Text, 23, 1993, special edition Africa.

EXHIBITION CATALOGUES

1969
Contemporary African Art, Studio International, Camden Arts Centre, London.

1988
Alaoui Brahim (ed.)
Art contemporain arabe. Collection du Musée d' Institut du Monde Arabe, Institut du Monde Arabe, Paris.

1989
Magiciens de la terre, Centre Georges Pompidou, Paris.

Wooden sculpture from East Africa from the Malde Collection, Museum of Modern Art, Oxford.

1990
Art from the Frontline. Contemporary Art from Southern Africa, Glasgow Art Gallery (touring exhibition), London, Frontline States/Karia Press.

Art from South Africa, Museum of Modern Art, Oxford, London, Thames & Hudson.

Contemporary African Artists: Changing Traditions, The Studio Museum of Harlem, New York.

1991
Suzanne Vogel (ed.)
Africa Explores: 20th Century African Art, Center for African Art, New York.

Africa Hoy (Africa Now), Centro Atlántico de Arte Moderno, Las Palmas de Gran Canaria, Las Palmas (touring exhibition).

1992
La Naissance de la Peinture Contemporaine en Afrique Centrale 1930–1970, Musée Royal de l'Afrique Centrale, Tervuren, Belgium.

1994
Simon Njami (ed.)
Otro País. Escalas Africanas, Centro Atlántico de Arte Moderno, Las Palmas de Gran Canaria.

Rencontres Africaines, Institut du Monde Arabe, Paris.

1995
Africus, Johannesburg Biennale, Transitional Metropolitan Council, Johannesburg.

Yukiya Kawaguchi (ed.)
An Inside Story. African Art of our Time, The Yomiuri Shimbun, Japan Association of Art Museums, Setagawa Art Museum, Tokyo.

Big City. Artists from Africa, Serpentine Gallery, London.

Clémentine Deliss (ed.)
Seven Stories about Modern Art in Africa, Whitechapel Art Gallery, London, and Konsthall, Malmö, Paris and New York, Flammarion.

1996
Peter Weibel (ed.)
Inklusion: Exklusion. Versuch einer neuen Kartografie der Kunst im Zeitalter von Postkolonialismus und globaler Migration, steirischer herbst, Graz,1996.

Neue Kunst aus Afrika, Haus der Kulturen der Welt, Berlin.

1997
Die Anderen Modernen. Zeitgenössische Kunst aus Afrika, Asien und Lateinamerika, Haus der Kulturen der Welt, Berlin.

Salah Hassan (ed.)
Gendered Visions. The Art of Contemporary African Women Artists, Trenton, New Jersey, Africa World Press.

Suites Africaines, Couvent des Cordeliers, Paris, Ed. Revue Noire.

Okwui Enwezor (ed.)
Trade Routes: History and Geography, Royal Academy of Arts, London, Thames & Hudson.

1998
Africa Africa. Vibrant New Art from a Dynamic Continent, Tobu Museum of Art, Tokyo.

1999
South meets West, 1999, National Museum of Ghana, Accra, Kunsthalle Berne.

2000
Simon Njami (ed.)
El Tiempo de Africa, Centro Atlántico de Arte Moderno, Las Palmas de Gran Canaria, Madrid

Enrico Mascelloni e Sarenco (ed.)
Il Ritorno dei Maghi, Orvieto, Palazzo dei Sette, Milan, Skira.

2001
Pep Subiros (ed.)
Africas. The Artist and the City, a Journey and an Exhibition, CCCB (Centre de Cultura Contemporània de Barcelona), Actar, Barcelona.

Salah Hassan and Olu Oguibe (eds.)
Authentic/Ex-centric. Conceptualism in Contemporary African Art, 49. Biennale, Venice, Forum for African Arts, New York, Ithaca, New York.

Okwui Enwezor (ed.)
The Short Century. Independence and Liberation Movements in Africa, 1945–1994, Museum Villa Stuck, Munich (touring exhibition, Haus der Kulturen der Welt, Berlin, Museum of Contemporary Art, Chicago, P.S.1 Contemporary Art Center, New York), Munich, Berlin, London and New York, Prestel.

Salah Hassan and Dadi Iftikhar (eds.)
Unpacking Europe. Towards a Critical Reading, Museum Boijmans van Beuningen, Rotterdam (NAi Uitgevers/ Publishers).

2003
A Fiction of Authenticity. Contemporary Africa Abroad, Contemporary Art Museum, St Louis, Missouri.

Allen Roberts and Mary Nooter Roberts (eds.)
A Saint in the City. Sufi Arts of Urban Senegal, UCLA (University of California, Los Angeles), Fowler Museum of Cultural History, Los Angeles.

Elizabeth Harney (ed.)
Ethiopian Passages. Contemporary Art from the Diaspora, Smithsonian Museum, Washington D.C., London, Philip Wilson Publishers.

Gilane Tawadros and Sarah Campbell (eds.)
Fault Lines. Contemporary African Arts and Shifting Landscapes, Institute of International Visual Art (inIVA), London.

Laurie Ann Farrell (ed.)
Looking both Ways. Art of the Contemporary African Diaspora, Museum for African Art, New York.

LIST OF WORKS

This list includes all the works featured in the Düsseldorf showing of *Africa Remix.* Only works marked with * are in the Hayward Gallery showing.

Works marked † are in the Hackney Museum showing.

All measurements are height x width x depth. Page references are to illustrations in this book.

AKINBODE AKINBIYI
Nigerian; born 1946 in Oxford, UK; lives in Berlin

1 (p.153)
Cairo: Masr, 2003*
9 gelatin silver prints
50 x 50 cm each
Courtesy of the artist

2 (p.154)
Lagos: all roads, 2003*
9 gelatin silver prints
50 x 50 cm each
Courtesy of the artist

SUNDAY JACK AKPAN
Born 1940 in Ikot Ide Etukudo, Nigeria

3
Chef de la police (3 galons)
Reinforced glycerophtalic cement
184.5 x 54 x 41 cm
Musée d'Art Contemporain de Lyon

JANE ALEXANDER
Born 1959 in Johannesburg, South Africa; lives and works in Cape Town

4 (pp.56–57)
African adventure, 1999–2002*
Mixed media and bushsand
c.400 x 900 cm
Courtesy of the artist
© Jane Alexander 2005
Photo: Installation views at the Castle of Good Hope, Cape Town (© Mark Lewis)

FERNANDO ALVIM
Born 1963 in Luanda, Angola; lives and works in Brussels and Luanda

5 (p.59)
Belongo, 2003*
Belgian flag with sewn lettering
209 x 209 x 6.5 cm
Courtesy of Collection Sindika Dokolo

6 (p.59)
Camouflage – In God we trust, 2003*
Canvas, collage of US Dollars, bronze lettering
190 x 190 cm
Courtesy of Collection Sindika Dokolo

7 (p.58)
Camouflage – Washington Oyé, 2004*
Acrylic printed on fabric
190 x 190 cm
Courtesy Ricardo Viegas D'Abreu

8 (p.58)
We are all post exotics, 2004*
Canvas, pencil lettering, mirror
190 x 190 cm
Courtesy of Costa Reis / Compliação de Arte Africana Actual

GHADA AMER
Born 1963 in Cairo, Egypt; lives and works in New York

9 (p.98)
Black and White Kiss, 2003*
Acrylic, gel and embroidery on canvas
200 x 213 cm
Ovitz Family Collection, Los Angeles
© ADAGP, Paris and DACS, London 2005
Photo: Rob McKeever

10 (p.99)
Wallpaper RFGA, 2003*
Acrylic and embroidery on canvas
183 x 178 cm
Courtesy of the artist and Gagosian Gallery, New York
© ADAGP, Paris and DACS, London 2005
Photo: Rob McKeever

11
Beauty and the Lovers, 2004*
Acrylic and embroidery on canvas
178 x 183 cm
Courtesy of the artist and Gagosian Gallery, New York

EL ANATSUI
Born 1944 in Anyako, Ghana; lives and works in Nsukka, Nigeria

12
Open(ing) Market, 2004
Mixed media
Dimensions variable
Collection of the artist
Courtesy of October Gallery, London

13 (pp.154–55)
Sasa, 2004*
Aluminium and copper wire
640 x 840 cm
Collection of the artist
Courtesy of October Gallery, London
Photo: Martin Barlow, Oriel Mostyn Gallery

JOËL ANDRIANOMEARISOA
Born 1977 in Antananarivo, Madagascar; lives and works in Paris

14 (pp.100–01)
Paravents, 2004
Textiles, cardboard
Dimensions variable
Courtesy of the artist
Photo: Lothar Milatz

RUI ASSUBUJI
Born 1964 on Ilha do Ibo, Cabo Delgado, Mozambique; lives and works in Maputo, Mozambique

15 (pp.158–59)
Religion in Mozambique, 2003†
6 gelatin silver prints
40 x 50 cm each
Courtesy of the artist
© Rui Assubuji 2005

LARA BALADI
Born 1969 in Beirut, Lebanon; lives and works in Egypt

16 (pp.60–61)
Shish Kebap, 2004*
Video installation, mixed media
c.120 x 47 x 42 cm
Running time: 5 minutes
Courtesy of the artist

YTO BARRADA
Moroccan; born 1971 in Paris; lives and works in Paris and Tangiers, Morocco

17
The Strait Project, 1998–2004*
13 C-print photographs
5 at 60 x 60 cm
5 at 80 x 80 cm
1 at 123 x 123 cm
1 at 103 x 103 cm
1 at 125 x 125 cm
Courtesy of the artist and Galerie Polaris, Paris

LUÍS BASTO
Born 1965 in Maputo, Mozambique; lives and works in Maputo and Harare, Zimbabwe

18 (pp.160–61)
Maputo, 2003†
Fibre-based photographic prints
40 x 50 cm each
Courtesy of the artist

MOHAMED EL BAZ
Born 1967 in El Ksiba, Morocco; lives and works in Lille, France

19 (pp.156–57)
Bricoler l'incurable. Niquer la mort / Love supreme, 2004*
Mixed media
c.500 x 800 cm
Courtesy of the artist
Photo: Lothar Milatz

HICHAM BENOHOUD
Born 1968 in Marrakech, Morocco; lives and works in Marrakech

20 (p.102)
La salle de classe, 1994–2001*
4 photographs
on aluminium
40 x 60 cm
Courtesy of the artist and Galerie VU

21 (p.103)
Version soft, 2003
4 photographic prints on aluminium
120 x 80 cm each
Courtesy of the artist and Galerie VU

WILLIE BESTER
Born 1956 in Cape Town, South Africa; lives and works in Cape Town

22 (pp.64–65)
For those left behind, 2003*
Recycled metal
470 x 218 x 140 cm
Courtesy of the artist
Photo: Vgallery (South African Virtual Art Gallery)

BERRY BICKLE
Born 1959 in Bulawayo, Zimbabwe; lives and works in Harare, Zimbabwe

23 (pp.162–63)
Swimmer, 2004*
4 laminated photojet prints
84 x 119 cm each
Courtesy of the artist

BILI BIDJOCKA
Born 1962 in Duala, Cameroon; lives and works in Paris, Brussels and Mana, French-Guyana

24 (p.104)
The Room of Tears / Pédiluve #4, 2004
Video-sound installation
c.800 x 500 x 370 cm
Courtesy of the artist

ANDRIES BOTHA
Born 1952 in Durban, South Africa; lives and works in Durban and Glennwoca, South Africa

25 (p.66)
History has an aspect of oversight in the process of progressive blindness, 2004*
Mixed media
Dimensions variable
Courtesy of the artist
Photo: Lothar Milatz

WIM BOTHA
Born 1974 in Pretoria, South Africa; lives and works in Pretoria

26 (pp.164–65)
Commune: Onomatopoeia, 2003*
Mixed media
Dimensions variable
Michael Stevenson Contemporary, Cape Town

ZOULIKHA BOUABDELLAH
Algerian; born 1977 in Moscow, Russia; lives and works in Paris

27 (p.67)
Dansons, 2003*
DVD installation
Dimensions variable
Running time: 5 minutes
Courtesy of the artist

FRÉDÉRIC BRULY BOUABRÉ
Born c.1923 in Zepreguhe, Ivory Coast; lives and works in Abidjan, Ivory Coast

28 (p.105)
L'Invention de la Casquette, 1993*
Crayon, felt pen on paper
44.5 x 55 cm
Collection Cyrille Putman

29
Trois plumes (Une plume d'aigle; Une plume d'un coq blanc; Une plume d'un pigeon), 1996*
3 crayon and ballpoint pen drawings on cardboard
9 x 15 cm each
Collection Cyrille Putman

30
Genèse de la machine à coudre, 1988*
Pencil, crayon, needles, thread collage
15.2 x 20.3 cm
Courtesy of the CAAC (Contemporary African Art Collection), The Jean Pigozzi Collection, Geneva

31 (pp.106–07)
Genèse du missile, 1988*
8 crayon and ballpoint pen drawings on cardboard
10 x 15 cm each
Courtesy of the CAAC (Contemporary African Art Collection), The Jean Pigozzi Collection, Geneva

32
La descendance, 2003*
Pencil, crayon on cardboard
28 x 109 x 3 cm
Courtesy of the CAAC (Contemporary African Art Collection), The Jean Pigozzi Collection, Geneva

PAULO CAPELA
Born 1947 in Ouiz, Angola; lives and works in Angola

33 (pp.108–09)
Che Guevara, 1999*
Mixed media
c.200 x 200 cm
Courtesy of Camouflage

CHÉRI CHERIN
Born 1955 as Joseph Kinkonda in Kinshasa, Democratic Republic of Congo (formerly Zaire); lives and works in Kinshasa

34 (pp.202–03)
Moké: Le début de la fin (Hommage á Moké), 2001
Acrylic on canvas
142 x 293 cm
CAAC (Contemporary African Art Collection), The Jean Pigozzi Collection, Geneva

LOULOU CHERINET
Ethiopian / Swedish; born 1970 in Gothenburg, Sweden; lives and works in Stockholm

35 (p.110)
Bleeding Men, 2003
Projection, autoloop on DVD
Running time: 9 minutes
Courtesy of the artist
© Loulou Chérinet 2003

36 (p.111)
White Women, 2002*
Projection, autoloop on DVD
Running time: 52 minutes
Courtesy of the artist
© Loulou Chérinet 2002

SOLY CISSÉ
Born 1969 in Dakar, Senegal; lives and works in Dakar

37 (pp.68–69)
Monde perdu I – XVI, 2003*
Charcoal on paper
47.5 x 52 cm each
Courtesy of Ronald Jung
Photo: Walter Klein

OMAR D.
Born 1951 in Algeria; lives in Paris and Algiers

38 (pp.112–13)
Algérie, Portraits
4 C-print photographs
120 x 120 cm each
Courtesy of the artist

TRACEY DERRICK
Born in South Africa; lives and works in Cape Town

39 (pp.166–67)
EarthWorks, 2001–04*
10 black-and-white photographic prints
7 at 81.1 x 61.4 cm
3 at 63.5 x 80.4 cm
Courtesy of the artist

CHEICK DIALLO
Born 1960 in Bamako, Mali; lives and works in Rouen, France

40 (pp.116–17)
Reading Room for Africa Remix, 2004*
Metal, recycled material and plastic
Dimensions variable
Courtesy of the artist
Photo: Lothar Milatz

DILOMPRIZULIKE
Born 1960 in Enugu, Nigeria; lives and works in Lagos, Nigeria

41 (p.168)
Waiting for bus, 2003*
Metal, textile, wood, mixed media, video
16 figures: c.180 cm height, 275 cm length
Courtesy of the artist

MARLENE DUMAS
Born 1953 in Cape Town, South Africa; lives in Amsterdam

42 (pp.70–71)
Blindfolded, 2001*
20 India ink and washed ink drawings on paper
35 × 29 cm each
Stichting de Pont, Tilburg
Courtesy of Galerie Paul Andriesse, Amsterdam

YMANE FAKHIR
Born 1969 in Casablanca, Morocco; lives and works in Marseilles, France

43 (p.72)
Un ange passe, 2003†
13 C-print photographs on aluminium
60 × 90 cm each
Courtesy of the artist

MOUNIR FATMI
Born 1970 in Tangiers, Morocco; lives and works in Paris and Tangiers

44 (pp.74–75)
Obstacles, 2003
Mixed media
Dimensions variable
Courtesy of the artist
© ADAGP, Paris and DACS, London 2005
Photo: Lothar Milatz

Manipulations, 2004*
DVD
Running time: 6 minutes, 30 seconds
Courtesy of the artist

BALTHAZAR FAYE
Born 1964 in Dakar, Senegal; lives and works in Paris

45 (p.169)
Music Bar for Africa Remix, 2004*
Mixed media
Dimensions variable
Courtesy of the artist
Photo: Lothar Milatz

SAMUEL FOSSO
Born 1962 in Kumba, Cameroon; lives and works in Bangui, Central African Republic

46 (pp.76–77)
Série Tati, autoportrait I – V, 1997*
5 C-print photographs
3 at 127 × 101 cm
2 at 101 × 101 cm
Centre Georges Pompidou, Musée national d'art moderne – Centre de création industrielle

MESCHAC GABA
Born 1961 in Cotonou, Benin; lives and works in Amsterdam

47 (p.73)
The African Bakery, 2004*
Mixed media
Dimensions variable; shelf: 160 × 170 cm
Courtesy of the artist, Lumen Travo Gallery, Amsterdam, Netherlands and Artra Gallery, Milan, Italy
© DACS 2005
Photo: Anselme Hounkpatin, Cotonou, Benin

JELLEL GASTELI
Born 1958 in Tunis, Tunisia; lives and works in Paris

48 (pp.170–71)
Eclipse n°1, 2001
Gelatin silver prints mounted on aluminium
7 at 100 × 100 cm each
Courtesy of Michael Hoppen Gallery, London

GERA
Born 1941 in Tsata, Ethiopia; died 2000

49 (p.114)
Cahiers V–VII, juillet – octobre 1975
Crayon and ink on paper
32 × 24 cm
Private collection

50 (p.115)
Livre des mystères du ciel et de la terre, 1984*
Crayon and ink on paper
24 × 32 cm
Private collection

DAVID GOLDBLATT
Born 1930 in Randfontein, South Africa; lives and works in Johannesburg

51 (pp.172–73)
Waiting to sell food to construction workers from 93 Grayston office park, Sandton, Johannesburg. 14 November 2001; Women singing, Newtown Squatter Camp, Johannesburg. 1 November 2001; Advert, 11 Street and 11 Avenue, Lower Houghton, 27 November 1999; Brooms for sale, Elm and First Avenue, Edenvale. 22 November 1999; Foundations: Johannesburg from the southwest. 12 July 2003; Alexandra Township and Sandton, Johannesburg. 11 May 2003; George Nkomo, hawker, Fourways, Johannesburg. 21 August 2002; Digging a ditch at the portico to Saranton Private Estate, Fourways, Johannesburg. 3 April 2002; Silencers for sale and fitting, Hillbrow, Johannesburg. 13 January 2002
9 digital prints
4 at 61 × 75 cm, 5 at 112 × 136 cm
Courtesy of the artist

ROMUALD HAZOUMÉ
Born 1962 in Porto Novo, Benin; lives and works in Porto Novo

52 (pp.174–75)
Bidon Armé, 2004*
Mixed media, photograph
380 × 110 × 110 cm
Courtesy of the artist
© ADAGP, Paris and DACS, London 2005

JACKSON HLUNGWANI
Born 1923 in Nkanyani, Gazankulu, South Africa; lives and works in Mbhokoto, South Africa

53 (p.118)
Adam and the birth of Eve, 1985–89
Wood
404 × 142 × 87 cm
Collection: Johannesburg Art Gallery
Photo: Wayne Oosthuizen

54 (p.119)
Tiger Fish (III), 1987–89*
Wood
94 × 470 × 26 cm
Collection: Johannesburg Art Gallery
Photo: Wayne Oosthuizen

ABD EL GHANY KENAWY AND AMAL KENAWY
Brother and sister Abd El Ghany and Amal Kenawy were born in Cairo, Egypt, in 1969 and 1974, respectively; both live and work in Cairo

55 (p.120)
Frozen Memory, 2003*
Video installation
Dimensions variable
Courtesy of the artists

WILLIAM KENTRIDGE
Born 1955 in Johannesburg, South Africa; lives and works in Johannesburg

56 (p.79)
Ubu Tells the Truth, 1997*
Animated film on DVD
Running time: 8 minutes
Courtesy of the artist, Goodman Gallery, Johannesburg, and Marian Goodman Gallery, New York
Photo: Lothar Milatz

57 (p.78)
Untitled (anamorphic drawing), 2001*
Charcoal on paper, mounted on table, metal cylinder
92 × 106 cm
Collection Gemma de Angelis Testa
Courtesy of the artist, Goodman Gallery, Johannesburg, and Marian Goodman Gallery, New York

BODYS ISEK KINGELEZ
Born 1948 in Kimbembele Ihunga, Democratic Republic of Congo (formerly Zaire); lives and works in Kinshasa, Democratic Republic of Congo

58 (pp.176–77)
Sète en 3009, 2000*
Mixed media
210 x 300 x 89 cm
Collection Musée International des Arts Modestes, Sète, France
Photos: Pierre Schwartz (p.176); François Lagarde and André Morin (p.177)

ABDOULAYE KONATÉ
Born 1953 in Diré, Mali; lives and works in Bamako, Mali

59 (pp.122–23)
L'initiation, 2004*
Textiles, mixed media
7 elements at 265 x 180 cm each
Courtesy of the artist

MOSHEKWA LANGA
Born 1975 in Bakenberg, Northern Province, South Africa; lives and works in Johannesburg and Amsterdam

60 (p.178)
Collapsing Guides, 2000–03*
Adhesive tape and collage on plastic film
1: 244 x 250 cm
2: 248 x 250 cm
3: 252 x 244 cm
Courtesy of the artist
Photo: Courtesy Kunstverein für die Rheinlande und Westfalen, Düsseldorf

ANANIAS LEKI DAGO
Born 1970 in Abidjan, Ivory Coast; lives and works in Paris and Abidjan

61 (pp.180–81)
Peregrination 1, 2001–04†
Gelatin silver prints
50 x 60 cm each
Courtesy of the artist

GODDY LEYE
Born 1965 in Mbouda, Cameroon; lives and works in Duala, Cameroon, and Amsterdam

62 (p.124)
Dancing with the Moon, 2002*
DVD projection, mirrors, blue light, fan
Dimensions variable
Courtesy of the artist / Centre d'Art Contemporain, Freiburg, Switzerland
Photo: Eliane Laubscher. Installation view at Fiction ou Réalité, Fri'Art, Freiburg (Switzerland)

GEORGES LILANGA DI NYAMA
Born c.1940 in Maasi, Tanzania; lives and works in Dar es Salaam, Tanzania

63 (p.125)
A town is people, without people it is not a town, we are people as you are, 1992
Acrylic on wood panel
245 x 123 cm
CAAC (Contemporary African Art Collection), The Jean Pigozzi Collection, Geneva

64 (p.125)
Have good relations with neighbours, they will help you when you are in need, 1992
Acrylic on wood panel
245 x 123 cm
CAAC (Contemporary African Art Collection), The Jean Pigozzi Collection, Geneva

65 (p.126)
Donkey Rider, 2000
Painted wood
65 x 29 x 25 cm
CAAC (Contemporary African Art Collection), The Jean Pigozzi Collection, Geneva

66 (p.126)
Bhang smoking, 2002
Painted wood
65.8 x 19 x 30 cm
CAAC (Contemporary African Art Collection), The Jean Pigozzi Collection, Geneva

67 (p.126)
Life in the ghetto, 2002
Painted wood
96 x 33 x 22 cm
CAAC (Contemporary African Art Collection), The Jean Pigozzi Collection, Geneva

68 (p.126)
Looking for water in the village, 2002
Painted wood
64 x 18 x 14 cm
CAAC (Contemporary African Art Collection), The Jean Pigozzi Collection, Geneva

69 (p.126)
Old Katembo and Mr Chicken, 2002
Painted wood
63 x 21 x 21 cm
CAAC (Contemporary African Art Collection), The Jean Pigozzi Collection, Geneva

70 (p.127)
Sindimba ngoma player, 2002
Painted wood
70 x 17 x 22 cm
CAAC (Contemporary African Art Collection), The Jean Pigozzi Collection, Geneva

71 (p.126)
Trying to get assistance through cellular phone, 2002
Painted wood
75 x 22 x 25 cm
CAAC (Contemporary African Art Collection), The Jean Pigozzi Collection, Geneva

FRANCK K. LUNDANGI
Born 1958 in Maquela do Zombo, Angola; lives and works in Paris

72 (p.128)
Femme à l'enfant, 2003
Mixed media on canvas
162 x 80 cm
Courtesy of the artist
© ADAGP, Paris and DACS, London 2005

73 (p.128)
La Maison de Sens, 2003
Mixed media on canvas
154 x 84 cm
Courtesy of the artist
© ADAGP, Paris and DACS, London 2005

GONÇALO MABUNDA
Born 1975 in Maputo, Mozambique; lives and works in Maputo

74 (p.182)
Eiffel Tower, 2002*
Metal, recycled weapons
200 x 150 x 150 cm
Courtesy of the artist and Centro Cultural Franco-Moçambicão, Maputo

75 (p.183)
Chair, 2003*
Metal, recycled weapons
c.130 x 130 x 130 cm
Property of the artist
Courtesy of Centro Cultural Franco-Moçambicão, Maputo

MICHÈLE MAGEMA
Born 1977 in Kinshasa, Democratic Republic of Congo (formerly Zaire); lives and works in Neuilly-sur-Marne, France, and Paris

76 (p.80)
Oyé Oyé, 2002*
2 DVDs, continuous loop
Dimensions variable
Courtesy of the artist

ABU-BAKARR MANSARAY
Born 1970 in Tongo, Sierra Leone; lives and works in Freetown, Sierra Leone, and Harlingen, The Netherlands

77 (p.82)
Masterpiece, 2000 (with installation drawing)*
Steel wires, cables, copper wires, batteries, aluminium plates
40 x 138 x 80.5 cm
Drawing: 34.5 x 97 cm
Courtesy of the artist

78
The Sector 2000, 2002*
Pen, pencil and colour pens
56 x 75 cm
Courtesy of the artist

79
Nuclear telephone discovered in hell, 2003*
Pen, pencil and crayon
106.5 x 137 cm
Courtesy of the artist

80
Syndrom II, 2003*
Pen, pencil
60 x 45 cm
Courtesy of the artist

81
The Feature of Law Enforcement,
2003*
Pen, pencil
34 x 46 cm
Courtesy of the artist

82 (p.82)
Turbo Charger, 2003*
Pen, pencil and crayon
36 x 84.5 cm
Courtesy of the artist

JULIE MEHRETU
Born 1970 in Addis Ababa, Ethiopia;
lives and works in New York

83 (p.184)
Enclosed Resurgence, 2001
Ink and acrylic on canvas
122 x 152 cm
Private collection, New York

84 (p.185)
Ruffian Logistics, 2001*
Ink and acrylic on canvas
152 x 335 cm
Thomas Dane, London

MYRIAM MIHINDOU
Born 1964 in Libreville, Gabon;
lives and works in Rabat, Morocco

85 (p.129)
Folle, 2000*
DVD video projection
Dimensions variable
Courtesy of Galerie Trafic,
Ivry sur Seine, France
© ADAGP, Paris and DACS,
London 2005

SANTU MOFOKENG
Born 1956 in Johannesburg,
South Africa; lives and works in
Johannesburg

86 (pp.186–87)
Rethinking landscape, 1996–2002*
6 gelatin silver prints
50 x 80 cm each
Recontres de la Photographie
Africaine de Bamako

ZWELETHU MTHETHWA
Born 1960 in Durban, South Africa;
lives and works in Cape Town

87 (pp.188–89)
Untitled, 2003*
5 C-print photographs, mounted
on UV Plexiglas
4 at 85 x 108 cm
1 at 155 x 200 cm
Courtesy of Jack Shainman
Gallery, New York

HASSAN MUSA
Born 1951 in Sudan; lives and
works in Domessargues, Gard,
France

88 (p.85)
Great American Nude, 2002*
Ink on textile
204 x 357 cm
Courtesy of the artist
Photo: Alain Arnal

89 (p.84)
Worship objects, 2003
Ink on textile
274 x 294 cm
Courtesy of the artist

N'DILO MUTIMA
Born 1978 in Luanda, Angola;
lives and works in Luanda

90 (pp.130–31)
Cosmogónicos, Masks I–III, 1997
3 C-print photographs on
aluminium
120 x 150 each
Hans Bogatzyke Collection of
Contemporary African Art

WANGECHI MUTU
Born in Nairobi, Kenya; lives
and works in New York

91 (p.133)
*A passing thought such frightening
ape*, 2003*
Ink and collage on Mylar polyester
film
172 x 127.5 cm
Collection of Jeannie Greenberg
Rohatyn, New York
Courtesy of the artist and Susanne
Vielmetter Los Angeles Projects

92 (p.132)
*In killing fields sweet butterfly
ascend*, 2003*
Ink and collage on Mylar polyester
film
107.5 x 85.5 cm
Collection of Jeannie Greenberg
Rohatyn, New York
Courtesy of the artist and Susanne
Vielmetter Los Angeles Projects

INGRID MWANGI
Born 1975 in Nairobi, Kenya; lives
and works in Ludwigshafen,
Germany

93 (pp.86–87)
Down by the river, 2001*
DVD installation; soil, metal
cylinder, spotlight
Dimensions variable
Running time: 22-second loop
Courtesy of the artist

SABAH NAIM
Born 1967 in Cairo, Egypt;
lives and works in Cairo

94 (p.190)
Cairo Noises, 2004*
Painted photographs on
canvas and newspaper relief
50 x 65 cm each
Courtesy of Lia Rumma,
Milan / Naples

MOATAZ NASR
Born 1961 in Alexandria, Egypt;
lives and works in Cairo

95 (p.81)
Tabla, 2003*
DVD projection, c.100 tablas
(various sizes)
Dimensions variable
Courtesy of the artist

OTOBONG NKANGA
Born 1974 in Kano, Nigeria;
lives and works in Amsterdam,
Paris and Nigeria

96 (pp.192–93)
Stripped Bare II, V, VIII, IX, X, 2003*
5 C-print photographs
50 x 80 cm each
Courtesy of the artist

SHADY EL NOSHOKATY
Born 1971 in Damiette, Egypt;
lives and works in Cairo

97 (p.121)
*The tree of my grandmother's
house, The Dialogue*, 2001
DVD installation
c.720 x 750 cm
Running time: 10 minutes
Courtesy of the artist

AIMÉ NTAKIYICA
Born 1960 in Burundi; lives and
works in Beersel, Belgium

98
Pieces of cake, 2004
Mixed media (4 DVDs,
4 soundshowers)
Diameter: 300 cm
height: 350 cm
Courtesy of the artist

99 (pp.88–89)
WIR, 2003*
3 C-print photographs
Posters
104.5 x 157.5 cm each
Courtesy of the artist

ANTONIO OLE
Born 1951 in Luanda, Angola;
lives and works in Luanda

100 (pp.194–95)
Townshipwall No. 10, 2004*
16 parts, mixed media
(found materials)
180 x 120 cm each
Courtesy of the artist
Photo: Lothar Milatz

RICHARD ONYANGO
Born 1960 in Kisii, Kenya; lives
and works in Malindi, Kenya

101 (p.134)
The Prey. Serial III – Vol II – D&M,
2000
Oil on canvas
119 x 159 cm
CAAC (Contemporary African
Art Collection), The Jean Pigozzi
Collection, Geneva

102 (p.135)
*The young man hides from the big
woman. Serial II – Vol II – D&M*,
2002
Oil on canvas
119 x 159 cm
CAAC (Contemporary African
Art Collection), The Jean Pigozzi
Collection, Geneva

OWUSU-ANKOMAH
Born 1956 in Sekondi, Ghana;
lives and works in Lilienthal,
near Bremen, Germany

103 (p.136)
Mouvement N° 33, 2004*
Acrylic on canvas
190 x 250 cm
Courtesy of the artist

104 (p.137)
Mouvement N° 39, 2004
Acrylic on canvas
190 x 250 cm
Courtesy of the artist

EILEEN PERRIER
Ghanaian; born 1974 in London;
lives and works in London

105 (pp.138–39)
Grace, 2000*
10 C-type photographs on Perspex
62 x 62 cm each
Courtesy of the artist

RODNEY PLACE
Born 1952 in Johannesburg,
South Africa; lives and works in
South Africa

106 (pp.196–97)
*Three Cities Triptych (Cape Town,
Johannesburg, Durban)*, 2002*
Mixed media in resin
Cape Town and *Johannesburg*:
123.5 x 82 x 8 cm
Durban: 123.5 x 123.5 x 8 cm
Courtesy of the artist
© the artist 2002

PUME
Born 1968 in Democratic Republic
of Congo (formerly Zaire); lives
and works in Kinshasa, Democratic
Republic of Congo

107
La Chaussure transformable, 1997*
Photographic paper, metal, wood
9.5 x 10 x 28.5 cm (shoe)
22 x 20.5 x 37 cm (total)
Courtesy of Revue Noir

108
*3 drawings (La chaussure trans-
formable)*, 1996–97
Ink on paper
2 at 42 x 56 cm
1 at 56 x 42 cm
Courtesy of Revue Noire

109 (p.199)
Ear chair, 2004*
Mixed media (plastic, plastic film,
wood)
135 x 80 x 80 cm
Courtesy of the artist
Photo: Lothar Milatz

110 (p.198)
Papillon chair, 2004
Mixed media (plastic film, wood)
150 x 90 x 120 cm
Courtesy of the artist
Photo: Lothar Milatz

TRACEY ROSE
Born 1974 in Durban, South
Africa; lives and works in
Johannesburg

111 (pp.140–41)
TKO, 2000*
DVD video projection with sound
on free hanging screen
Dimensions variable
DVD running time: 5 minutes,
54 seconds
Courtesy of the artist
Photo: Lothar Milatz

CHÉRI SAMBA
Born 1956 in Kinto M'Vuila, Demo-
cratic Republic of Congo (formerly
Zaire); lives and works in Kinshasa,
Democratic Republic of Congo, and
Paris

112
La faillite, 2003*
Acrylic on canvas
250 x 300 cm
Courtesy of the artist

113 (p.201)
Collège de la Sagesse, 2004
Acrylic on canvas
200 x 250 cm
CAAC (Contemporary African
Art Collection), The Jean Pigozzi
Collection, Geneva

114 (p.200)
Le Monde Vomissant, 2004*
Acrylic on canvas
200 x 260 cm
CAAC (Contemporary African
Art Collection), The Jean Pigozzi
Collection, Geneva

SÉRGIO SANTIMANO
Born 1956 in Lourenço Marques
(Maputo), Mozambique; lives and
works in Maputo

115 (pp.204–05)
Untitled, 1993–2000†
6 gelatin silver prints
40 x 50 cm each
Courtesy of the artist
© S. Santimano 2005

ZINEB SEDIRA
Algerian; born 1963 in Paris;
lives and works in London

116 (p.83)
Mother, Father and I, 2003*
3 DVD video projections
Dimensions variable
Commissioned by Contemporary
Art Museum, St Louis, Missouri
Courtesy of The Agency, London,
and Galerie Kamel Mennour, Paris

BENYOUNÈS SEMTATI
Born 1966 in Oujda, Morocco;
lives and works in Paris

117
Untitled, 1999
Charcoal on paper
c.184 x 454 cm
Courtesy of the artist

118 (p.142)
Untitled, 2003–04*
80 felt-tip pen and oil crayon
drawings on paper
28 x 21 cm each
Courtesy of the artist

YINKA SHONIBARE
Nigerian; born 1962 in London;
lives and works in London

119 (pp.90–91)
Victorian Philanthropist's Parlour,
1996–97*
Mixed media
Dimensions variable
Collection Eileen Harris-Norton
and Peter Norton, Santa Monica,
California